Braddock's Road

Braddock's Road

MAPPING THE BRITISH EXPEDITION *from* ALEXANDRIA *to* THE MONONGAHELA

NORMAN L. BAKER

THE
History
PRESS

Published by The History Press
Charleston, SC 29403
www.historypress.net

Cover images: Front top: Section of Christopher Gist's 1755 map of Braddock's Road. *John Carter Brown Library, Brown University*. Front bottom: *The Crossing*, by Robert Griffing, of the second fording of the Monongahela by Braddock's army. *Paramount Press Inc*. Back top: Braddock's Road at Puzzley Run. Lacock & Weller, 1908. *Braddock Road Preservation Association*. Back bottom: Troops of Braddock's army assist movement of cannons up an incline. *From Braddock's Defeat by Charles Hamilton*.

First published 2013

Manufactured in the United States

ISBN 978.1.62619.114.3

Library of Congress Cataloging-in-Publication Data

Baker, Norman L., 1926-
Braddock's Road : mapping the British expedition from Alexandria to the Monongahela /
Norman L. Baker.
pages cm
ISBN 978-1-62619-114-3 (pbk.)
1. Braddock's Campaign, 1755. 2. Braddock's Campaign, 1755--Maps. 3. Military roads-
-Maryland--History--18th century. 4. Military roads--Pennsylvania--History--18th century.
I. Title.
E199.B33 2013
973.2'6--dc23
2013030404

*For those who have fought or sacrificed
their lives in the defense of freedom.*

Contents

CONTENTS

Preface

It is beyond our power to properly express our appreciation to the many people who provided assistance when our paths crossed during the several years we have devoted to the quest of resurrecting Braddock's Road. Their cooperation and hospitality are forever embedded in our memory. The sharing of their knowledge and appreciation of our devotion for this important corridor of our nation's history often revitalized and sustained our determination. We have walked and rewalked untold miles along this historic path, mainly alone, but often there were those who briefly shared the ventures through the forests, over the mountains and across the meadows and cleared fields, along the often elusive traces of the army's struggle through what was once a vast wilderness. Many miles of the road are in private hands. It has been through the willingness of the owners of the land etched by the road that we could fulfill our task. Most often, they have welcomed us and permitted us to walk freely over their property, follow the road or search for its remains.

One person stands out for the contribution he provided several years ago. A lecturer on Braddock's Road, who shall remain unnamed, attempted to discourage those who sought the remnants of the road. It was his conclusion that very little remained and that its course mainly could only be approximated. Based on our previous years of research in this area, this was a challenge that could not be ignored. We had learned early on of the pioneer work of Thomas C. Atkinson, in the mid-nineteenth century, and of John Kennedy Lacock, more than a century ago, who took to the field to

put into the historical record what they could determine about the course of the road. From them we were offered another challenge—to explore more deeply what they had begun.

There are the works of several historians that no student of the Braddock experience can ignore: Neville B. Craig, Winthrop Sargent, James Veech and Archer Butler Hulbert, among others. There are the maps of Christopher Gist, Harry Gordon and Joseph Shippen Jr. that are so revealing. Then there were the revelations of the past century of material not available to Atkinson and Lacock, including Gist's map, based on his firsthand knowledge of the expedition, and the journal discoveries by Charles Hamilton. There are the more recent works of Walter S. Hough, Paul A.W. Wallace, Frank and Elizabeth Cassell, James V. Steeley and Robert L Bantz. I am especially indebted to Bantz, who shares our attraction and enjoyment with our mutual friend, the road, and has assisted us often and willingly in the research of the Maryland portion of the road.

It was Dr. Walter Powell, president of the Braddock Road Preservation Association (BRPA), who requested that we introduce our study at an annual Jumonville French and Indian War Seminar a few years ago and encouraged us to detail our study in the present work. We are thankful for the many hours that Robert Nipar and Jaye Beatty of the BRPA have shared with us as we researched and walked sections of Braddock's Road. Robert Nipar has assisted us in conducting tours of the road as we have found it. To Dr. David Preston, professor in the Department of History at The Citadel in Charleston, who has also spent hours with us walking the road in Virginia and Maryland, and to Citadel cadet Paul Whitten, we owe much to their generosity in assisting us with the preparation of this work, making it compatible with the publisher and my efficient and cooperative senior commissioning editor, Hannah Cassilly.

We shall never forget the times when the owners of the land on which we walked provided us a welcoming drink of cold water on a hot summer day on the slopes of Spring Gap Mountain in West Virginia or near Sewickley Creek below Hunker, Pennsylvania. There were the comforting meetings and conversations on Red Ridge, Meadow Mountain, Negro Mountain, Puzzley Run and Keyser's Ridge in Maryland, as well as on a cold, heavy snow-whipped day in the isolation under the Winding Ridge in Pennsylvania. There was the welcoming into the warmth of homes in winter and the coolness of homes in summer. It was the heat of the summers and the closeness of the forests that allowed us to better understand the toil and suffering of the soldiers of Braddock's command. Most of the time, we

walked alone, physically, but not without sharing mentally what we believed the soldiers had to endure.

This study required a great amount of archival research. The historical depositories of most of the local county libraries and society records were searched in Virginia, Maryland and Pennsylvania. A considerable amount of effort was devoted to the compilation of the surveys of land grants along the road issued in the years after the expedition. The Pennsylvania Historical & Museum Commission's land surveys, compiled by the Department of Internal Affairs of Pennsylvania, were especially helpful in our plotting of the road and the resolution of conflicting issues regarding the course of the road.

The United States Geological Survey, located in Reston, Virginia, provided us the historical and modern maps used in the plotting of the surveys and the road, as well as their juxtaposition with air and satellite photographs, in the compilation of our Braddock's Road maps.

Most recently, through the generous efforts of Brian Reedy and Lawren Dunn of the Fort Necessity National Battlefield, a 1932 map of plotted surveys along the Braddock's Road, prepared by the Department of Internal Affairs, was unveiled for our viewing. It allowed us to confirm our own previous compilation of the surveys along the road.

However, finally, as Atkinson expressed it, "the only solution was to see the ground" for ourselves.

"How brilliant the morning, how melancholy the evening."

—*Dr. Thomas Walker, survivor, in wake of Braddock's Defeat*

Chapter 1

The Genesis

N o passage in early America has been subjected to more confusion and misinformation regarding its birth, its course and its relation with other paths, trails and roads than the route used by General Braddock's army through Virginia, Maryland and Pennsylvania.

Braddock's military road utilized a combination of passages. It began on the south banks of the Potomac River in present Alexandria, Virginia, and took two long-established roads through the well-inhabited sections of eastern and northern Virginia and eastern Maryland. The two roads—after reaching the vicinity of the eastern and earlier branch of the Great Warrior's Path (also known as the Warrior's Trail, the Virginia Road and the Great Road[1]) west of the Blue Ridge in Virginia and South Mountain in Maryland—united, out of necessity, as one in northern Virginia a few miles north of Winchester. Braddock's deputy quartermaster general Sir John St. Clair chose an existing packhorse traders' path for the army's route through northwestern Virginia and back across the Potomac into Maryland and along the north side of the river to Fort Cumberland.

The traders' path was established early and was the route from the first established town west of the Blue Ridge, Frederick Town (later Winchester), to the mouth of Will's Creek on the Potomac (later Fort Cumberland), where the Ohio Company established a trading post or store, and to the Monongahela and the Ohio Rivers. The traders' path followed by Braddock's army crossed the Bear Garden and Spring Gap Mountains and followed the Little Cacapon River to the north bank of the Potomac. It then turned

westward to Thomas Cresap's settlement and trading post at the Shawnee Oldtown on one of two western branches of the Great Warrior's Path.[2] Cresap, whose settlement was a gathering place for the earliest traders from Virginia, Maryland and Pennsylvania, was a member of the Ohio Company.

Militia colonel James Patton, county lieutenant of Augusta County, rode the traders' path from Winchester to Cresap's at Oldtown in September 1751. Patton was on his way to Loggs Town to extend Virginia's invitation for a new treaty (reaffirming the Treaty of Lancaster of 1744) regarding the Ohio lands. He purchased supplies and wampum from Cresap and hired David Castleman as a guide. There were two routes to the Will's Creek path to the Forks of the Ohio from Cresap's. One was on the north side of the North Branch of the Potomac, in Maryland, and the other on the south side of the North Branch, through present Mineral County, West Virginia, to the Short Gap of Knobly Mountain and across the North Branch. Patton took the latter route, which, after crossing the Potomac, continued north to the southwest branch of Will's Creek (later Braddock Run) in the vicinity of present Allegany Grove, Maryland,[3] joining the north branch of the path from the mouth of Will's Creek over Sandy Gap of Will's (Haystack) Mountain.

Two months after his return from his 1750–51 exploration through future Ohio, Kentucky and West Virginia, Christopher Gist received instructions from the Ohio Company to undertake his second exploration, this time south of the Ohio, between the Monongahela River on the north and the "Big Conhaway" (Kanawha—Wood's River or New River) on the south. He was "to look out & observe the nearest & most convenient Road you can find from the Company's Store at Wills's Creek to a Landing at Mohongeyela" before proceeding down the south side of the Ohio.[4] In October, returning from Loggs Town, Patton met with Gist at the Ohio Company's store at Will's Creek, where Gist was preparing for his new exploration. Patton returned to Augusta County by way of Cresap's and the traders' path to Winchester.[5]

Accompanied by his son, Nathaniel, Gist left the Ohio Company's storehouse the following month, on November 4, 1751, crossed the North Branch of the Potomac into Maryland and rode west four miles to "a gap in the Allegany mountains upon the S.W. fork of the said creek [Braddock Run]." Traveling over the Sandy Gap of Will's Mountain, Gist camped that night on present Braddock Run in the vicinity of Allegany Grove, the later first encampment of the major body of Braddock's army. Gist, in his journal, advised the Ohio Company that the gap "is the nearest to the Potomac River of any in the Allegany Mountains, and is accounted one of

the best, tho the Mountain is very high, The Ascent is no where very steep but rises gradually near 6 M [miles], it is now very full of old Trees & Stones, but with some Pains might be made a good Waggon Road." He added that the gap was on a direct way to the Monongahela and "several Miles nearer than that the Traders commonly pass thro, and a much better way."[6] Gist was referring not only to Sandy Gap but also to the passage through the mountains west up Braddock Run. However, the army found the Sandy Gap passage too difficult as an army road for the heavy wagons and artillery carriages and opted for the Narrows passage to Allegany Grove discovered by naval lieutenant Charles Spendelow as the passage for the main body of the army. It is evident from his narrative that Gist personally endorsed a path that should be credited to his vision. It is now the avenue for the primary highways of western Maryland, Highway 40 and Interstate 68.[7]

Gist continued his exploration up the southwest branch of Will's Creek, later followed by Braddock's army and a continuation of the major thoroughfares of Maryland, past present Frostburg and over Big Savage Mountain. On his second day, he encamped immediately west of Big Savage Mountain in the Savage River Valley.[8] On November 8, Gist, indicating that he was continuing to follow a path that would later be used by Braddock's army, passed the site where the army would make its third encampment above the Carey Run branch of the Savage River. He encamped that night in the vicinity of the pass used by the army over the Eastern Continental Divide, where many years later the National Road and Interstate 68 would make a near convergence over the same pass.[9] The next day, Gist reached the area of the Little Meadows west of Meadow Mountain.[10]

Gist remained in the area for almost two weeks, exploring for several miles around the Little Meadows and Castleman's (Casselman) River. On November 20, the explorer shifted his course to the northwest over Negro Mountain, away from the path that would later be followed by Braddock's army. On this course, on November 24, he crossed the Turkey Foot forks of the Youghiogheny, near the present town of Confluence, Somerset County, Pennsylvania, about five miles north of the army's Great Crossings of the Youghiogheny. His encampment that night was near the future National Road in the vicinity of Flat Rock, Pennsylvania, and probably within a mile of the future Braddock's Road. The following day, Gist's encampment was on Stony Fork of Big Sandy Creek—near, on or not far from the future path of the army's road south of present Farmington and the site of Fort Necessity.[11] Pursuing his exploration west and northwest for several miles, encountering and passing over the Chestnut Ridge, Gist spent several days

exploring between present Uniontown and Mount Braddock. He expressed praise for the quality of the land he found there, an area in which he would begin a settlement in the immediate months ahead.

From the head of Redstone Creek, in the area of present Uniontown, Gist rode west six miles on December 7 to a Delaware camp on Dunlap's Creek;[12] their chief identified himself as "Nemicotton" (Nemacolin).[13] The camp, about two miles southwest of the present National Road, was in the vicinity of the present community of Shamrock, Fayette County, and about six miles east of the Monongahela. Gist indicated that this was his first encounter with and knowledge of Nemacolin. After remaining in the camp for a day, Gist resumed his exploration, riding west to the Monongahela, where he found a twenty- by thirty-foot cavity, seven feet high, in a rock[14] before turning and continuing north for the next several days, examining the lands on the east side of the Monongahela. His exploration took him across Dunlap's and Redstone Creeks to the east of their mouths at present Brownsville, Fayette County, and north over the lands between the Monongahela and the Youghiogheny, finally crossing the Monongahela on December 15.[15] Gist's path of exploration then swung southwest, through southwestern Pennsylvania and into present West Virginia, through the lands southeast of the Ohio River as far as the Kanawha River near Point Pleasant, West Virginia. Gist returned to the Ohio Company's "Factory" at Will's Creek on March 29, 1752.[16]

One month after his return, on April 28, the Ohio Company instructed Gist: "If Col Cresap has not agreed with any person to clear a Road for the Company, you are with the advice and assistance of Col. Cresap to agree with the proper Indians, who are best acquainted with the ways, immediately to cut a road from Wills Creek to the Fork of Mohongaly [Monongahela] at the cheapest Rate you can for Goods, and this you may mention publicly to the Indians at the Loggs Town or not as you see occasion." The road sought by the Ohio Company extended to the mouth of Redstone Creek on the Monongahela at present Brownsville, where the company would build a storehouse. To what extent Cresap and the contemporary Indians participated in designating and clearing this road is not known, but Gist was paid more than forty-four pounds for work on the road and for expenses incurred.[17]

The road was properly Gist's road, his responsibility. Romantic embellishment and folklore, prominent in the nineteenth century, has tended to shift the recognition for this road's existence to Nemacolin and to Cresap. One of the earliest purveyors of this recognition (with Cresap

family ties), writing in 1826, credited Thomas Cresap with hiring Nemacolin to lay out and mark the road, not just to the mouth of Redstone Creek but "from Cumberland to Pittsburgh." This, the writer related, became Braddock's Road and "does not materially differ from the present great National Road."[18] It has been suggested that "some exaggeration has taken place" about the extent of Nemacolin's participation in the development of the road. There is no mention of Nemacolin's employment in the Ohio Company records dealing with the road.[19] In the extreme, even the road from the Chestnut Ridge to the field of battle on the Monongahela has been called the northern branch of Nemacolin's Path.[20]

The path for this road already existed, a long-established Indian and traders' path to the Forks of the Ohio, a packhorse passage that forked at the Chestnut Ridge into one path to the landing at the present site of Brownsville, between the mouths of Redstone Creek and Dunlap's Creek, and the other north, overland to the Forks of the Ohio. Gist's responsibility for the Ohio Company was to mark or blaze the path for a packhorse passage to a storehouse site at the Redstone Creek landing on the Monongahela. There were essentially two viable options. One passage already existed as an Indian trail and traders' packhorse path known as Dunlap's Path.[21] The conversion to a wagon road, as far as the Chestnut Ridge and beyond, would come later. Gist began his settlement west of the Chestnut Ridge in the fall of 1752. In the immediate months ahead, the path to the Forks of the Ohio along the ridge became a priority passage for the movement of his family and in furtherance of the Ohio Company plans to settle families in the region. The other option for the Ohio Company passage to the Monongahela was to clear a wagon road from Gist's settlement to the mouth of Redstone Creek.

George Washington met Gist on November 14, 1753, at Will's Creek. Washington delivered a letter to Gist from the Virginia Council requesting him to guide Washington to the commandant of the French Fort LeBoeuf near the shores of Lake Erie. Traveling the traders' and Ohio Company path, they camped for the night on George's Creek, with its headwaters at Frostburg, Maryland, the site of Braddock's second encampment. Washington and Gist next encamped at the "big hill" (Negro Mountain, which had not yet been named) in the forks of Youghiogheny. On the sixteenth, they were at the ford of the Great Crossings, encamping for a day to rest their horses. The following day, they reached Gist's house "in the new settlement" in snow that was ankle-deep.[22]

On the crest of Chestnut Ridge, Washington and Gist took the path's fork to the right at the Rock Camp (Half King's Rocks) and rode the crest

of the ridge to the valley and Gist's settlement. This fork in the road was the ancient division of the Indian paths to the Forks of the Ohio. As noted earlier, the left branch, or Dunlap's Path, ended on the Monongahela at present Brownsville and the landing for the water passage north down the river to the Forks.

The right branch of the path joined the ancient Catawba Path at Gist's settlement. The Catawba Path[23] was a path of the Senecas, the western Iroquois nation, in their war against the Cherokees and Catawbas. It crossed the Pennsylvania line and the Cheat River near the mouth of Grassy Run in Fayette County's southwest corner.[24] In its northward passage, it followed generally the track of Highway 119, crossing the Redstone branch of the traders' path in the area of present Uniontown, before reaching the northern traders' land route to the Forks of the Ohio at Gist's plantation.

Riding twenty miles the next day, Washington and Gist reached the site of Jacobs' Cabins.[25] After crossing the "Big Youghiogany" at what would become known as Stewart's Crossings, they continued by the Catawba Path along the elevations east of Jacobs' Creek. At a fording of Jacobs' Creek in present Hammondville, Fayette County, the path to the Forks of the Ohio swung northwestward on the Glades Path. This path in its eastward course joined briefly with the Catawba Path before separating, with the Catawba Path continuing northeast to a crossing of the Raystown Path[26] at present Ligonier, Westmoreland County, Pennsylvania. The Glades Path stayed its eastern course to present Bedford, the earlier site of Raystown on the Juniata River. It was the Glades Path northwest from Jacobs' Creek that was followed by Washington and Gist and later Braddock's army to the banks of the Monongahela—the path the army left and to which it returned after the side trip to Blunder Camp.

The day after leaving Jacobs' Cabins, Washington and Gist reached the area where Braddock's army would encamp on July 4, 1755, north of Thicketty Run and south of present Madison, Pennsylvania.[27] After a day in camp, they rode to John Frazier's home and trading post at the mouth of Turtle Creek on the east bank of the Monongahela near Braddock's later field of battle.[28] They returned to Frazier's on December 30 after completing their mission to the French Fort LeBoeuf. The last day of the year, Washington visited with the Delaware queen Aliquippa, and on January 1, 1754, Washington and Gist were back at Jacobs' Cabins. The following day, they crossed the Youghiogheny at Stewart's Crossings on the ice and reached Gist's settlement. They were back at Will's Creek on January 6. Before arriving at Will's Creek, they met on the path a seventeen-horse

pack train loaded with materials and stores for the Ohio Company fort to be built at the Forks of the Ohio. Following them were some families going out to settle.[29]

The earliest attempts to convert the packhorse or bridle path into the semblance of a viable road had begun with the packhorse train for the Ohio fort followed by the settlers. The Ohio Company would first build a storehouse at the mouth of Redstone Creek before dispatching a small cadre of men to begin the erection of a fort at the Forks of the Ohio. Captain William Trent of Pennsylvania was placed in charge of the Ohio Company operation, with John Frazier second in command. Overseeing the construction was apparently the responsibility of Ensign Edward Ward, with a total force of only forty-one men, including thirty-three soldiers.[30]

Three months later, Washington, with his new commission as a lieutenant colonel of the Virginia Regiment and second in command to Colonel Joshua Fry, began the next phase in the upgrading of the road. Virginia's Governor Dinwiddie ordered the march of the troops of the regiment at Alexandria toward the Ohio to aid Captain Trent in building and defending the Ohio Company fort. Washington began his march on April 2 with about 150 men, with other troops under Colonel Fry to follow. Marching by way of what would later be a section of the route of a part of Braddock's army through northern Virginia, Washington took his small force over the Blue Ridge at Keyes' Gap. By April 19, taking a settlers' wagon road from Winchester to the South Branch of the Potomac, he had reached present Romney, West Virginia. While there, he received word from Captain Trent that French troops were on the move toward the Forks of the Ohio and that he needed immediate reinforcement. The next day, on the march to Thomas Cresap's at Oldtown, Washington learned that the French had taken Ensign Ward's fort, while Captain Trent was at Will's Creek and Frazier remained at his trading post at Turtle Creek. Ward, after the surrender, took his men to the storehouse at the mouth of Redstone Creek, arriving there in two days. Continuing to Will's Creek, he met and reported to Washington the details of the encounter with the French.[31]

At a council of war convened at the Ohio Company store opposite the mouth of Will's Creek on April 23, the decision was made to march Washington's troops to the mouth of Redstone Creek, build a fortification and clear "a road broad enough to pass with all our artillery and our baggage." It was noted that the "stores are already built at [Redstone] for the provisions of the Company, where in our Ammunition may be laid up, our great guns may be also sent by water whenever we shall think it convenient

to attack the Fort [at the Forks of the Ohio]."[32] By May 9, Washington's troops had cleared the road to Little Meadows. A week later, in the vicinity of the Great Crossings of the Youghiogheny, two traders fleeing from the French, who were often seen near Gist's settlement, were encountered. Washington noted that the traders were of the opinion, "as well as many others," that it was not possible to clear a road for loaded wagons to Redstone Creek. Encountering very high waters on the Youghiogheny, Washington embarked in a canoe with an officer, three soldiers and an Indian downriver to determine if he could find a water passage. Passing the Turkey Foot forks of the river, they continued down the river about ten miles until rapids in the vicinity of the Ohio-Pile (Ohiopyle) Falls forced them to call off the exploration and return to the Great Crossings and a resumption of the overland march toward Redstone Creek. The Great Meadows was reached on May 24, and upon learning that a strong detachment of French was on the move toward them, Washington placed his troops and wagons behind "two natural entrenchments."[33]

Three days later, Gist came into the camp at the Great Meadows from his settlement over the Chestnut Ridge, reporting that a force of about fifty French soldiers had been at his plantation the day before and that he had seen their tracks only five miles from the Great Meadows. The Delaware chief Tanacharison, the Half King, on his way to join Washington, would later the same day follow the tracks of two men along the road to "a low obscure place," where he believed the French force was located. In a nighttime march in heavy rain, Washington led a group of his men and a small body of allied Indians under the leadership of Half King to a sunrise attack on the French force under the command of M. de Jumonville. Nine of the French were killed, including Jumonville; one was wounded; and twenty-one were captured. Washington lost one killed and three wounded. Correctly fearing that he would be attacked by a considerable body of the French, Washington began building Fort Necessity.

For almost a month, Washington kept his troops in a defensive position before aggressively resuming his clearing of a road toward Redstone Creek. On June 27, he detached two officers and sixty-five soldiers led by Captain Andrew Lewis to clear the road from Gist's to the mouth of the creek on the Monongahela.[34] The following day, after a council of war, acting on intelligence from scouts, the road-building operation was canceled, and Washington's troops were concentrated at Gist's in preparation for an attack by a large French force. After additional intelligence of the advancing French force, another council of war opted for an immediate retreat to

Will's Creek. By the time Washington's troops reached Great Meadows, they were so exhausted and hungry that the decision was made to make a stand at Fort Necessity.[35] The French opened fire on the fort on the morning of July 3. The firing continued in a driving rain until the evening. Washington surrendered at about midnight, and his troops marched toward Will's Creek at sunrise on July 4.[36] The sixty-five-mile section of the road to the Forks of the Ohio, from Will's Creek to Gist's plantation, was now well defined and cleared as a wagon road. This section of the traders' path, inherited as Gist's Ohio Company path, was now also Washington's Road. In a year, it would become Braddock's Road.[37]

Braddock's Road would define the general course of the future roads for America's westward expansion. It was never the Cumberland Road or the National Road. For the first ten miles from Fort Cumberland, the nineteenth-century Cumberland and National Roads would follow closely Braddock's military road.

The National Road crossed or joined briefly the military road eight times by the time it reached the present community of Clarysville at the head of Braddock Run. At Clarysville, it separated from the route of the army road by several miles and did not again contact the military road until it reached the Eastern Continental Divide, a short distance east of the dense pine forest of Shades of Death in the valley of Two Mile Run.

Another near contact would be made at Little Meadows, with a crossing and brief convergence between Little Meadows and the Little Crossings at the Casselman River. The two roads would not cross again until they were ascending the east slope of Negro Mountain. They would cross on the west slope of the mountain and, finally, west of Puzzley Run, again crossing and converging at Keyser's Ridge.

A long separation would follow at Keyser's Ridge until they reached the crossings at the line between Maryland and Pennsylvania on the Winding Ridge, followed by still another long separation to the Great Crossings of the Youghiogheny. The National Road again joined the military road on the west side of the Great Crossings up the Jockey Hollow before decisively separating for several miles, crossing Braddock's Road for the last time beyond Fort Necessity and near the grave of General Braddock.

A total of twenty crossings or very brief convergences over a distance of about fifty-four miles is confirmation that the engineers who laid out the Cumberland Road and the National Road could not disagree that the early traders' path that evolved into Gist's Ohio Company road, Washington's Road and, finally, Braddock's Road to the Chestnut Ridge exhibited good

judgment. However, they never shared enough common ground to state, as did an earlier writer,[38] that they did not "materially differ" or to note the recent assertion that Braddock's Road "was later improved as the Cumberland Road, the National Road, the National Pike, and eventually U.S. Route 40, the so-called National Highway."[39]

The Initial Thrust

Alexandria to Fort Cumberland

The overwhelming defeat of General Edward Braddock's army by the French on the banks of the Monongahela on July 9, 1755, was one of the most significant battles of the final French and Indian War. It was a delayed awakening of the British colonies to the realization that it was an all-out war for America.

Braddock's Road, the army's path to that battle, is one of the best-known icons of American history. The general course of the road has long been known, yet its near-precise physical identification has to a large degree eluded historians. There have been many narratives of the epic struggle of that small army's laborious trek through and beyond the inhabitants of Virginia, to the frontiers of Maryland and Pennsylvania, over a mainly untamed wilderness and to the brutal and bloody slaughter on the banks of the Monongahela.

Only a few writers have put aside the romantic telling of Braddock's defeat in order to concentrate on the tedious on-site exploration for the etching of the landscape of that historic path. When the precious and sometimes elusive signs have been eradicated or buried beneath the aftermath landmarks of modern development, some have found it convenient to rest on generalizations regarding the road's course. There has been much discourse, subsequent confusion and only a few definitive conclusions.

In late March 1755, a few weeks after arriving at Hampton Roads in Virginia, General Braddock and his regiments sailed up the Chesapeake Bay and the Potomac River. On the west bank of the river at Alexandria, Virginia,

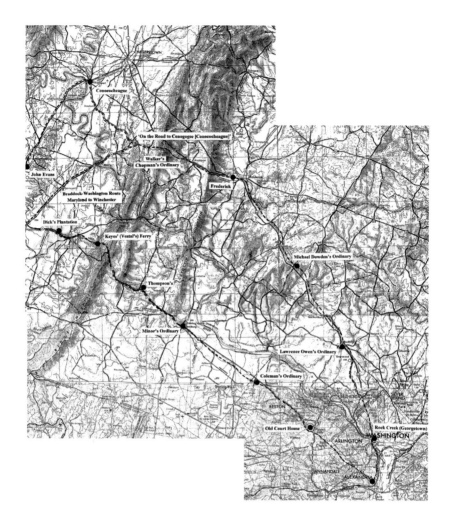

Braddock's Road: Alexandria to the Shenandoah Valley. *Author map.*

he began to assemble his army. By early April, the first detachments of his army were ready to march westward. For the first three weeks of the initial thrust of General Braddock's expedition, there were two Braddock roads: one through eastern Maryland and the other through northern Virginia.

The first men to march on April 5, 1755—a corporal and six soldiers from Colonel Thomas Dunbar's 48th Regiment—left on that date with stores for the army's planned hospital at Frederick, Maryland. Two days later, an officer and thirty men of Dunbar's command marched to the mouth of Rock Creek in Maryland.[40]

On April 8, an officer, one sergeant and twenty men from Sir Peter Halkett's 44th Regiment were ordered to march through Virginia to Winchester. The next day, all of Braddock's Rangers and troops of the Light Horse, along with six companies of Halkett's regiment, began the march to Winchester. On April 13, another company of Halkett's regiment left Alexandria escorting two wagons of artillery, also to Winchester.[41]

THE EASTERN MARYLAND ROAD

ROCK CREEK (GEORGETOWN)—On the morning of April 12, Dunbar's 48th Regiment marched north along the west bank of the Potomac. Passing through the area of the present Pentagon and Arlington National Cemetery, the regiment was ferried across the river at what is now known as Theodore Roosevelt Island to a landing near the mouth of Rock Creek, at Georgetown, and within the future environs of Washington, D.C.

LAWRENCE OWEN'S ORDINARY—After halting for a day at Georgetown, the regiment began its march northward on April 14, following what is now Wisconsin Avenue and Highway 355 to the present Old Georgetown Road, or Highway 187. Continuing on this road to a return to Highway 355, Dunbar's troops arrived at Lawrence Owen's Ordinary, now Rockville, Maryland, after marching about fourteen miles.[42]

DOWDEN'S ORDINARY—Dunbar's troops completed another march of about fourteen miles[43] on April 15, following the general course of the old Frederick road, now Highway 355, to Dowden's Ordinary in the present community of Clarksburg,[44] where a halt was called the following day.

FREDERICK—The march was resumed on April 17, crossing the Monocacy River by flatboat and reaching the center of present Frederick in about 14.7 miles.[45] The following day, a company of grenadiers was dispatched to the mouth of Conococheague Creek on the Potomac River at present Williamsport, Maryland, at the ferry crossing of the river of the Great Road into the Valley of Virginia. The grenadiers were ordered to secure the area for the arrival of the remainder of the army.

Dunbar's troops remained in Frederick, encamped on the outside of the town, for eleven days, while awaiting the arrival of General Braddock on April 21 and Governor Horatio Sharpe of Maryland on April 23. In addition to Governor Sharpe, who confessed that he was unable to supply the wagons and horses needed, Braddock met with Benjamin Franklin, who

provided a better accounting of the state of affairs but who also promised and would deliver the much-needed horses and wagons.

By April 27, Braddock had learned that there was not a passable road from the Conococheague to Will's Creek through the colony of Maryland.[46] It would be necessary to return to Virginia south of the Potomac, march south along the Great Road (present Highway 11) and join the road that Halkett was following through Virginia to Will's Creek. Dunbar was ordered to march on the twenty-ninth to the crossing of the Potomac at Conococheague, at present Williamsport. Dunbar was given a timetable of eleven days, with two halting days of rest, to march an estimated distance of 129 miles from Frederick to Will's Creek, an average march of about 14 miles per day.[47]

CHAPMAN'S ORDINARY/"WALKERS"—On their first day's march from Frederick, Dunbar's troops traveled to "Chapmans Oardianary" and "Walkers."[48] Braddock ordered the detachment of sailors to march with Dunbar. While the batman wrote that his detachment, after marching 18 miles, had encamped at "Chapman's Oardianary," the Seaman's Journal recorded an encampment the same distance from Frederick at "Walkers," on the west side of South Mountain. Moses Chapline Sr. was granted a tract of land on both sides of the army's road west of Fox's Gap of South Mountain, on a draft of Little Antietam Creek. Chapline's land, an ideal and likely encampment site, extended 1.8 to 2.6 miles along the road west of Fox's Gap. The sailors may have made camp to the west of Chapline's. The Seaman's Journal identification of "Walkers" may have been a reference to the prepositioning of provisions for the troops at Chapline's by Dr. Thomas Walker, one of Braddock's commissaries.

In a separate order, Captain Gates was directed to take his company to Conococheague to protect the magazines. The orders of the day detailed the route that the soldiers of Dunbar's command would take to the Conococheague and through the Virginia colony.[49]

CONOCOCHEAGUE—Leaving Frederick, the route followed the course of Highway 40 (the old National Road) through present Middletown and over Little Catoctin Creek, where the army moved to the left on present Marker Road and ascended South Mountain at Fox's Gap.[50] On the west side of South Mountain, the route, known as the Old Sharpsburg Road, continued over Little Antietam Creek to a fork in the road south of present Keedysville. Taking the fork to the right, the army marched along the present Keedysville, Bakersville and Spielman (Route 63) roads to the mouth of Conococheague at present Williamsport. On April 30, Dunbar's regiment

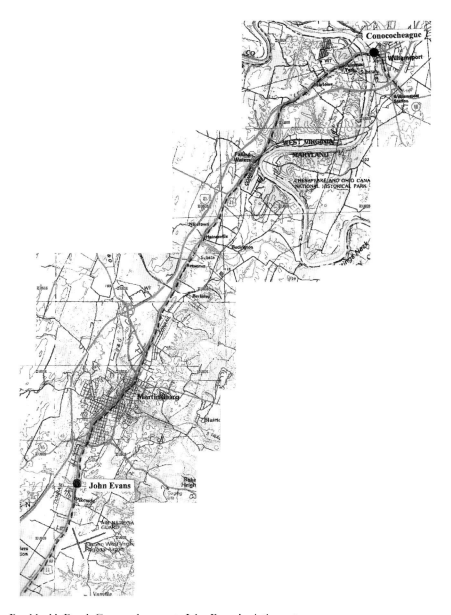

Braddock's Road: Conococheague to John Evans's. *Author map.*

reached the Conococheague and the crossing of the Potomac. The batman recorded eighteen miles for the day's march, while the Seaman's Journal recorded only sixteen miles, over an actual distance of about fourteen miles from Chapline's.[51]

George Washington joined Braddock in Frederick on May 1, accompanying the general and his staff the next day over the South Mountain to a crossing of the Potomac on the way to Winchester. Braddock, taking a shorter route to Winchester than the one followed by Dunbar's regiment, was hopeful of meeting and acquiring the aid of allied southern Indians for his expedition. Once over the South Mountain through Fox's Gap, Braddock's route took the left fork south of present Keedysville and followed the course of present Highway 34 through present Sharpsburg and over the Potomac at Swearingen's Ferry at present Shepherdstown, West Virginia.[52] The general and his staff rode from Shepherdstown to Winchester, south of Halkett's crossing of the Great Road or Indian War Path (present Highway 11[53]) and the turning of the route of Dunbar's march from his crossing of the Potomac. Braddock arrived at Winchester on May 3 and waited four days for the Indians, who did not appear, before returning to the army's path toward Will's Creek.

EVANS—Crossing the river on May 1 at Watkins' Ferry,[54] another march of about 16 miles on the wagon road and former Indian path (Highway 11) was completed by Dunbar's troops before reaching the settlement of John Evans.[55] A halt was called the following day, May 2, at Evans's, located at the "Big Spring," about 2.6 miles south of the center of present Martinsburg, West Virginia.[56] On April 27, Dunbar received orders "to make the new road to their Right, which leads from the Opeckon [Opequon Creek] Bridge [ford]."[57] Dunbar, at Evans's, was now only about 13 miles north of the point of rendezvous with Halkett's road through Virginia, at present Clear Brook on the Great Road (Highway 11) in Frederick County, Virginia.

THE VIRGINIA ROAD

Originally, the route for marching Sir Peter Halkett's regiment through Virginia included passage through Winchester. That route plan designated a road over the Keyes' Gap, now followed by Highway 9, and across the Shenandoah River at Keyes' to Winchester. The plan included a total of six encampments in as many days and an estimated distance of ninety-seven miles, for an average of about eleven miles per day. However, as early as April 11, Braddock noted in orders for the day that a road was being cleared for the artillery that would allow the army to bypass Winchester to the north. Halkett's road, prior to reaching the point of rendezvous with Dunbar's road,

was to bridge Opequon Creek, a few miles east of where the roads were to meet on the Great Road, the former Indian War Path (present Highway 11) in present Clear Brook, before continuing on to a gap in the Bear Garden Mountain on the traders' packhorse path.[58] Actually, the breadth and depth of the creek at the fording of the road is not sufficient, except perhaps in flood, to require bridging.

Detachments of Halkett's 44th Regiment left Alexandria over a period of three weeks. Initial elements of the regiment began their march toward Winchester on April 8, when, as noted earlier, a twenty-two-man detachment left Alexandria, followed the next day by all the Rangers, the Light Horse and six companies of the regiment, and on the thirteenth, another company of the regiment left escorting artillery wagons. Seven wagons loaded with powder, with a thirty-one-man detachment, left for Will's Creek on April 17. Ten days later, on April 27, the regiment's artillery—including the twelve-pounders, six-pounders and the howitzers—and the remainder of the regiment began their march through Virginia.[59]

"OLD COURT HOUSE"—The first encampment was at "ye old Court House" of Fairfax County, Virginia, built in 1742. The general's orderly book put the distance at eighteen miles. The courthouse was located at the "Spring Fields" on the Spring Branch of Difficult Run in present Tysons Corner. The site of the encampment is at the highest natural point in Fairfax County at 520 feet, in the vicinity of the intersection of Old Courthouse Road (State Route 677), which extends east in the Gallows Road, and the Chain Bridge Road. The route from Alexandria was by what is now designated East Braddock Road and West Braddock Road[60] to the road's intersection[61] with the present Leesburg Pike (Highway 7), which becomes King Street in Alexandria. The military road followed the general course of Highway 7 to the vicinity of the old Court House encampment. The road swung to the south of Highway 7 before reaching the vicinity of Tysons Corner, on the Old Courthouse Road, and returning to Highway 7 a short distance west. More than two centuries of intensive development and the straightening and paving over in the area from Alexandria to Tysons Corner has eradicated any evidence of the original Braddock's Road.

COLEMAN'S ORDINARY—Led by the pioneers, the men responsible for clearing any obstacles in the road, the remainder of Halkett's regiment resumed its march from the old Fairfax Court House on April 28 to "Mr. Colemans on Sugar Land Run w[h]ere there is Indian Corn, etc," a distance estimated at twelve miles.[62] In the 1740s, Richard and James Coleman established their ordinary on the banks of Sugarland Run, about half a mile

south of Highway 7, known earlier as the Potomac Path. Braddock's Road, past the site of the ordinary, is now State Route (SR) 604. It swings south of Highway 7 a short distance east of the crossing of the Fairfax County Parkway and continues to the east bank of Sugarland Run in the vicinity of the ordinary site near the present intersection of SR 604 and Millwood Pond Drive. Fording the run, Braddock's Road continues as SR 604, or Sugarland Road, parallel with Juniper Avenue, crossing Sterling Boulevard before reaching what is now Claude Moore Park. Beyond the park, the former Braddock's Road now becomes the Vestals Gap Road until it crosses the Cascades Parkway (VA 1794), where it is identified as Maries Road, or SR 638. Beyond Maries Road, the course of the army's road was through the area now dominated by the Dulles Town Center shopping complex, continuing across Broad Run and eventually returning to Highway 7. In the area from Sugarland Run, prior to reaching the vicinity of the Dulles Town Center, the first traces of the military road since leaving Alexandria may be found.

MINOR'S ORDINARY—Halkett's third Virginia encampment on April 29 followed a march of about fifteen miles on the Potomac Path from Coleman's Ordinary on Sugarland Run to "Mr. Minors."[63] This was the settlement of Nicholas Minor, located in the present environs of Leesburg, near the intersection of the ancient Carolina Road, used originally as a pathway to war by the northern and southern Indian nations. On this day's march, the military road paralleled the general course of Highway 7, crossing Goose Creek a short distance south of the present highway. Halkett's troops halted for a day at Minor's, resuming their march on May 1.

THOMPSON'S—Followed by the route of Market Street west out of Leesburg, the army's road returned to the course of Highway 7 for about two miles, until reaching Clarks Gap and the intersection with present Highway 9, the Charles Town Pike. In less than half a mile after leaving Highway 7, the road forks at present Paeonian Springs, with Highway 9 taking the fork to the left, while the one to the right is known as the Clarks Gap Road (SR 662). It has been suggested that Halkett took both routes to the next encampment.[64] However, the route to the right extends in a direct course north more than two miles before turning back to the west and toward the passage of the Blue Ridge Mountains. It is a longer, deviant, more difficult course through the present community of Waterford, confronting additional water passages. The passage of Highway 9 is to the northwest in a straight course toward the Blue Ridge passage, crossing the South Fork of Catoctin Creek while avoiding other branches of the stream.

After a twelve-mile march from Minor's, Halkett's troops reached their scheduled encampment site at "Mr Thompson ye Quaker wh[ere] ye is 3000 w[eight] corn." This was the residence of Edward Thompson, immediately west of the intersection of the Old Wheatland Road (SR 698) and Highway 9 and between the intersection and the crossing of the Berlin Pike (Highway 287). The Thompson encampment site is almost two miles east of the center of the community of Hillsboro, in a gap of the Short Hill Mountain.[65] A month later, Charlotte Browne, a widowed nurse accompanying her commissary officer brother in a supply detachment, encamped at Thompson's. Browne joined the Braddock expedition at Fort Cumberland, where she remained throughout the campaign. She kept a journal during her trek across northern Virginia and during her stay at the fort above Will's Creek, providing a personal view of her encounters along the route.[66]

KEYES' AT VESTAL'S FERRY—The fifth encampment site for Halkett's regiment was on the banks of the Shenandoah River, immediately west of Keyes' Gap of the Blue Ridge, at "Mr. They's [Keyes'] 17 ye Ferry of Shann [Shenandoah] 12." A distance of seventeen miles was listed for the march from Thompson's.[67] On May 2, after leaving Thompson's, the troops were confronted with a laborious, steady climb, first through the Short Hill Mountain Gap at Hillsboro and then up the eastern slope of the Blue Ridge. Reaching the crest of the Blue Ridge, Braddock's Road left the route of Highway 9 to the right. Its trace can be followed down the western slope, beginning about 350 yards east of where the current road, Chestnut Hill Road (County Route 32), begins, joining CR 32 about 200 yards north of Highway 9. The military road is followed by CR 32 until a fork is reached with Hollow Creek Lane. Braddock's Road continued straight ahead, and although abandoned, its trace is easily followed. The road joins briefly the Annie Grove Road and returns to the Chestnut Hill Road (CR 32) for about 230 yards to another fork. At the fork, CR 32 turns to the right, while the Keyes Gap Road (CR 32/1), following the course of the military road, turns to the left. The Keyes Gap Road follows the course of the military road to within 230 yards of the water's edge of the Shenandoah River where the east bank ferry landing was located. The road's course from the end of the present road to the landing is clearly discernible. It was here on the land of Gershom Keyes that Halkett's troops encamped and began crossing the river on Vestal's Ferry. John Vestal[68] owned the land on the west side of the river and operated the ferry to and from Keyes' landing.[69]

DICK'S PLANTATION—On May 3, the ferrying of Halkett's soldiers and artillery across the Shenandoah from Gershom Keyes', which began the

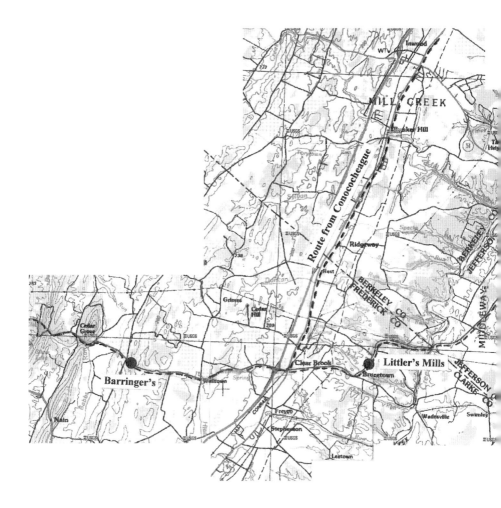

afternoon of the day before, was completed by midmorning. After crossing the approximately five hundred feet of the river, the military road moved northwestward past Vestal's three-story stone house on higher ground about 250 yards from the river's west bank.[70] For about 0.83 mile from the west bank of the river to a terminated Keyes Ferry Road,[71] the traces of Braddock's Road have been destroyed by a large quarry operation.

Getting a late start in order to complete the ferrying of the troops and artillery, the sixth encampment was at "Dicks Plantation,"[72] about 6 miles from the east bank of the Shenandoah. The Keyes Ferry Road (CR 26), now ending on the west side of the quarry, follows the course of Braddock's Road about 1.86 miles to Highway 340. Turning west-southwest, the approximate course of the road is followed by East Washington Street, the main street of

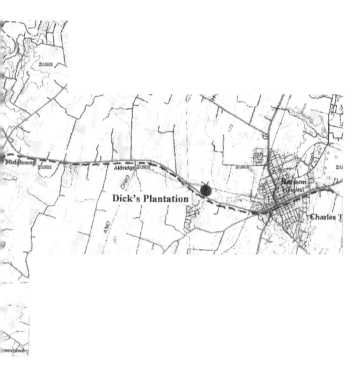

Braddock's Road: Dick's Plantation to Barringer's. *Author map.*

Charles Town, West Virginia. It would be twenty-six years after the passage of Halkett's troops before the town was founded on the lands of Charles Washington, the youngest brother of George Washington.[73] At about 1.78 miles from the Keyes Ferry Road, the course of the military road along the town's main street turned to the west along Highway 51. The area of the sixth encampment is reached another 1.35 miles along the highway, at an entry road on the right, Piedmont Drive.

Piedmont Drive leads to the plantation house and dependencies of Piedmont,[74] the home of Charles Dick, passing the ruins of St. George's Chapel[75] and Evitt's Run.[76] Formerly the home of Robert Worthington, Dick purchased the property in 1753–54.[77] At this plantation encampment, the regiment was able to provide its horses with pasture.

35

LITTLER'S MILLS—The march to the seventh encampment began at 4:00 a.m. on May 4. Leaving Dick's Plantation, the troops, wagons and artillery continued along the present course of Highway 51. At about 1.43 miles west of Piedmont Drive, the regiment passed on the left the future homesite of Washington's oldest brother, Samuel Washington. In about 1770, Samuel built his home of stone, Harwood, alongside Braddock's Road near the headsprings of Worthington's Marsh (Evitt's Run).[78]

The course of Braddock's Road continued along the route of Highway 51 until it reached what is now Old Middleway Road (CR 1-7), afterward turning south through the present Middleway community until it reached the Hinton Road (CR 1-11). For another 3.23 miles, the Hinton Road follows the course of the military road until "the bridge on the Opeckon [Opequon Creek]"[79] is reached, now known as Abril's Ford.[80] The military road on the west side of the ford is now identified as Sir Johns Road (SR 667), which continues for another 1.9 miles to "Widdow Littlers Mills,"[81] about 0.2 mile north of the crossroads in the current community of Brucetown. The site of Widow Littler's House is believed to have been on the north side of the road, on the northeast side of a stream and across the road from a small lane identified as Jobes Mill Lane. At a distance of 8.95 miles from Dick's Plantation, tents were pitched for a day of rest.

BARRINGER'S—On May 3, the day the final columns and wagons of Halkett's 44th Regiment were completing the passage of the Shenandoah and marching to Dick's plantation, Dunbar's regiment left its encampment at Evans's. Dunbar marched down the Valley of Virginia to the present community of Clear Brook and turned on the road westward followed by the earlier detachments of Halkett's regiment. Leaving the Great Road (Highway 11) and turning to the right on the Hopewell Road (SR 672), Dunbar's regiment reached the settlement of "Widow Billingers [Barringer's] about 19 miles."[82] The road holds to a westward course, past the Hopewell Friends Meetinghouse, through a present orchard farm on Pumpkin Hill and to the Welltown community, where the identification of the route is changed to the Hiatt Road (SR 672). The Barringer encampment site is at the springhead of Hiatt's Run, a few hundred yards east of Apple Pie Ridge Road (SR 739), about 3.8 miles west of the Clear Brook road intersection and about 5.25 direct-line miles north of Winchester.[83]

POTT'S CAMP—Dunbar's regiment left the Barringer camp the morning of May 4, crossing the present Apple Pie Ridge Road, where SR 672 becomes the Catalpa Road until it joins the Old Baltimore Road (SR 677). Continuing on this course, the road becomes the St. Clair (Sir John St. Clair)

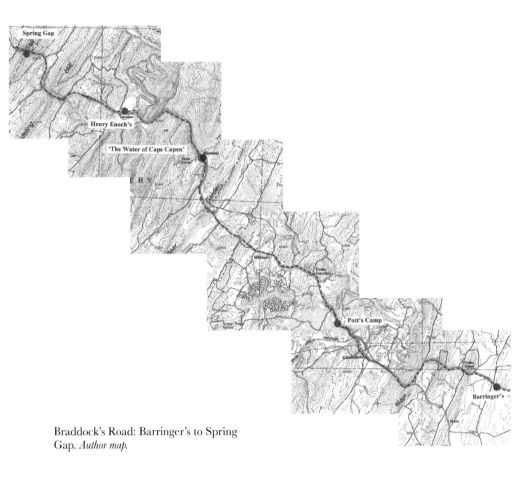

Braddock's Road: Barringer's to Spring Gap. *Author map.*

Road, now ending on the east bank of Lake Saint Clair, formed by the damming of Babbs Run. Braddock's Road resumes on the west side of the lake, leaving deep abandoned scars from the water's edge as it ascends the east slope of Hunting Ridge. The trace of the road remains prominent to the top of Hunting Ridge, where it meets SR 608. The course of the military road follows closely SR 608 south until it veers right about 385 yards from Frederick Pike (Highway 522), leaving its trace through the woods. Prior to reaching Highway 522, the military road follows an abandoned section of an earlier highway. It is here that Braddock's Road connects with the old packhorse trail from Winchester to the Ohio. Crossing briefly Highway 522 to the south side, the military road from this point is closely followed by the highway until it forks to the left on an older section of the highway, the Gainesboro Road (SR 684) through the community of Gainesboro, earlier known as Pugh Town.

In the north section of Gainesboro, a short distance prior to reaching Stony Hill Road, also known as the Tuscarora Trail (SR 688), Braddock's Road veers from and continues to the left of the present road through the village, crossing SR 688 and leaving an abandoned discernible trace a short distance beyond. It climbs over a spur of the following ridge to bypass a precipice above Back Creek. Descending the north face of the ridge spur, the road forded the creek and returned to the south side of Highway 522 and is followed closely in parallel by the highway for about 500 yards. To ascend the next ridge, the military road began a transverse course, crossing to the north side of Highway 522 about 250 yards northwest of Flowers Lane and then abruptly turning to the northwest. On a converging course, the road diagonally crossed the highway at the Gainesboro School, providing a residential driveway before turning, again abruptly, to the right for about 130 yards to the Pott's camp area.[84] Captain Cholmley's batman estimated that the march covered nine miles.[85]

As Dunbar's troops marched over Back Creek to the ridge crest encampment at Pott's, the last elements of Halkett's soldiers and artillery were marching to their halting day camp on the west side of Opequon Creek at Littler's Mills.

HENRY ENOCH'S—A long, difficult day awaited Dunbar's soldiers as they began their march the morning of May 5. It rained during the night and in the morning, soaking and increasing the weight of the baggage as they departed their encampment at Pott's for the march to "Kennets [Henry Enoch's]."[86] The army's road stayed near the present eastbound lanes of Highway 522, initially along the west side, before moving briefly to the median and back again, crossing Ebenezer Church Road (SR 705) as it descended the encampment ridge to a fording of Isaacs Creek. After crossing the creek, the road again resorted to a transverse ascension of the next ridge, and this took it briefly to the north side of the present highway. Braddock's Road was followed through the present Cross Junction village by the older of the modern highways. Returning to the present highway and crossing it to the Red Oak Road for about 0.45 mile, it turned left at a fork, and the army's path is now followed by Redland Road (SR 701), with visible scars alongside the present road. Passing through the present community of Whitacre, the military road left the present road to the right at the base of Timber Ridge and for a short distance is now a farm road. Leaving the farm road and ascending the ridge to its crest on the line between Virginia and West Virginia, the military road left a deep, impressive scar before rejoining the present road (West Virginia CR 6/2).

Timber Ridge: A deeply worn scar of Braddock's Road ascending the east slope of Timber Ridge, a short distance northwest of Whitacre, Frederick County, Virginia. At the crest of the ridge, the road enters West Virginia on its approach to Bear Garden Mountain. *Author photo.*

From the crest of Timber Ridge to the gap through Bear Garden Mountain, the road stayed on a steady course to the northwest. At about 0.3 mile from the crest of Bear Garden Mountain, the military road left the course of the present road, staying on a northwest bearing through a heavily wooded, undeveloped section south of Good, West Virginia. The road leaves a well-defined and very impressive path through the woods, reaching and passing through the cleared yards of two homes. Here, near the crest of the mountain, Braddock's Road crosses Highway 127 and immediately completes a major switchback to the west in order to clear the crest of the gap of the mountain along the north side and several feet higher than the present highway.

For about 6.6 miles beyond the gap of Bear Garden Mountain, the road to the next encampment wound its way through several gaps in the mountains, following downstream Bloomery Run, a tributary of the Cacapon River, past the present community of Bloomery. The closeness of the gaps along

the run forced the army's columns to ford the stream several times.[87] The traces of the road are clearly visible on both sides of present Highway 127. Reaching the Cacapon River, the army road turned north, off the present highway, in order to ford the river at the Cacapon's fork with its North River branch. Across the ford, it followed the north bank of a small stream flowing into the North River. South of the stream and on the west banks of the river, the troops encamped on the land of Henry Enoch in the vicinity of a mill he operated with the waters of the North River. An advance company of Halkett's 44th Regiment was at Enoch's when Dunbar's columns arrived.[88] Dunbar's columns had marched about 13.6 miles from the encampment site at Pott's.[89] The next day was a halting day for Dunbar's troops, and they received five days of provisions. The batman noted that there was no forage for the horses or anything "to be sold," reflecting the sparseness of inhabitants or plantations in the area.

BACK CREEK—The rear columns of Halkett's regiment, after a day of rest at Littler's Mills, began to march at 4:30 a.m. on the morning of May 6. They would end the day at "Back Creek," which was probably at or near the Pott's encampment on the crest of the ridge above Back Creek.[90] This placed Halkett's encampment a day's march behind the Dunbar columns, halted at Enoch's beside the North River of the Cacapon. Apparently due to the slower rate of travel for Halkett's artillery, his troops' distance from Dunbar would be extended another marching day.

WOODS THREE MILES SHORT OF MRS. JENNINGS[91]—While Dunbar's march from Pott's above Back Creek to Enoch's was completed in one long day's trek, Halkett's march, with the heavy and cumbersome artillery, was extended over three days. On May 7, Halkett, struggling with the artillery train, traveled to an encampment in the "Woods Three Miles Short of Mrs. Jennings," probably in the vicinity of the present community of Whitacre or in the valley before Timber Ridge, and south of the Bear Garden Mountain gap.[92]

"THE WATER OF CAPE CAPEN"—On the second day's march, Halkett reached an encampment site beyond the Bear Garden Mountain, at the "The Water of Cape Capen [Cacapon]."[93] The site was probably in the vicinity of the present community of Bloomery, on Bloomery Run, a major tributary of the Cacapon River. Braddock's Road followed along the banks of the run as it flows westward to the river near the Forks of Cacapon and the site of Enoch's settlement.

"GREAT CAPE CAPON [ENOCH'S]"—Halkett's remaining two companies, artillery and supply wagons crossed the ford below the meeting of the North River and the Cacapon and arrived at Enoch's on May 9 for a day's halt.[94]

Surviving near its original condition in the dense woods along the undeveloped ridge between the Forks of Cacapon and Crooked Run, Braddock's Road continues as an unimproved trace known as the Winter Road. *Author photo.*

Dunbar's regiment had left the encampment two days earlier on its way to the crossing of the Potomac at Friend Cox's settlement and ferry.

Cox's Camp—Dunbar's regiment began its march from Enoch's on May 7. Confronting the troops were two major mountains and the surmounting of the ridges leading to the gaps through them. Departing the level expanses along the Cacapon, the military road sought the nearest spur of the ridge to the west of Enoch's. This section of the road on the north side of the stream flowing into the Cacapon at the Braddock's Road fording is now a residential and farm road. Before reaching the ridge spur, the road crossed present Highway 29, paralleling a short distance to the west of the highway as a section of the present Falls Road. Still farther ahead, and beyond a present temporary blocking of the road by a residential shed, it becomes Winter Road, an unimproved one-lane trail through the dense woods, partly in use by the sparse and isolated inhabitants. This stretch of Braddock's Road is one of the longest and most impressive traces of the road, mainly surviving as near its original state in an undeveloped area as during the time of the army's march.

The Winter Road–identified trace of the military road continues for about 1.62 miles, from the general area of the encampment site at Enoch's to where it finally leaves the Winter Road. Continuing as a completely abandoned, unnamed course for about another 1.28 miles, it crosses present Pin Oak Road at the entrance to the Crooked Run Farm and descends to Crooked Run at about 2.9 miles. Clinging to the side of the run through the gap of Sideling Hill, it leaves the present road on the west side of the gap ("Braddock School Road," CR 2-1) about 230 yards west of CR 29-1, turns north and begins a steady climb of Spring Gap Mountain.[95] For about 1.8 miles, Braddock's Road leaves deep, impressive scars, crossing present Whispering Pines Road, a large hayfield (about 250 yards west of CR 29-1[96]) and through heavy woods until it reaches CR 2-3, which follows the military road to Spring Gap.[97]

West of the crest of Spring Gap, in about two hundred yards, Braddock's Road leaves the present road, moving to the right and down into the hollow cut by the mountain spring, Dug Hill Run. The road through this section leaves a deep and very distinct scar. Staying to the south of the stream, the course of the military road rejoins the present road (which becomes the Dave Moreland Road) a short distance beyond the intersection, with the Spring Gap Road (CR 2) leading north to the Potomac River. The military road descends the mountain for about 2.7 miles from Spring Gap to a fording of the Little Cacapon River, with only one short deviation to the right from the present road, before reaching the river.[98] From this point about 3.6 direct-line miles to the Potomac River,[99] Braddock's Road followed along the banks of the river, repeatedly fording it,[100] and keeping with the traders' and settlers' path, the only reasonable and accessible path from the western slopes of the Spring Gap Mountain.[101] The trace of the military road can still be followed over much of the river passage.

The settlement of Friend Cox was on both sides of the mouth of the Little Cacapon River.[102] The "Ferry Field" was on the west side of the river at its mouth on the Potomac, where Braddock's army encamped and was ferried over the Potomac into Maryland.

SPRING GAP—On May 11, four days after the departure of Dunbar's regiment for Cox's on the Potomac, Halkett's troops left their encampment at Enoch's. While Dunbar took only one day to reach the "Ferry Field," the movement of Halkett's artillery and baggage wagons required a stop at "the Camp betwixt Enoxes [Enoch's] & Coves [Cox's]."[103] The encampment was probably in the Spring Gap, almost halfway to the crossing of the Potomac.[104] The gap was named for the spring on the west slope of the mountain, on

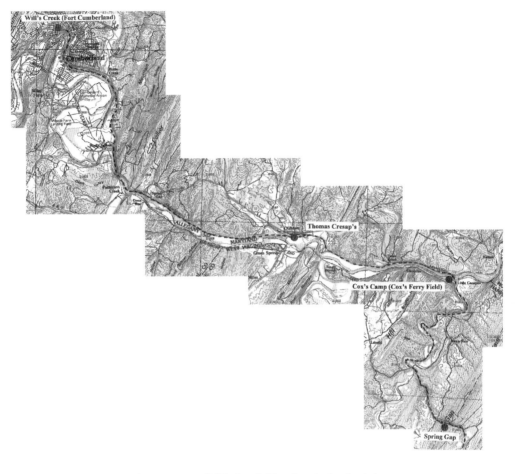

Braddock's Road: Spring Gap to Will's Creek (Fort Cumberland). *Author map.*

the south side of Braddock's Road, about 250 feet from the crossing of the gap. The area south of spring is the most suitable site for an encampment in the area. On June 11, the supply detachment, accompanied by the nurse Charlotte Browne, encamped at the site.[105] This is the last recorded encampment site listed in Halkett's Orderly Book, with the next entry at Fort Cumberland on May 18.[106]

THOMAS CRESAP'S—On May 8, the advance elements of Dunbar's regiment reached the settlement of militia colonel Thomas Cresap at present Oldtown, Maryland. Cresap's house and trading post was on the north bank of the Potomac River, at the site of a former major village of the Shawnees and a principal fording of a western branch of the Great Warrior's Path.

The troops halted for a day of rest and to receive provisions.[107] After being ferried across the river at Cox's Camp, the army followed the long-established traders' path along the north side of the North Branch of the Potomac.[108] Cholmley's batman listed the day's march at nine miles.[109]

WILL'S CREEK—Dunbar's regiment arrived at Will's Creek on May 10 after a march recorded by the batman of fifteen miles along the path on the north side of the North Branch.[110] "We pas[s]ed the foart and Incamped upon the hill above the Fort which his [is] Called Fort Cumberland."[111] On that date, General Braddock's Orderly Book was datelined "Camp at Fort Cumberland."[112] The first train of the artillery, with two companies of Halkett's regiment, arrived at the fort on May 16.[113] Two days later, Halkett's Orderly Book datelined its first entry at the "Camp at Wills's Creek."[114]

There was a total of twenty-three encampment sites during the army's initial thrust through Maryland east of Fort Cumberland and northern Virginia—fifteen in Virginia and eight in Maryland. Another twenty awaited the army beyond Will's Creek in the march to the Monongahela.

With the gathering of the army at Fort Cumberland, the first phase of Braddock's expedition was completed. Less than two weeks later, the first detachments of the army marched from the fort, beginning the final thrust of the expedition. A month after arriving at Will's Creek, the remainder of the army began the march westward. Only another month remained before the fatal conflict on the banks of the Monongahela.

The Final Thrust

Fort Cumberland to the Monongahela

More than 160 years ago,[115] and almost a century after General Braddock's ill-fated expedition, a fascinated student of the history of Braddock's Road, Thomas C. Atkinson, expressed concern for the confusion that attends the routes of celebrated expeditions after the lapse of years. He noted how the writers of the history of those routes resorted to copying from one writer to another until the only solution was to see the ground for himself. Atkinson foresaw that "the time [was] coming when the road by which the unfortunate Braddock marched to his disastrous field [would] be invested with antiquarian interest, akin to that attending Hannibal's route."[116]

The predominate pioneers in identifying and preserving the route of Braddock's Road are Christopher Gist, Harry Gordon, Joseph Shippen Jr., Alexander McClean, Thomas C. Atkinson, Neville B. Craig, Winthrop Sargent, James Veech, Archer Butler Hulbert, John Kennedy Lacock and, more recently, Paul A.W. Wallace, Walter S. Hough, Frank A. Cassell and Elizabeth W. Cassell, James V. Steeley and Robert L. Bantz.[117]

Sixty years after Atkinson, John Kennedy Lacock also decided that it was time to take to the field to gain a more precise mapping of the road's remains for the final phase of the expedition from Fort Cumberland to the Monongahela. It has been a century since Lacock, whose principle tool of reference was Captain Robert Orme's journal, published by Sargent, sought and walked traces of Braddock's Road. Orme, Braddock's aide, wrote his journal weeks after the battle. Lacock supplemented Orme's first-person but meager definitive record with bits and pieces of local

records and histories, as well as the traditional histories of the residents and their farms, which he used as landmarks that at times are difficult to identify so many years removed.

After the publication of Lacock's account of his research and in the last half of the past century, there were the discoveries of the journal of the batman of Captain Robert Cholmley, one of Braddock's vanguard officers; the journal of an unidentified British officer who also participated in the march and the battle; and the publication of Lieutenant Daniel Disney's Orderly Book of Sir Peter Halkett, colonel of the 44th Regiment of Foot.[118] These documents filled many of the voids and ambiguities in Lacock's research, but unfortunately, later researchers continued to rely heavily on Lacock in their search for the route of Braddock's army and the encampments. The result has been the incorrect locations of the road and encampment sites and the erroneous placement of historical markers. In more recent years, researchers such as Bantz, Hough, Steeley and Wallace have made significant strides in seeking to refine the route and encampments. Hough (in Virginia) and Bantz (in Maryland) have fathered a more precise mapping of the road. In Pennsylvania, Wallace and Steeley have contributed greatly to the approximation of some of the camps while straight-lining the routes between their proposed encampments.

Significantly overlooked have been the original land records of the first settlers along the route of Braddock's march. Many of these settlers, within the first years following the end of the French and Indian War, were using the road to reach choice lands. Often the surveyors noted or depicted on the land grant surveys the presence of Braddock's Road.[119] Lacock, only briefly and unsuccessfully, sampled this tedious and time-consuming reviewing and plotting resource.

Also not to be overlooked is the realization that Braddock's Road was considered such an outstanding landmark a century before Lacock's research that public officials of the counties of Fayette and Westmoreland in Pennsylvania used it to divide their townships. Lacock learned as he searched for the remnants of the road that those township lines were often in the vicinity of the road. Like the compilers of a graph, the public officials laid out the district lines that represented the mean value of the road's course and its junction with familiar landmarks.

It is Christopher Gist, "the General's guide,"[120] who provided a Rosetta stone to the current efforts to more precisely locate and map Braddock's Road and the encampments in Maryland and Pennsylvania.

Gist prepared the first official map of the expedition's route and encampments. One of the earliest explorers of Pennsylvania, Ohio, Kentucky and western Virginia,[121] a surveyor and a guide for George Washington, Gist prepared at least two drafts or maps of Braddock's route and encampment sites from Fort Cumberland to the battle on the Monongahela.[122] One of the maps, signed "Christopher Gist," recorded 122 miles from Fort Cumberland to Fort Duquesne. It has much less detail than the second map, which was signed (and thus titled) "The Draught of Genl. Braddocks Route Towards Fort DuQuesne as Deliver'd to Capt. McKeller Engineer. By Christ. Gist the 15th of Sept. 1755,"[123] a few days more than two months after the battle. The total distance

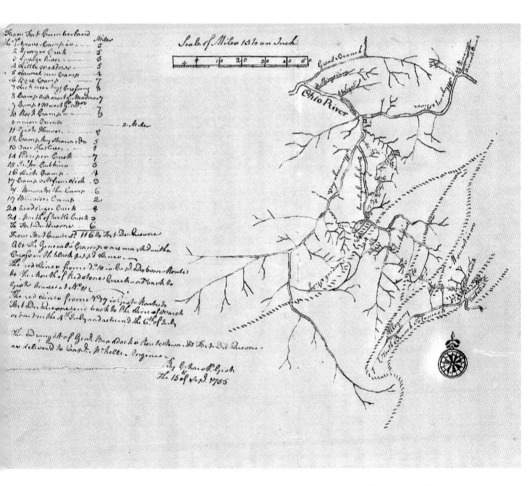

Christopher Gist, *The Draught of Genl. Braddocks Route Towards Fort DuQuesne as Deliver'd to Capt. McKeller Engineer. By Christ. Gist the 15th of Sept. 1755. John Carter Brown Library.*

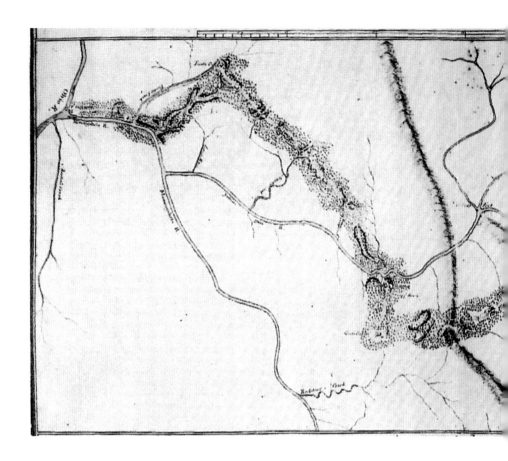

on this map is 116 miles. To those experienced in the preparation and interpretation of maps, Gist's cartography provides an exciting, more precise narrative of the expedition. This was Gist's country. The route was Gist's neighborhood road and was intimately familiar to him. The waterways, the ridges and the valleys were familiar landmarks. One only needs to compare Gist's map with other contemporary maps of that previously uncharted frontier to realize its immense value in providing details utilized in later cartography.

Harry Gordon, one of Braddock's engineers on the expedition responsible for supervising the conversion of the traders' path and Indian trails into a military road, prepared an artistic topographical map of the route taken from Fort Cumberland to the battlefield.[124] Suffering from a serious battle wound to his lower right arm that prevented him from using his drawing hand for an extended period of time,[125] his delayed sketch relied to a great extent on Gist's earlier work. Gordon acknowledged that the "Courses

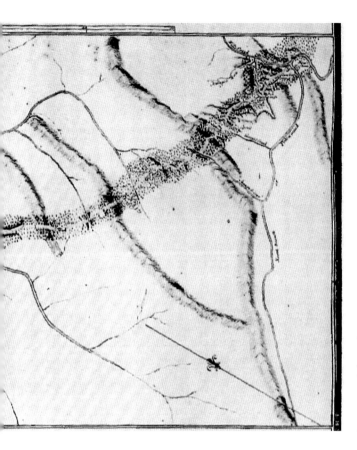

Harry Gordon, *A Sketch of General Braddock's March from Fort-Cumberland on the 10th of June 1755 to the Field of Battle of the 9th July Near the River Monongahela.* Supplied by Royal Collection Trust/© H.M. Queen Elizabeth II, 2013.

of the Waters are taken from a Sketch of Mr. Gist's." He added that the road "being full of short windings," the "different Bearings" could not be expressed, but "the general Bearings are pretty just." Also, Gordon relied in the main on Gist for the location and identification of the encampment sites and the mileage between encampments.[126]

There were twenty encampments in the final thrust between Fort Cumberland and the Monongahela, with a wide range of identifications reflecting the preference of the journalists.

Chapter 4

Fort Cumberland to Grove Camp

*To Camp 1 Via Sandy Gap of Will's Mountain
and the Narrows*

O ver a period of thirteen days, from May 29 to June 10, Braddock
deployed his army from Fort Cumberland. An advance party of six
hundred men and two engineers commanded by Major Russell Chapman,
with the objective of opening the road and preparing a forward base at Little
Meadows, marched on May 29. They were accompanied by fifty wagons
with provisions, two cannons and two cohorn mortars.[127]

The detachment followed the early trail over Will's (or Haystack)
Mountain through Sandy Gap, used by the Ohio Company, Christopher
Gist and George Washington and his troops in their trips to the Ohio
country. Cholmley's batman recorded an eight-hour march of seven miles
over "very Bad Roads" the first day. Every hundred yards, the old road had
to be made passable. The road-clearing detachment was led by Sir John St.
Clair and two engineers, including naval lieutenant Charles Spendelow, six
seamen and some Indians. After reaching the first encampment, a working
party of one hundred men, guided and protected by another one hundred
soldiers, was sent ahead.[128]

By nightfall of the first day, the baggage of the advance party had
cleared Sandy Gap, about 2.4 miles. Orme wrote that the ascent and
descent "were almost a perpendicular rock." Three wagons were
destroyed and many more "extremely shattered." Yet a company of three
hundred men "had already been employed several days upon that hill."
General Braddock made an inspection trip of the mountain and put
three hundred more men to work on the road to make it passable for

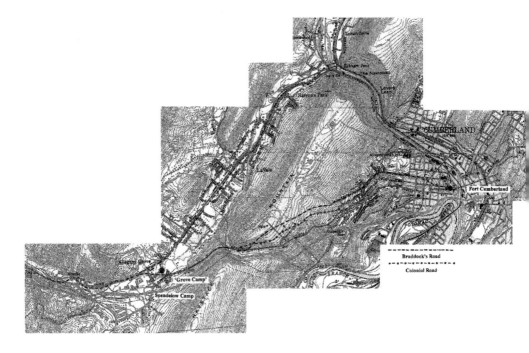

Braddock's Road: Fort Cumberland to Grove Camp. *Author map.*

howitzers. Up to this point, the general did not believe that any other road could be made passable.[129]

Despite all the expenditure of manpower to convert the old trail over Will's Mountain, this section of Braddock's Road has been one of the most difficult to accurately trace. Until recently, the course of the road as defined by Lacock was generally accepted. Lacock concluded that from Fort Cumberland to the foot of the mountain, "no trace can be found today [1914]." He accepted the probability that the road followed present Greene Street in Cumberland, Maryland, while acknowledging that the route could have followed what is now Fayette Street past the Rose Hill cemetery; instead, he opted for the Greene Street course. He then concluded that the road continued north of and parallel to the later Cumberland Road, which is now identified approximately as Route 49, or the "Braddock Road," finally joining the Cumberland Road in Sandy Gap.[130]

Lacock's route followed what is now identified as a former colonial road, located below or south of the route of Braddock's military road. The colonial road was apparently established to improve the passage over Sandy Gap. The military road left Fort Cumberland west by present Washington

A major intersection in Cumberland, Maryland, in 1908, as viewed by Lacock and Weller. The road to the left led to Cresaptown, Maryland; directly ahead, the road up Will's (Haystack) Mountain was the Cumberland Road; and the path to the right ascended to Fayette Street. Braddock's military road was along the line of trees in the right background, beyond the dwelling. Lacock and Weller, postcard No. 3, 1908. *Braddock's Road Preservation Association.*

The present intersection, with the road to Cresaptown to the left and the Cumberland Road (now Highway 49, incorrectly identified as "Braddock Road") ascending the mountain, with the earlier path to the right now a major paved street. What was once farmland is now a suburban community. *Author photo.*

Street and followed the contours of the ridge to present Fayette Street, past the Rose Hill Cemetery to Camden Avenue. Following Camden Avenue to its end on the side of the mountain, it continued through the housing developments beyond. The course of the military route is now crossed by Seton Drive and Seneca Avenue before reaching present Route 49, the road presently identified as "Braddock Road," a short distance east of Sandy Gap.[131] Distinct traces of both Braddock's Road and the colonial road remain through the woods immediately east of Sandy Gap.

Lieutenant Spendelow returned to Fort Cumberland from the advance party on June 1. The following day, after a personal reconnaissance, Spendelow returned to the fort, informing General Braddock that he had discovered a valley on the other side of Will's Mountain that provided a passage from the fort around the mountain. A detachment of one hundred men was immediately dispatched to open a road through this passage. Completed in two days, the new road followed Will's Creek north through what is now known as the Narrows of the mountain to a southwestern branch of the creek, a tributary later to be known as Braddock Run. The new road followed upstream to join with the original road over Sandy Gap. Braddock decided to take the rest of his army over this new route.[132]

On June 7, Sir Peter Halkett's 44th Regiment left Fort Cumberland over the Narrows road. The next day, Colonel Ralph Burton marched with the Independent Companies and Rangers, followed on June 10 by Colonel Thomas Dunbar with the 48th Regiment and accompanied by General Braddock. The first camp was made on the north banks of the branch of Will's Creek, about five miles from Fort Cumberland, at the junction of the two military roads in the present community of Allegany Grove. Gist identified the encampment as the Grove Camp. Orme named it the Spendelow Camp in recognition of the architect of the Narrows road.[133]

Chapter 5

George's Creek

Camp 1 to Camp 2

The advance party forged ahead, opening the road to Little Meadows and reaching the site on June 5. The troops began the next day clearing the campsite and building a shelter for the provisions. On June 9, they began constructing a breastwork of trees cut during the clearing of the camp. Work on the breastwork continued until the main army joined them on June 17.[134]

The main body of the army, encamped at the Grove (or Spendelow) Camp, sent back to Fort Cumberland all unnecessary baggage, and almost one hundred horses were shifted from personal use into public service.[135] The extent of the train of the army was tightened from front to rear to less than half a mile. Two six-pounder cannons with their ammunition were sent back to the fort. This left a train of four twelve-pounders, four six-pounders, four howitzers, fifteen cohorns and three months' provisions for two thousand men. On June 13, the army marched out of the first encampment at present Allegany Grove.[136] The road followed the southwestern branch of Will's Creek, which would become known as Braddock Run, to the second encampment estimated at five and six miles distant at "Martin's Plantation," or "George's Creek" camp.[137]

Braddock's Road followed closely Braddock Run, crossing it four times. Leaving Allegany Grove, it stayed north of the run, passing southwest of the present intersection of the National Road (Highway 40) and Route 658 and crossing to the north of Highway 40 about 350 yards west of the intersection. At about 900 yards west of the intersection, at the Highway 40–Interstate 68 interchange, the course of the road swung south of Highway

Right: Braddock's Road: Grove Camp to George's Creek. *Author map.*

Opposite, bottom: At the beginning of the twentieth century, the trace of Braddock's Road (on the far side of the rail fence) passed this spring, known as Braddock Spring, on the north bank of Braddock Run at the base of Red Hill west of Allegany Grove, Maryland. Lacock and Weller, postcard No. 9, 1908. *Braddock's Road Preservation Association.*

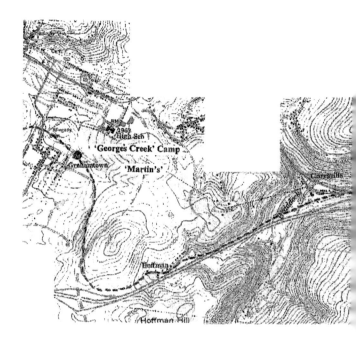

40 and between it and Interstate 68. It returned to the north of Highway 40 and crossed the run near the former nineteenth-century Six Mile House,[138] passing to the north of this former landmark before crossing the run near the old National Road tollhouse.[139] The road crossed again to the north side of the run at the site of Red Hill.

In this area at the time of Lacock's survey was the Laber farm, where there is a large spring on the north side of the run and between it and Braddock's Road.[140] Beyond the spring, the road arced south back across the run, coinciding briefly with the present course of Highway 40 before the trace moved again to the north of the highway, but staying south of the run. After crossing a lane that Lacock identified as the Short Gap road, about fifty yards north of the highway, the road continued to the west and back to the south side of the highway.[141] The road turned to the southwest on the Flaggy Run branch of the run at the present community of Clarysville. The course of the road southwest up Flaggy Run is followed very closely by Interstate 68, eradicating it partway, until it reaches the present community of Hoffman. West of Hoffman and north of the Interstate 68 interchange,

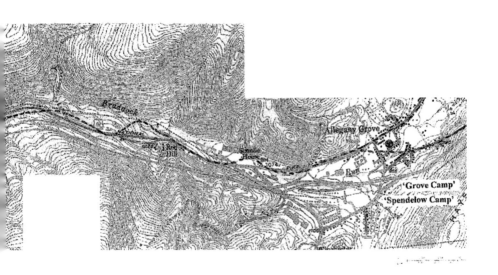

A garage now sits on the path of Braddock's Road, but the spring, under a similar replacement structure, continues to serve local residents. *Author photo.*

the military road made a ninety-degree turn to the north, over the ridge and into the valley of the head branches of George's Creek.[142] The road passed through what is now the Maplehurst Country Club. On the north end of this property, the army made its second encampment in the environs of the present Grahamton section of Frostburg, Maryland.

The encampment was in the general vicinity of the head springs of the east branch of George's Creek and the southeast side of the Allegany Cemetery. Gist identified it as the "George's Creek" camp. Gordon and Orme called the camp "Martin's" or "Martin's Plantation."[143] The first brigade reached the encampment on the thirteenth; the second brigade did not reach the camp until almost noon of the fourteenth, "the road being excessively mountainous and rocky." A halt was called at this encampment to rest the men and the horses.[144]

Savage River

Camp 2 to Camp 3

The army began to move from the George's Creek camp at five o'clock in the morning on June 15. The road led off the Allegany Cemetery hill into the valley of the east branch of George's Creek in the Grahamton section of Frostburg. Crossing present Grant Street, the George's Creek branch and the present old railroad bed, it was noon before all the army's carriages were moving up the next hill to the west a quarter of a mile from the front of the campsite.[145] Half of the troops had to ground their arms to assist the movement of the carriages up that hill, while the other half were posted for security.[146]

The hill that the army ascended, between Frostburg's Glenn and Spring Streets, is steep and remains wooded and sparsely developed. Crossing Spring Street northeast of its junction with Warns Lane, the road continued to the west, crossing Park Avenue to the former area of Braddock Park near the crest of the hill.[147] North of the former park on what is now Frostburg State University property, alongside present Route 736 (Midlothian/Braddock Road), there once stood an old milestone whose date of origin is unknown; the marker cited landmarks that did not come into being until years after Braddock's army passed through the area.[148]

Leaving what is now the vicinity of the former Braddock Park, the army descended the hill into the valley of Sand Spring Run, the western branch of George's Creek. Touching and following briefly the present Route 736, "Braddock Road," before continuing to the northwest across the present Frostburg State University property, it traced a course across the university's

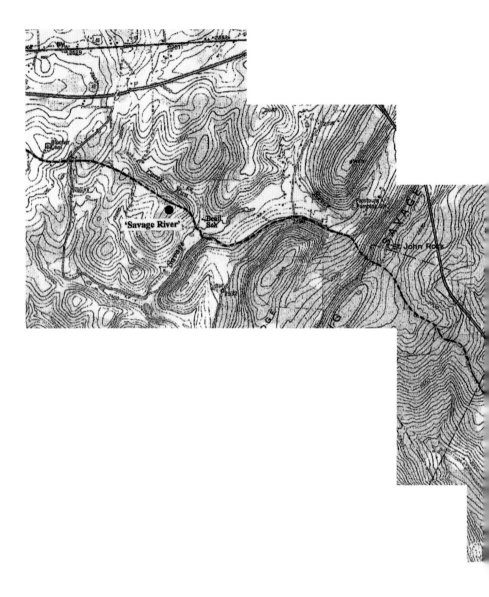

football field. Fording Sand Spring Run near the field's center, it crossed present University Drive and began the ascent of Big Savage Mountain, where there is now a practice field. The initial ascent of the mountain was west through the approximate center of a present strip mining operation. The course of Braddock's Road through this area—ascending the gentler, least stressing spurs—extends about one mile from Sand Spring Run to where Interstate 68 crosses the military road. The interstate crossing point is

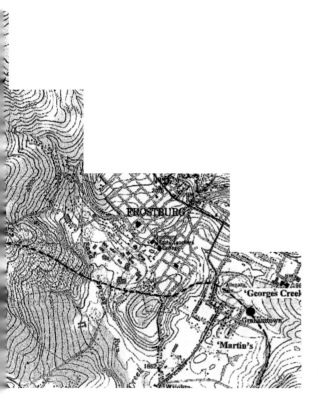

Braddock's Road: George's Creek to Savage River. *Author map.*

on a prominent, relatively flat plateau immediately south of the interstate's crossing of the line between Allegany and Garrett Counties and about one mile south of an Interstate 68 truck weight station.

From the Interstate 68 crossing, the course of the road climbed steeply northwest about 1.25 miles to the crest of a gap through Big Savage Mountain. In about 260 yards from the interstate, the trace passed the line between Garrett and Allegany Counties, again reaching for the flattest

The trace of Braddock's Road, on the summit of the hill between the head branches of George's Creek, cut through the center of Braddock Park in Frostburg, Maryland, during the visit by Lacock and Weller in 1908. Lacock and Weller, postcard No. 12, 1908. *Braddock's Road Preservation Association.*

In the spring of 2012, Braddock Park and its trace of road succumbed to a housing development and became a memory. *Author photo.*

and most extended spurs. The traces of the road on the eastern slope and over the crest are very prominent. Orme described the climb as "in many places extremely steep."[149] About 250 yards north of the road's crossing of the crest is the landmark known as St. John's Rock, with an elevation of 2,930 feet. The descent of the road on the western slope of the mountain is very steep, described by Orme as "very rugged and almost perpendicular; in passing which we intirely demolished three wagons and shattered several." An appreciation of the difficulties encountered by the army on this slope is demonstrated by the steepness of the remaining traces of the road.[150]

Descending the western slope of the mountain, the trace of the road reaches the intersection of the Beall School Road and St. John's Rock Road in the valley of the Savage River. The road continued to the northwest, now followed by Beall School Road, continuing to and along the course of the Old Frostburg Road to the Carey Run Road. The army forded the Savage River near the mouth of Carey Run and ascended the ridge to the northwest near the present Beall School on the north side of the river. Orme noted that the river, at the army's passage, "was an insignificant stream" but that the Indians explained that during the winter, the river is very deep, broad and rapid. Also, he noted that this was the last water that flowed into the Potomac.[151]

On the east slope of Big Savage Mountain, near the summit, above Frostburg, Maryland, recorded by Lacock and Weller in 1908. Lacock and Weller, postcard No. 14, 1908. *Braddock's Road Preservation Association.*

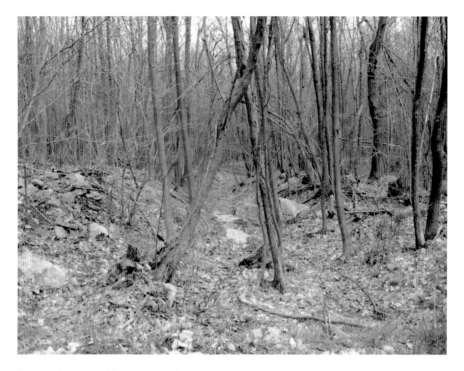

In an early spring visit, the trace of the road survives with young trees and patches of white in its scar from a recent snowfall. *Author photo.*

During the ascent of Big Savage Mountain, British officers were instructed to order their Regulars to assist in pushing the wagons and cannons if necessary. *From Hamilton's* Braddock's Defeat, *nineteenth-century illustration.*

Opposite, bottom: Big Savage Mountain: The "extremely steep…very rugged and almost perpendicular" descent of the road that Captain Orme spoke of, on the western slope of the mountain toward the Savage River. *Author photo.*

The third encampment was made on the elevated land on the southwest side of Carey Run. Orme noted that in reaching the camp, there was "another steep ascent" that took the wagons six hours to complete. In addition, during this day's march, the army sometimes was extended to a length of 4 or 5 miles. The first brigade, for example, encamped still farther northwest, about 3 miles from the river, placing it in the vicinity of the crossing of Interstate 68 at the Eastern Continental Divide and the National Road (Highway 40)

about five hundred yards west of the Green Lantern Road and about 0.89 mile west of the present Mount Zion Church.

Gist recorded 5 miles from the second encampment at George's Creek to the Savage River camp. The actual computed distance for the course is about 4.96 miles. The distance from Fort Cumberland, by way of the Narrows route, is about 15.85 miles, or about 14.44 miles through Sandy Gap.[152]

Chapter 7

Little Meadows

Camp 3 to Camp 4

The army resumed its march on June 16 from camps extending from the elevations of Little Savage Mountain above the Carey Run branch of the Savage River to the camp of the lead brigade three miles north of the river. The forward first brigade, with slightly less than three miles to travel, reached the Little Meadows the same day, while the second brigade's arrival was extended to June 17 and June 18.[153]

Once the army reached the Little Savage Mountain heights above the Carey Run branch, it followed the elevations west by northwest through what Lacock found to be Blocher farmland.[154] The Old Frostburg Road intersects this land and crosses the course of Braddock's Road 1 mile northwest of the road's fording of the Savage River and 0.5 mile south of Interstate 68. While some visual sections of the road have been destroyed by many years of farming in this area, a prominent scar of the route can be followed from Ross Lane west for about 0.3 mile to the Old Frostburg Road. On the west side of the Old Frostburg Road, the route of Braddock's Road continues west as the Blocher Cemetery Road, passing to the south of the cemetery. The trace of the road extends from the end of the Blocher Cemetery Road and can be followed across the cultivated fields to and through a Christmas tree farm immediately south of Interstate 68. In the Christmas tree farm, Braddock's Road reaches, at about 0.89 mile, Blocher Road, which follows the army road west about 0.82 mile to the Green Lantern Road overpass of Interstate 68, marking the Eastern Continental Divide, about 0.22 mile south of the National Road.

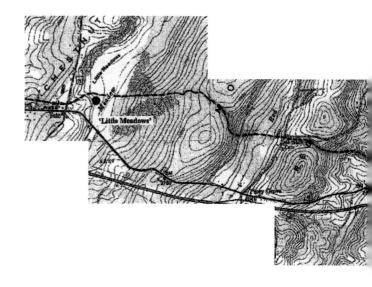

Right: Braddock's Road: Savage River to Little Meadows. *Author map.*

Opposite, bottom: Savage River to the Shades of Death— about 1.93 miles west of Savage River and 1.78 miles east of the Shades of Death at Two Mile Run, looking east. *Author photo.*

The National Road (Highway 40) passes over the route of Braddock's Road about five hundred yards southwest of the Green Lantern Road intersection. This was the area of the first brigade's encampment. The army road, after crossing an elevated cultivated spur north of the National Road, can be traced descending into the wooded valley of Two Mile Run.[155] In this valley, the troops marched through the Shades of Death, a dense foreboding growth of white pines. More than a century ago, the pines were harvested for lumber.

The road's course from Two Mile Run ascended the steep eastern face of Red Ridge, moving through a saddle gap of the ridge westward and climbing about three hundred feet in elevation over a distance of about 0.60 mile through a heavily wooded area. Descending into the valley of Red Run, where Lacock encountered the Merrbach family,[156] the army crossed the present Meyersdale Road, about 0.53 mile northeast of the community of Piney Grove on the National Road. In the Red Run Valley, the army encountered the swampy area along the run that was made passable by Sir John St. Clair's advance party "with infinite labour."[157]

Another 575 yards, on a course to the west, the road reached the foot of Meadow Mountain and the present Guthrie Lane, about 0.47 mile north

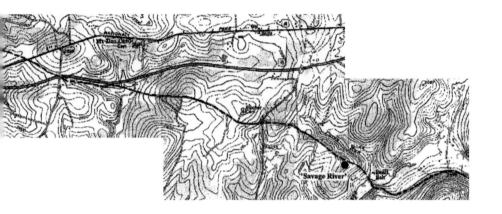

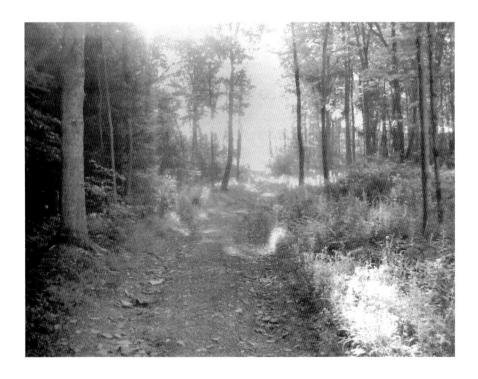

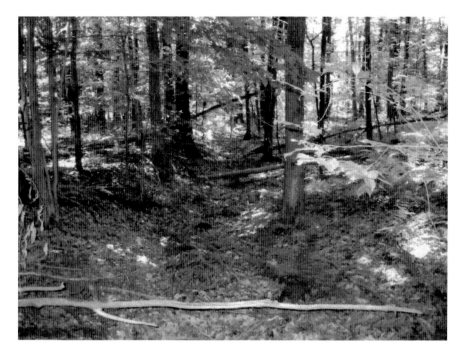

Red Ridge and the Shades of Death: Braddock's Road on the saddle of Red Ridge, after crossing Two Mile Run and passing through the Shades of Death. *Author photo.*

of the National Road. The road made a steep climb over a boulder-strewn eastern slope of the mountain, at one point climbing 140 feet in elevation over a distance of 260 yards, or from the foot of the mountain to the saddle of the gap of 175 feet in elevation over a distance of 575 yards.

Once over the saddle of the Meadow Mountain, Braddock's Road made a less stressing descent due west into the Little Meadows Valley of Meadow Creek. There is now the major intersection of the National Road and Highway 219 in the community of High Point a short distance southwest of this fourth encampment site. Another short distance south, Highway 219 intersects with Interstate 68.

Orme noted that the past four days of travel revealed that it was impossible to continue with the present number of carriages; many of the horses were failing, and many had died. Furthermore, the troops would not be able to undergo "the constant and necessary fatigue," and the extent of the baggage increased the line of the train to the point of weakness. General Braddock decided to divide his army into a flying column to be followed by the wagon train of provisions and ammunition and then the rest of the army and

The road-building detachment under Sir John St. Clair had the grueling and exhausting tasks of clearing old-growth timber, removing and blowing rocks and boulders, grading and leveling roads and bridging swampy ground. *From Hamilton's* Braddock's Defeat, *nineteenth-century illustration.*

artillery. He ordered a detachment of four hundred men, equipped with two six-pounders, wagons of tools and thirty-five days' provisions on carrying horses, to march on June 18 to open the road to the Little Crossings of the Casselman (Castleman) River branch of the Youghiogheny River.[158] The general would march the next day with the two eldest grenadier companies and five hundred rank and file. Accompanying him would be the seamen, eighteen light horses, four howitzers, four twelve-pounders, three cohorns, one hundred rounds of ammunition for each man and a total of thirty wagons, including a wagon of Indian presents. Colonel Dunbar commanded the reserve division.

Five years after Braddock's army camped on the Little Meadows, Joseph Tomlinson was granted a patent for land on the north side of Braddock's Road, on the east side of Little Meadows. The Tomlinson family kept a tavern at the Little Meadows, and when the Cumberland Road (National Road) was laid out in 1807, Jesse Tomlinson owned the land. The inn or tavern built on Braddock's Road was torn down in about 1867. Many years prior to the original inn's destruction, Tomlinson built a new inn south of the original called the Stone House, possibly in 1816. The building still stands on the north side of the National Road a short distance east of Highway 219.[159]

Laurel Run

Camp 4 to Camp 5

The assault detachment of the final thrust of the campaign began on June 18, 1755, when the advance and pioneer road-clearing detachment of four hundred men left the base camp at the Little Meadows, about three miles east of present Grantsville, Maryland.[160] The following day, the general departed the camp, the fourth camp since leaving Fort Cumberland, leading the flying column of his now divided army.[161]

Departing Little Meadows, the army marched west over the gentle slopes of Chestnut Ridge.[162] The course of the road, leaving a prominent scar, was a short distance north of the present National Road (Highway 40) and the present community of High Point. The trace swings south of the National Road at 1.40 miles west of the intersection with Highway 219 in High Point. For the next 0.82 mile, the trace of the road has fallen victim to development and Interstate 68, following a course under and between the interstate and the National Road. This area was, early in the twentieth century, the farmland of Eli Stanton and was crossed by the Jennings Brothers' railroad,[163] now abandoned, with its bed used for River Road where it enters the National Road. A short distance west, the army road is joined briefly by the National Road before approaching the surviving Stanton's Mill and turning sharply south, fording the Casselman (Castleman) River between the modern National Road bridge and Interstate 68. This fording was the Little Crossings, described by Orme as about eighty feet wide and knee deep.[164] About three hundred yards north of the road's crossing of Casselman is the 1815 stone arch bridge, now used only as a pedestrian bridge at the Casselman Branch

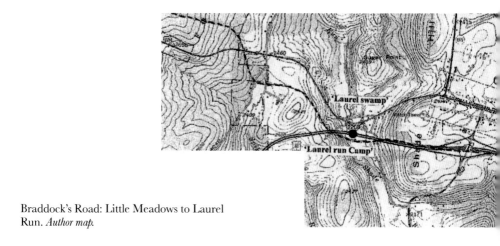

Braddock's Road: Little Meadows to Laurel Run. *Author map.*

State Park. A short distance after fording the river, the road is now buried for almost 2 miles, to the army's next encampment, under Interstate 68.

Ahead of the advance party, Monacatootha, Oneida chief, leader of the small contingent of Indians accompanying Braddock's expedition, and his son were surrounded and captured by a French and Indian war party on this day's march. The French in the party wanted Monacatootha killed, but the French-allied Indians rebelled and threatened to join Braddock's forces if he were to be slain. An agreement was reached to tie him to a tree and leave him. The son escaped and informed the army's Indians, who released him.[165]

Orme related that four miles from the Little Meadows, Braddock's flying column of the assault division came up with the rear of the advance party and was compelled to encamp.[166] The army had reached the Shade Run Valley, where the Big Shade Run and the Little Shade Run join to form the main stream. The camp was made between the two tributaries between Shade Hill and the foot of Negro Mountain. It lies partly under a large elevated fill across the valley, forming the base for Interstate 68, and between that base and the National Road, a site that engineer Gordon called a laurel swamp. The selection of the site, which ran counter to the expedition's desire to avoid low, defile areas, was forced on the division because the advance pioneer detachment was hard at work in cutting a traverse road over "an immense mountain [Negro Mountain]," work that could not be completed until the next day. The division arrived at the site by moving over an elevated ridge about a quarter of a mile south of the present town of Grantsville, a route now covered by Interstate 68. The road exited the ridge over Shade Hill, dropping down into the laurel

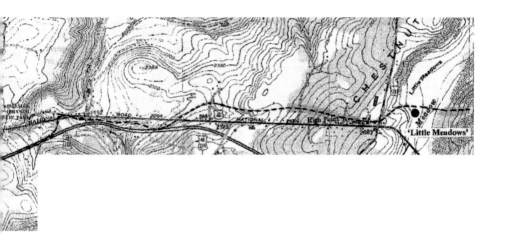

George Washington, engraving after Charles Willson Peale's 1772 portrait. Washington wrote that at the Little Meadows, he had advised Braddock to divide his army to expedite its movement toward Fort Duquesne. *From Hamilton's* Braddock's Defeat, *nineteenth-century illustration.*

valley through a slight saddle that the surveyors of Interstate 68 also considered a desirable path.

The British officer wrote that his unit traveled eight miles from Little Meadows before it made camp, or about three and a half miles farther than the actual distance between the two encampments. He wrote of Monacatootha's capture but said that it took place the day before (on June 18). He said that the enemy party was composed of seventy Indians and "some French at their head." Cholmley's batman said that his master's unit marched six miles on June 19 before pitching tents for the night.[167]

An alarm was raised when the tracks of several men were discovered by Braddock's Indian guides near the advance guard, but no enemy appeared. A point column commanded by Lieutenant Colonel Thomas Gage reached the crest of Negro Mountain, took possession of the mountaintop and, after scouring the woods, encamped there during the night.[168] The army's road at the top of the passage of Negro Mountain is 2.37 miles beyond the Shade Run camp. The batman's journal entry noted that his captain's unit "was Alarm'd by the Indians and lay upon our Arms for two hours after" before pitching their tents for the night. This indicates that his unit was either with Gage's advance column or in the immediate vicinity on the mountain.[169]

Bear Camp

Camp 5 to Camp 6

The advance party on Negro Mountain[170] marched early the morning of June 20. General Braddock, apparently concerned about the large party of French and Indians encountered by his Indian guides the previous day, took steps to ensure the security of the movement of his army train over the mountain. At daybreak, General Braddock ordered a detachment of one hundred men led by a captain to march from the Laurel Run Camp between Little and Big Shade runs and occupy the crest of the mountain until he could pass with the artillery and baggage train.[171]

The army marched to the next encampment without further incident. Orme reported a march of about 9 miles to the new camp. He said that the route was "over a chain of very rocky mountains and difficult passes." The encampment was not reached until about seven o'clock at night, about three hours later than usual. Orme said that "there was no water, nor even earth enough to fix a tent, between the great [Negro] Mountain and this place."[172] The British officer, this time indicating with his distance estimate that he was somewhere in the vicinity of the general's column, recorded that his unit, marching at five o'clock in the morning, covered 8 miles over a road that was "stony & some hills."[173] On his map, Gist called it the "Bare Camp," and he and Gordon recorded a distance of 7 miles between the camps. The military journalists were in agreement with calling it the "Bear Camp."[174] The actual distance over the trace of the road is about 8.4 miles.[175]

The military road, immediately upon leaving the Laurel Run (Shade Hill Run), moved steeply on an elevated spur of Negro Mountain, leaving

Right: Braddock's Road: Laurel Run to Bear Camp. *Author map.*

Below: Braddock's Road approaching Puzzley Run at the west base of Negro Mountain, as recorded by Lacock and Weller in 1908. Lacock and Weller, postcard No. 20, 1908. *Braddock's Road Preservation Association.*

Opposite, bottom: The same trace as it appeared more than one hundred years later, preserved by dense foliage. *Author photo.*

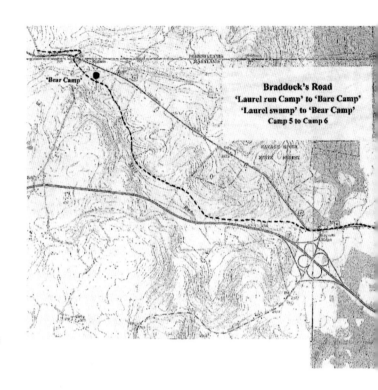

Braddock's Road
'Laurel run Camp' to 'Bare Camp'
'Laurel swamp' to 'Bear Camp'
Camp 5 to Camp 6

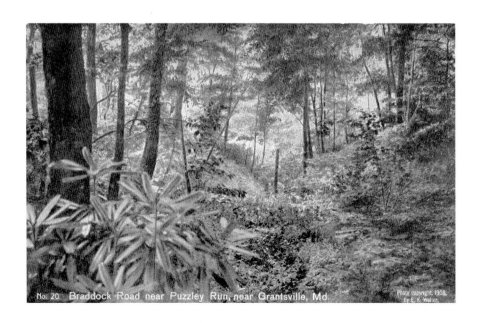

No. 20 Braddock Road near Puzzley Run, near Grantsville, Md.

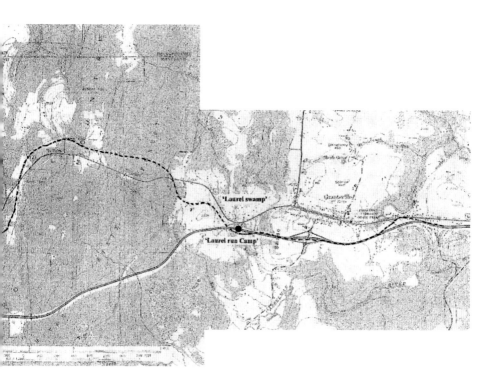

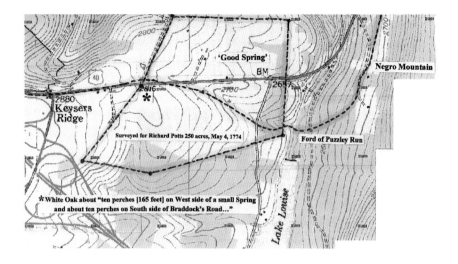

The 1774 "Good Spring" land grant on Braddock's Road: Puzzley Run to Keyser's Ridge. *Author map.*

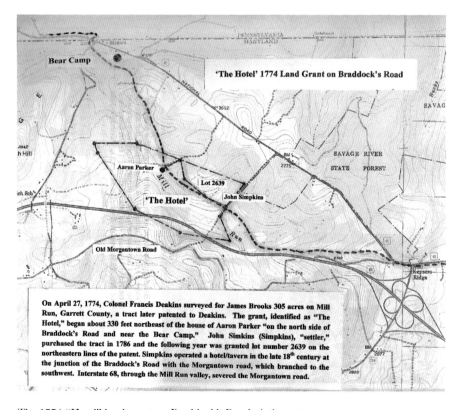

On April 27, 1774, Colonel Francis Deakins surveyed for James Brooks 305 acres on Mill Run, Garrett County, a tract later patented to Deakins. The grant, identified as "The Hotel," began about 330 feet northeast of the house of Aaron Parker "on the north side of Braddock's Road and near the Bear Camp." John Simkins (Simpkins), "settler," purchased the tract in 1786 and the following year was granted lot number 2639 on the northeastern lines of the patent. Simpkins operated a hotel/tavern in the late 18th century at the junction of the Braddock's Road with the Morgantown road, which branched to the southwest. Interstate 68, through the Mill Run valley, severed the Morgantown road.

The 1774 "Hotel" land grant on Braddock's Road. *Author map.*

The "Hotel" in Mill Run Valley: Braddock's Road went northwest through the Mill Run valley and the 1774 "Hotel" patent, past the site of the John Simpkins hotel/ordinary in the right foreground. The "Hotel" patent was later extended from Simpkins's Lot No. 2639, north and northeast to the Pennsylvania line. *Author photo.*

a prominent scar about 300 feet to the left (west) and in parallel with the National Road (Highway 40). At a saddle of the spur, the road swung west and across now long-cultivated farmland, making it difficult to trace the road until it reached, first, the road to the farmhouse and then another 220 feet to the north-south Amish Road, about 0.23 mile south of the present National Road. It then followed a small, gentle depression northwest until it crossed the present National Road about 0.16 mile west of the Amish Road intersection. It continued north and west until, staying to the north side of Spiker Run, it was about 0.24 mile north of the National Road in a very heavily forested area. The scars of the road reveal its course westward to a crossing near the head of the north fork of Spiker Run. From this crossing of the run, the trace continues westward until it crosses the gap of the mountain's most prominent saddle on present Rocky Acres Road, about 733 feet east of the road's intersection with the present Zehner Road. In the north angle of the Zehner Road intersection is the Oak Grove Mennonite Church, about 0.19 mile north of the National Road. This area or community is presently

known as Hi-Point, not to be confused with the community of High Point at Little Meadows.

To the west of the Zehner Road, the military road began its descent of the west slope of the mountain. The National Road again crossed Braddock's Road about 0.60 mile from the Zehner Road. Braddock's Road continued past this National Road, crossing on a general parallel course to what is now part of the south section of Holiday Road before turning to the southwest and west with deep scars to a ford of Puzzley Run. The run drains the west base of Negro Mountain, and there was no way to avoid a passage of the stream, forcing the army to navigate the steep banks encountered. The National Road was built 0.40 mile north of the army's fording of the run, again crossing the army road 0.65 mile west of the run. The army road briefly swung for a short distance several yards north of the present National Road before rejoining and sharing the same course to the crest at Keyser's Ridge.[176] This trace of Braddock's Road apparently eluded Lacock, who concluded that the roads paralleled for more than 2 miles to and along Keyser's Ridge. Rather, the army road continued to the west down a spur of the ridge into the valley of Mill Run. The National Road left the army road at this point and stayed with the ridge to the northwest. Lacock provided no indication that he followed the trace of the army's road from Keyser's Ridge to Bear Camp, but instead he followed a route that paralleled the National Road along the ridge crest.[177] Braddock's Road left prominent traces along the north and east side of Mill Run. From a point near the present Interstate 68, it turned to the northwest, staying a short distance to the north and east and crossing several small branches of Mill Run. The road left well-defined scars before reaching the relatively level site of the Bear Camp.

The following two days would be halting days as the advance party and the pioneers cut a very difficult road that would carry them out of Maryland and into Pennsylvania. The encampment was on a level south of the north branch of Mill Run, southeast from the crossing of the future Pennsylvania line. Ahead of the army was the steep switchback climb over the Winding Ridge, one of the most difficult passages.

Chapter 10

Great Crossings

Camp 6 to Camp 7

The army remained in camp until June 23, while the advance and pioneer units extended the road down into the valley of the north branch of Mill Run and over the steep pass of the formidable Winding Ridge. After clearing the passage of Mill Run, the road-clearing detachment labored with a very difficult, rocky and extreme ascent of the south face of the ridge.[178] It was here in the present community of Strawn that the road crossed the line that would later be surveyed between Maryland and Pennsylvania.

The next encampment was on the north side and near the mouth of a branch that became known as Braddock's Run,[179] on the east side of the Youghiogheny River at the fording known as the Great Crossings. Gist identified the camp as the "Lick near big Crossing,"[180] while Orme dubbed it "Squaw's fort.'[181] Engineer Gordon recorded it as the "Middle Crossing."[182]

The distances recorded by the source participants between Little Meadows, the Laurel Run Camp, the Bear Camp and the "Lick near big Crossing," or "Squaw's fort," provide only a brief consensus. Gist, as the guide who marched with or for General Braddock, and Orme provided data that more closely reflected the movements of the main body of the flying column of the army. However, Orme was not familiar with the country over which they marched (Gist was), which was often reflected in the estimates he provided. Gordon appears to have relied almost entirely on Gist for the distances between camps but was at variance with Gist in the application of his own identification of the encampments. Captain Cholmley's batman and the British officer varied greatly on their estimates and identifications,

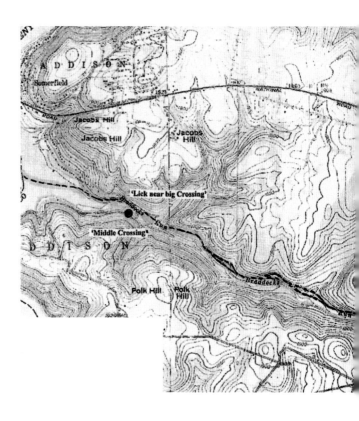

Braddock's Road: Bear Camp to Middle Crossing. *Author map.*

but this can again, in part, be attributed to unfamiliarity with the territory and the position of their units with respect to the main column. This was especially true with Cholmley's unit, which was often in advance operations.

While Orme miscalculated the mileage between Laurel Run Camp and Bear Camp by only about 0.60 mile, Gist committed a larger singular error in calculating the distance between Bear Camp and the camp on the east side of the Great Crossings of the Youghiogheny. He recorded 8 miles between the two encampments, which would have extended the course more than 2 miles west of the Youghiogheny.[183] Orme wrote that the march from Bear Camp to the Squaw's fort was "about six miles of very bad road,"[184] close to the actual distance of 5.52 miles.[185] It is starkly evident that the listing on Gist's map was an error and should have read 6 miles instead of 8. It was indeed a "very bad road" northwest from the heights of Winding Ridge and

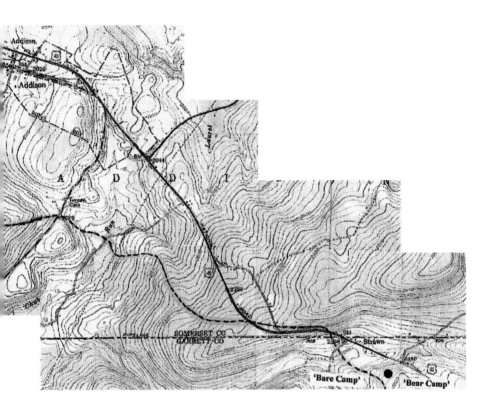

down into the stream-washed valley of Braddock's Run, to its mouth on the Youghiogheny. The upper ridge is covered with a profusion of rocks and boulders that had to be avoided or moved. Gordon noted that there was lots of rubble, "with a few hard pinches."[186] The road descended into the head of a valley, drained by the stream now known as Chub Run,[187] and ascended the next ridge[188] at the head of Braddock's Run. The valley military road, which Gordon described as a defile, forded four minor streams, including the three principal branches of the run, while staying mainly with the north side of the run to its mouth. The branches of the run flowed into the valley from the north.[189]

It was a far different course than the one plotted by Lacock, who traced a route more than one mile farther to the north. Lacock, possibly influenced by the misidentification in the early nineteenth century of segments of the new

National Road as "Braddock's Road," had the army's trace swinging north from Winding Ridge to and through the present Addison, Pennsylvania community.[190] After moving through the Addison area, Lacock had his course of the road swing about ninety degrees south to join Braddock's Run near the mouth of the north branch of the run close to the site of the river encampment.[191] It was a deviant course that no primary Indian trail or traders' path could be expected to take.

Lacock indicated that he was aware that the course of the road he had selected might not be the right one. In a footnote, he acknowledged that a survey of a tract of land in 1788, south of Addison, depicted a road identified as "Braddock's Old Road."[192] This discovery, he wrote, "recently made, necessitates a further examination of the ground in order, if possible,

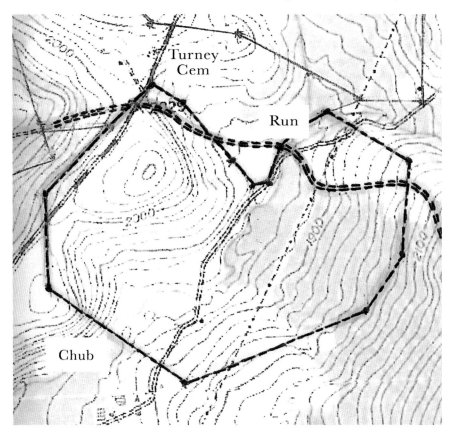

Braddock's Old Road and Conrad Wable's 1788 Survey: "Braddock's old road" crossed Conrad Wable's 223¾-acre 1788 survey on head branches of Froman's Mill Run (now Chub Run) from the Winding Ridge (lower right) to Hileman's Lane (upper left) leading to Braddock's Run. *Author map.*

to determine the exact location of the road between the state line [with Maryland] and the Youghiogheny." The survey was for a grant of land to Conrad Wable at the head of Braddock's Run and in the Chub Run Valley. There is no indication that Lacock furthered his examination or attempted to correct his course of the road.

Gist's map depicts the road following the north side of Braddock's Run, from the head branch of the run to the encampment site west of the mouth of the north branch on the east bank of the Youghiogheny. The trace of that road—from Wable's land grant west down Hileman's Lane[193] and then to the head branch of Braddock's Run and along the north side of the run to its mouth on the Youghiogheny—can still be followed.[194] This section of Braddock's Road apparently continued to be a main artery of travel until the opening of a road through Addison and, finally, the building of the National Road early in the nineteenth century. This is illustrated in surveys at the Great Crossings of the Youghiogheny in 1769, fourteen years after the passage of Braddock's army. These surveys show distinctly Braddock's Road

Hileman's Lane: This passage of Braddock's Road is located on the ridge between Chub Run Valley and the 1788 Wable grant and the head branch of Braddock's Run in the background. *Author photo.*

crossing the river at the mouth of Braddock's Run and proceeding north down the west side of the Youghiogheny before turning west on Hall Run, where the National Road now crosses the river.[195]

Orme noted in his journal of this day's march that three Mohawk Indians "pretending friendship" were encountered. They said that Fort Duquesne had been reinforced from Montreal and that additional troop strengthening at the fort was expected, but provisions were low due to the dry season, which had stopped navigation of the "Buffler river." The Mohawks left at night accompanied by one of the army's Indians "whom we had long suspected. This fellow had frequently endeavored to conceal himself upon the flanks on the March, but was always discovered by the flank parties."[196]

Chapter 11

Scalping Camp

Camp 7 to Camp 8

At five o'clock in the morning on June 24, the army began departing from the east bank of the Youghiogheny, at the lick on what is now known as Braddock's Run, at the Great Crossings. Orme described the crossing as about one hundred yards wide and three feet deep, with a very strong current.[197] The British officer, in his journal, was impressed with the crossing, stating that it "was extremely beautiful & afforded us a pleasant prospect; it undoubtedly appeared to us much more so having had nothing but a continued thickett to march through since our first setting out. Close to ye crossing of this River is a small Log Fort built by the Indian Women last year to secure themselves & children in when Mr. Washington was engaged with ye French."[198]

Before the next encampment was reached, a recently abandoned Indian camp was discovered, estimated by the number of huts to have provided shelter for about 170 warriors.[199] It was an average day's march. There was a wide variance in the estimated distance between encampments. Again, some of this may be attributed to the distance between the advance party and the rear guard elements. Gist recorded a distance of seven miles to an encampment six miles east of the Great Meadows, the site of Fort Necessity.[200] Orme estimated that only six miles were completed that day. The unidentified officer said that five miles were completed on the west side of the Youghiogheny. The batman, whose captain operated with the advance units, wrote that his unit marched ten miles.[201]

On his map, Gist placed the camp between the headsprings of the Pinkham Run branch of Hall Run, which empties into the Youghiogheny north of the

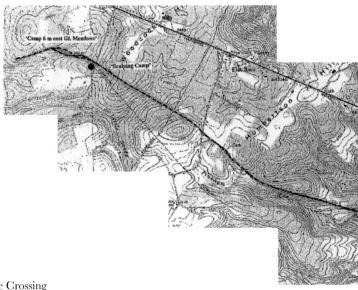

Braddock's Road: Middle Crossing
to Scalping Camp. *Author map.*

Great Crossings, and the headwaters of Little Sandy Creek, which flows into
the Monongahela by way of the Cheat River.[202] Although Orme identifies
the site only as "the Camp on the East Side the Great Meadows," Lacock,
apparently using landmark nomenclature in common use in the area and
identified as early as 1759, called it "the camp of the Twelve Springs."[203]
He located it at "about four miles east of Great Meadows," or two miles
closer to the Great Meadows than the distance cited by Gist.[204] None of
the participant writers referred to it as the Twelve Springs Camp. Halkett
identifies it as the "1st Camp from the Great Crossing."[205]

The site, when one adapts a composite average of the estimates of the
recording participants, was in the vicinity of the road's crossing of the
present Pike School Road, on Woodcock Hill, about 0.5 mile south of the
National Road (Highway 40). By Braddock's Road, the actual distance
from the encampment on the east side of the Youghiogheny to the site of
Fort Necessity, essentially in the center of the Great Meadows, is about
14 miles. Factoring in the margin of error, the June 24 encampment was
7.7 miles from the encampment on the east bank of the Youghiogheny
and 6.3 miles from Fort Necessity in the Great Meadows, compared
with the 7-mile estimate of the former by Gist, the journalist participant
most familiar with the road, and his estimate of 6 miles from the
Great Meadows.

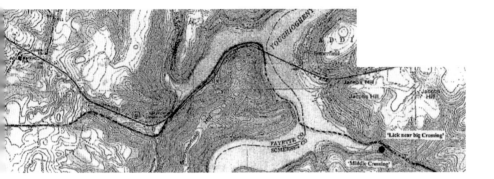

Gordon provided the most descriptive expedition identification of the encampment, calling it the "Scalping Camp."[206] At 4:00 a.m. on the twenty-fifth, the camp was alarmed by French-led Indians firing on a wagoner gathering his horses for the new day's travel. As many as five of Braddock's army were reported killed or scalped, including a servant of Halkett's, before Braddock's Indians drove the enemy away.[207]

The route taken by the army, departing the camp on the east bank of the Youghiogheny at the Great Crossings, forded the river on the north side of Braddock's Run, where the silt flow of the run provided a shallow passage of the river. The path turned north alongside the west bank of the river to the mouth of Hall Run, turning and following the run west-southwest, where the present National Road crosses the river. Surveys in 1769–70 depict this course of the road at the Great Crossings, decades prior to the building of the National Road.[208] The course of the road at the Great Crossings can be better appreciated only when the waters of the dam-blocked river have been lowered to its former level. The course of the road was along the near-base side of what is now identified as Summerfield Hill, which at the time of Lacock's survey was known as Turkey Garden Hill.[209]

The present National Road follows alongside Braddock's Road on the north side of the hill for about a mile into Jockey Hollow before the courses of the two separate, with the latter moving to the south of the National Road

Fork of the North Branch of Braddock's Run near the Great Crossings of the Youghiogheny River, as recorded by Lacock and Weller, postcard No. 25, 1908. *Braddock's Road Preservation Association.*

The site shows little change in a recent image. *Photo by Robert L. Bantz.*

The Great Crossings: Braddock's Run, right foreground, flows into the Youghiogheny at the Great Crossings. The river was crossed immediately downstream of the run's mouth. The photo, taken at a time when the water in the present reservoir was let down, approximates the 1755 appearance of the river. The National Road bridge (U.S. 40) is in the background. *Author photo.*

Humbertson Hill: 1 mile southeast of the Scalping Camp and 0.74 mile south of the National Road at Flat Rock, Pennsylvania, looking southeast. *Author photo.*

about 160 yards, paralleling the National Road for about 0.6 mile. The well-defined trace of the road, up the south side of a small branch flowing into Hall Run, continues westward, climbing gradually up River Hill (Second River Hill),[210] crossing the present T876 road on the hill and across farmland to the present T357 road, following it and a short, abandoned section to a crossing of Highway 281/T314, Markleysburg road, about 0.7 mile south of the National Road. For the next 2.12 miles to the west, along the north bank of the Pinkham Run, the road is identified as T359 or "Braddock Road." This section's modern-day use ends at the T800 Flat Rock Road, about 0.74 mile south of the National Road. Here is the division ridge of Humbertson Hill, between the waters of the Monongahela and the upper reaches of the Youghiogheny. The continuation of the abandoned section of the road for the next 1.15 miles, to the encampment site, is easily traced though a region that remains mainly forested and undeveloped on the upper branches of Little Sandy Run.

Chapter 12

Steep Bank

Camp 8 to Camp 9

After the June 25 daybreak confrontation with the French and Indians and a loss of as many as five members of the expedition to the attack, the army left its "Scalping Camp" on the headwaters of Little Sandy Creek, resuming its west-by-northwest trek.

The army passed through the Great Meadows about 160 yards southwest of the site of Fort Necessity, erected the year before by troops led by George Washington in the failed attempt to defend against a French and Indian attack. Orme made no mention of the former fort or battle, stating only that "we passed the Great Meadows, and encamped about two miles on the other side."[211] The batman noted that "we marched Eight miles and Marched a Cross the large Meadows, it being a Mile long and two hundred yards Broad."[212] The British officer also recorded that the army marched to an encampment about two miles beyond the Great Meadows, further observing that it "was strongly imagined if we met with any opposition, ye Meadows would be ye place, but we marched without any Molestation or alarm." He took time to visit the area, writing that the meadows were about 150 acres and entirely clear, with Fort Necessity in the middle. He said that Washington's "very good Swivells" had been entirely disabled and left in the ditch surrounding the fort site. "There are many human bones all round ye spott; but at present every thing is entirely pulled down," he added.[213]

A survey of the Great Meadows in 1769 depicts a 0.6-mile stretch of Braddock's Road crossing the tract of land, with the site of Fort Necessity on Meadow Run about midway along the stretch.[214] The southern boundary

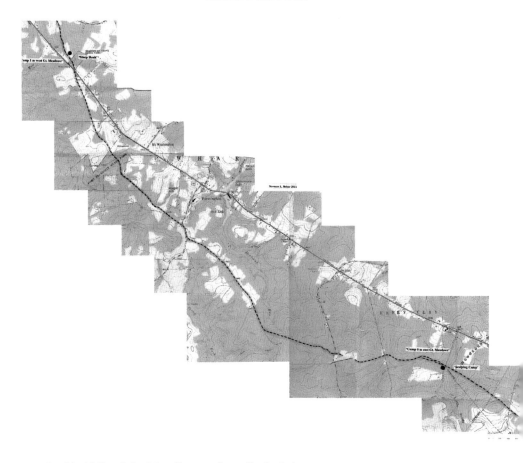

Braddock's Road: Scalping Camp to Steep Bank. *Author map.*

of the tract, at the entry of Braddock's Road, is about 6 miles from the Scalping Camp site on the headwaters of Little Sandy Creek. Gist located the new campsite 1 mile west of Great Meadows, in contrast to the 2 miles beyond cited by Orme and the unidentified officer. Not known is whether the reference point is from the site of Fort Necessity or from the Great Meadows southern or northern boundary, wherever those boundaries were considered at the time. Gist places the camp 7 miles from the Scalping Camp, on the northwest side of a south head branch of Big Sandy Creek (the branch was later identified as another Braddock Run).[215] The distance from the Scalping Camp by the army's road is about 7.86 miles.[216] Gordon identified the new halting site as the "Steep Bank" camp.[217] Orme said that it was the "Camp on the West Side of the Great Meadows"; Halkett's Orderly Book tags it the "Camp beyond the Great Medows."[218] Lacock, citing "many writers," called

Great Meadows: The reconstructed Fort Necessity, and site of Washington's 1754 engagement with the French and Indians, as seen from Braddock's Road in the Great Meadows. *Author photo.*

it the "Orchard Camp," a name other writers continue to give it, although none of the expedition participant writers used that identification.[219]

The road of the expedition on June 25, from the Scalping Camp at Little Sandy Creek, extended to the west from the encampment on Woodcock Hill, skirting around head branches of the Little Sandy Creek. It extended about 1.7 miles through a rugged, heavily forested area, crossing the present Dinner Bell/5 Forks Road (SR 2011) at about 1.37 miles south of the National Road. Continuing westward through the heavily forested, undeveloped land about another 1.1 miles, the army's road reached the present Howard Road/ Braddock Road near the head branch of Deadman Run. Stretches of the abandoned road through the forest from the Scalping Camp to this point can be followed with little difficulty. The Howard Road/Braddock Road follows the army's road for about 1.74 miles northwest along the ridge between Deadman Run and the Stony Fork of Big Sandy Creek, except for a 0.24-mile segment now bypassed around housing prior to its junction with Highway 381/Elliotsville Road. Turning north, the road is followed by Highway 381

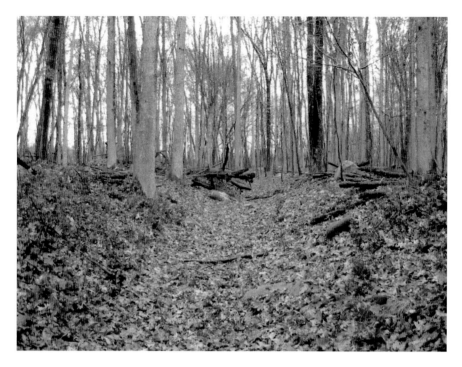

Fort Necessity to Steep Bank: The road, about 550 yards northwest of Fort Necessity, begins a gradual ascent toward Chestnut Ridge. Beyond this point, in 1.4 miles, the army reached its ninth encampment, "Steep Bank," on the north side of a branch of Big Sandy Creek, crossing the National Road and site of General Braddock's grave. *Author photo.*

for about 0.22 mile before it returns to the northwest, paralleling Rankin Road and running to the gap south of Hager Hill for about 1.52 miles to the site of Fort Necessity. Continuing through the Great Meadows and over Meadow Run, the army's road ascended a north ridge until it crossed the present National Road a short distance south of Braddock's grave and over the trace where he was originally buried. This trace, etching a sharp decline as it approaches the Braddock Run branch of Big Sandy Creek and the spur of the following ridge, may have prompted Gordon to apply his "Steep Bank" designation to the encampment site located on the ascending bank immediately north of the crossing of the branch.[220]

The French Indians continued to frequent the outskirts of the march and the encampments, and while attempting to reconnoiter the encampment, they were fired on by the sentinels. Returning to this camp after the battle on the Monongahela, Braddock died from his wounds and was buried in the road a short distance south of the run.

Chapter 13

Rock Camp

Camp 9 to Camp 10

Ahead lay formidable Chestnut Ridge. At five o'clock in the morning on the twenty-sixth, the army began its march from its encampment on the north side of an east head branch of Big Sandy Creek, later to be known as another Braddock Run.[221] Orme, noting the early departure, wrote that "but by the extreme badness of the road could make but four miles" to the next encampment.[222]

The actual distance for the day's travel was about 3.35 miles. Gist, not one to record fractional miles, listed 3 miles, while Gordon, in one of the few times he would break with Gist on distances between camps, estimated 3.5 miles.[223] The "badness" was in the climb up the Chestnut Ridge. In a distance of about 3 miles, after leaving the encampment north of Braddock Run, the army struggled with a climb of about five hundred feet.

Marching from the camp north by northwest, the army crossed several yards to the east what is now the intersection of the Chalk Hill SR 2010 and SR 2008 roads before grabbing for an elevation spur of the nearest ridge. Staying clear of the head branches of Trout Hollow, the road swung to the west through the present housing development, moving up the spurs of the ascending ridges. West of the housing development, the army's road is now crossed by a modern secondary road, known as the Half King Colony Road, or Half King Path. Beyond, the road can still be traced west by northwest to its intersection with SR 2021 and the Jumonville Road. In a ninety-degree swing to the north, the road followed the present course of SR 2021 to the encampment grounds, to the right of the road, at "Washington Springs," the

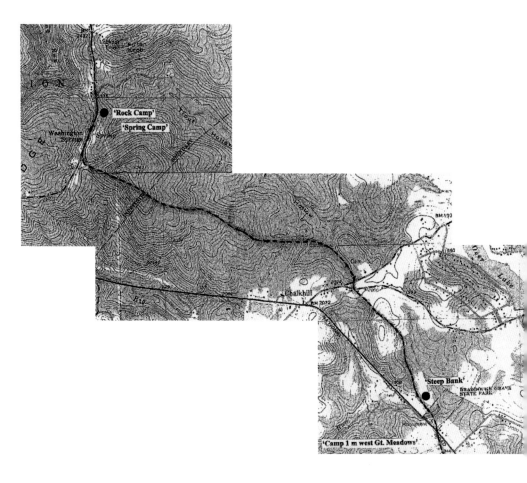

Braddock's Road: Steep Bank to Rock Camp. *Author map.*

Rock Camp or Spring Camp, a short distance from the "Rock Fort," or the "Half King's Rocks," at the intersection.[224]

In describing this encampment, Orme wrote, "At our halting place we found another Indian camp, which they had abandoned at our approach, their fires being yet burning. They had marked in triumph upon trees, the scalps they had taken two days before [at the Scalping Camp], and a great many French had also written on them their names and many insolent expressions. We picked up a commission on the march, which mentioned the party being under the command of the Sieur Normanville." Orme described the "Rock Fort" as a camp "in a strong situation, being upon a high rock with a very narrow and steep ascent to the top; it had a spring in the middle,

and stood at the termination of the Indian path to the Monongahela, at the confluence of the Red-stone creek."[225] By studying their tracks, it was believed that the French and Indian war party had divided at the site, with one group continuing on the trail to Fort Duquesne and the other returning to the Monongahela by Redstone Creek.[226]

The headsprings of the Lick Run and Coolspring Run branches of Redstone Creek are on the northwest side of the Chestnut Ridge encampment and the headsprings of Big Sandy Creek and Dunbar Creek on the southeast side.[227]

The unidentified British officer wrote in his journal that his unit marched about 4 miles to the Rock Camp "under a rocky hill where 150 or 200 french & Indians had encamped ye Night before. They had drawn many odd figures on ye trees expressing with red paint, ye scalps and Prisoners they had taken with them; there were three french Names wrote there, Rochefort, Chauraudray, & Picauday." He noted that Braddock had sent Captain Robert Dobson with seventy volunteers to Redstone Creek in an unsuccessful attempt to make contact with the French and Indian war party.[228] Dobson and his men rejoined the army at the next encampment at Gist's plantation. Orme said that Dobson marched down Redstone with four subalterns and ninety volunteers.[229]

Gist's House

Camp 10 to Camp 11

After a night at the Rock Camp, or Spring Camp, the army stayed with the traders' path, Ohio Company road and Indian trail on the crest of Chestnut Ridge for most of the day of June 27.[230] On a course north and slightly east of north, it was a path that Gist knew very well, for it was the path to the plantation that he had established in a pleasant valley immediately to the west of that challenging barrier. It was the plantation that figured so prominently in the preliminaries to the embarrassing defeat at Fort Necessity a year earlier. In the final days of June 1754, prior to falling back to the Great Meadows, Washington's troops had thrown up a makeshift fort of fence rails and trees at Gist's—"a Hog pen fort surrounded with standing Trees."[231] Now, Gist was returning to his plantation as the chief guide for General Braddock's army.

About a mile north of the Rock Camp, the army passed the pathway to the hidden glen, about one-quarter mile east of the road, where a French force of thirty-three soldiers, led by M. de Jumonville, was surprised and defeated at the end of May 1754 by a small British and allied Indian force led by George Washington. A quarter-mile farther north, the road turns to the northeast as it passes the present community of Jumonville, the farthest point reached by Colonel Thomas Dunbar's detachment of the army during the expedition. Throughout its course along the crest of Chestnut Ridge, the army's road is followed closely by the present road ("Old Braddock Road"), with two major exceptions: first, immediately within and beyond the present community of Jumonville, and second, where the military road began its northwest descent into

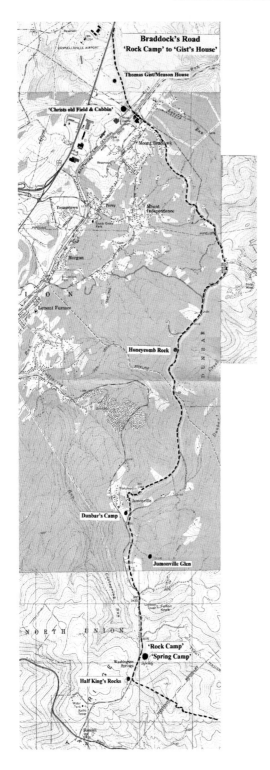

the valley of Gist's plantation. Reaching the area that would later be the site of Dunbar's Camp at present Jumonville, the military road swung to the left of the present road and ascended the nearest spur of Chestnut Ridge to its crest,[232] with the present road rejoining it about 1.2 miles from its intersection in the Jumonville community. From that point, the military road is followed by the present road along the crest of the ridge, above and west of Dunbar Creek. As the road begins its descent of Chestnut Ridge and approaches the present community of Mount Independence, near the base of the western slope, it reaches the intersection of the present "Old Braddock Road" and Shab's Road. Following Shab's Road for about 130 yards before moving to the right and continuing northwest across the head of a branch of Laurel Run, the road descends a spur north between the branch and a spring branch of Gist's Run. Staying a short

Braddock's Road: Rock Camp to Gist's House. *Author map.*

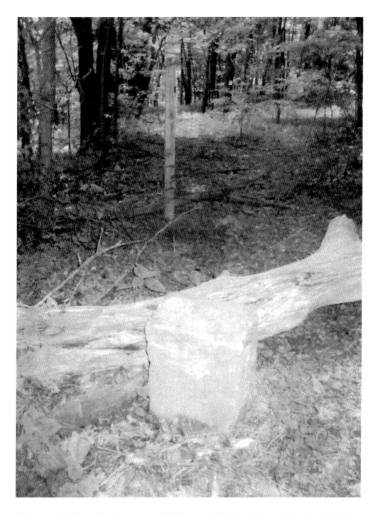

Chestnut Ridge: On the crest of Chestnut Ridge, about eight hundred yards northeast of the cross monument in the Jumonville community. An old stone marker, foreground, with an "X" on top and a fallen tree, lies on the side of the abandoned road. *Author photo.*

distance east of the branch, the road follows it across present Jefferson Road, over an abandoned trace known as Spring Road, to the present Pepper Hollow Road. It follows the present road, along the branch, to and across Gist's Run to the site of Gist's settlement.

Gist placed the distance from the Rock Camp to his house at 8 miles.[233] Orme estimated 6 miles to Gist's "plantation" over a road "mountainous and rocky"[234] and the batman, 9 miles to "guests plantation." The actual

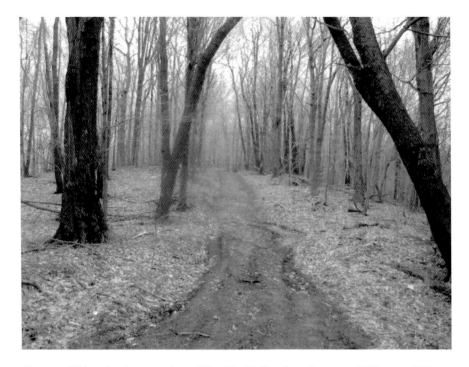

Chestnut Ridge: A private section of Braddock's Road on the crest of Chestnut Ridge seen toward the south and about four hundred yards north of the old "X" stone marker. Along this section of the road, the crest is very narrow and drops off sharply on either side. *Author photo.*

distance is 7.86 miles.[235] The British officer wrote that the march to "Guest's plantation" was "over a long & steep mountain…here ye mountains begin to diminish & a fine pleasant rich Soil is seen."[236]

The site of Gist's plantation is on a pleasant, gentle elevation on the west side of the Gist's Run branch of Dunbar Creek, which flows into the Youghiogheny a few miles north. It is fronted on the west by Highway 119 and the Connellsville Airport. Gist's settlement site is graced by a beautiful Georgian stone mansion built by Isaac Meason (Mason) in 1802. The site is rapidly being surrounded by industrial development. Meason acquired Gist's plantation lands from Gist's son Thomas's heirs.[237] Christopher Gist's initial efforts toward settlement in the area were made as early as late 1752.[238] He was driven from the settlement by the French immediately before the conflict at Fort Necessity in 1754. After Christopher's death in 1759, Thomas acquired his father's settlement and adjoining preemption land, totaling more than 1,500 acres, as well as another 1,200 acres granted to Gist's heirs.[239]

Chapter 15

Stewart's Crossings

Camp 11 to Camp 12

Remaining at Gist's plantation overnight, the army marched north by northeast on June 28 in a heavy rain over a pleasant landscape, providing a degree of relief to the troops widening the Indian trail and trudging forward with packs, equipment, provisions and cannons. In addition to the relatively less taxing route, the distance to the new encampment site was much reduced over the previous day's march. Confronting the army, hours into its march, was a new crossing of the Youghiogheny, which engineer Gordon called the "Main Passage."[240] It was known locally as Stewart's Crossings,[241] a wider, deeper fording than that of the earlier passage of the Great Crossings. The new encampment site was alongside the road on a wide terrace south of the river in what are now the west environs of Connellsville, Fayette County. Gordon noted that in general the soil at the site was "rich and in many places soft and deep."[242]

Gist and Gordon placed the distance from Gist's plantation to the new encampment at 5 miles. The actual distance is 5.19 miles. Leaving Gist's plantation, the army's route wound its way along the elevations, staying above the head of the drains that flowed on the northwest into Opossum Run (known originally as Harper's Run[243]) and on the southeast into Gist's Run and Dunbar Creek. The road continued its passage approximately midway between the branches flowing into the Youghiogheny until it reached and crossed Opossum Run at its mouth on the Youghiogheny. The main or central part of the encampment was probably located in the area between North Twelfth Street on the east and Dewitt Avenue on the west

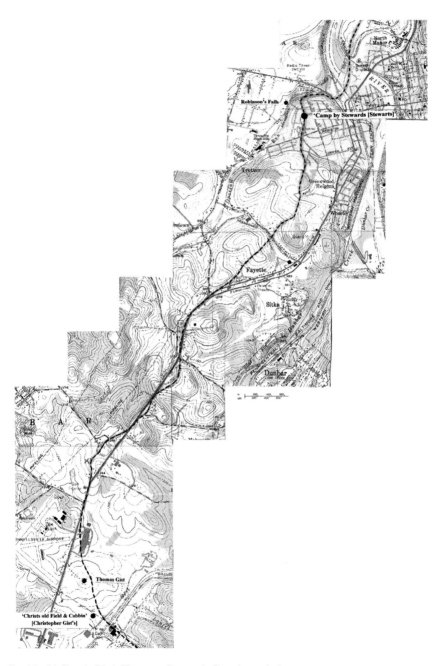

Braddock's Road: Gist's House to Stewart's Crossings. *Author map.*

and between West Crawford Avenue and St. Johns Cemetery on the south and Independence Avenue on the north.[244] A short distance to the west on Opossum Run is Robinson's Falls.

Lacock concluded that the route from Gist's plantation kept to the higher ground only until it reached "a point about a quarter of a mile east of Leisenring, where it turns into the valley of Opossum Run" and continued to follow the run until it flowed into the Youghiogheny. He stated further that although "no trustworthy scars of the road from Gist's Plantation… are discernible, there can be little doubt that this was the line of march." Citing a draft connecting a number of land tracts of the area from Gist's to Stewart's Crossings as confirmation of his selection of the route, Lacock said that this enabled him "to lay down the road between these two points with greater accuracy."[245]

In conflict with Lacock's conclusion regarding the route of Braddock's Road, original surveys and grants of the land between Gist's and Stewart's Crossings[246] and clearly discernible scars of the road confirm that the route did not drop down into the valley of Opossum Run, as cited by Lacock. Instead, the road continued to stay with the higher ground until the encampment was reached shortly before the run's meeting with the Youghiogheny in present Connellsville.

Across the lands to the north of Gist's plantation, the road is now followed by older stretches of Highway 119, weaving from one side to the other of the present Highway 119, the first of these older stretches beginning about 0.9 mile north of the Gist house. This stretch of Braddock's Road is noted on a 1773 land survey and grant[247] and depicted on the following two surveys and land grants in 1785, both adjoining on the north the first grant.[248] In the next two adjoining land grants, beginning about 2.7 miles north of the Gist house, where a present road turns to the left and goes down into the valley of Opossum Run to the east of Leisenring, as proposed by Lacock, the army's road instead takes a steady turn to the northeast, with old Highway 119 following the army's road. This section of the road is depicted in one grant as "the great Road" leading to the ferry of Connellsville founder, Zachariah Connell.[249]

At 3.26 miles from the Gist house, Braddock's Road separated to the west from the present route of Highway 119 in the community of Fayette and continued northeast, keeping to the elevated land where the next two grants were issued to Benjamin and Robert Ross.[250] This section of the road is abandoned, but its scars are very discernible. Adjoining the last of these two land grants on the north was the land grant to Lawrence Harrison Sr.

in 1769.[251] Braddock's Road is depicted extending through Harrison's grant from the south end of the grant adjoining Robert Ross to the road's meeting with Opossum Run (Harper's Run) near its junction with the Youghiogheny on the north.[252] Adjoining Harrison's grant on the east (Connellsville's North Twelfth Street is approximately the line dividing the two grants) was a grant issued to John Crawford.[253] The survey for Crawford, including "what is generally Called Stewards Crossings," also depicts Braddock's Road crossing Opossum Run (Harper's Run) in Crawford's northwest corner and the road crossing the Youghiogheny at the west side of the mouth of the run.[254] Adjoining Crawford on the northwest and fronting on the south side of the river was the land of Joseph Mansfield.[255]

The abandoned, but discernible, course of the army's road north of the community of Fayette extends for more than a mile over farmland west of the communities of Wheeler and Greenwood Heights. It crosses Oglevee Lane and an abandoned railroad that cut across the former army road. Continuing across the elevated fields, the road passed a short distance west and behind a recently built Walmart store at Greenwood Heights. About 1.25 miles north of Fayette, the road begins a descent of the ridge, becoming Pine Tree Lane before reaching a wide terrace in the environs of west Connellsville. Crossing West Crawford Avenue, near its intersection with Wood Street, the army's road passed through what is now the eastern side of St. Johns Cemetery, before reaching and crossing Independence Avenue. In this area, south of Stewart's Crossings, the army made its twelfth encampment since departing Fort Cumberland.

Over the River

After reaching the twelfth camp at Stewart's Crossings on June 28, Braddock's army halted for a day of rest, crossing the main body of the Youghiogheny River on June 30,[256] preceded and protected on the north side by the advanced guard until the artillery and baggage were moved over. Leaving the camp on the terrace, the army's pioneers cut a surviving trace of the road descending the north face of the terrace above the banks of Opossum Run. Coming off the terrace, the road crossed the run and continued a short distance to the west side of its mouth at the river ford.[257] The river at the crossing was about two hundred yards across and about three feet deep.

The twelfth camp's location was described by Orme as on the "east [west] side" of the river.[258] Lacock wrote that this encampment was "near Robinson's Falls" on Opossum Run.[259] The journal of the British officer recorded that his section of the army marched "within half a mile of ye great crossing,"[260] while the batman did not record the site of the encampment nor the passing of the river. Halkett's Orderly Book referred to the "Camp on the Yochoganney [Youghiogheny]."[261] Gist cited the "Camp by Stewards." The distances recorded indicate that the army prior to the fording of the river was extended back from the crossings for at least half a mile or more.

Lacock related that Braddock forded the Youghiogheny at "Stewart's Crossing, below [west of] the mouth of Opossum Creek [Run], to a point on the opposite side of the river above [east of] the mouth of Mounts Creek."[262] This position is in agreement with the understanding that the

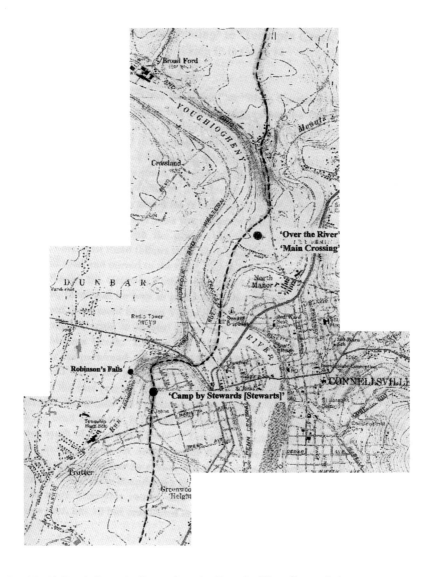

Braddock's Road: Camp by Stewart's to the Over the River Camp. *Author map.*

best fording places were at the downstream side of the inflow of silt from major streams flowing into a river. The south side of Stewart's Crossings was near and several yards east of the site of the reconstructed cabin of William Crawford[263] in the Connellsville City Park. However, the army did not cross the Youghiogheny a quarter of a mile downriver from Crawford's reconstructed cabin, as cited by one researcher, nor north of the mouth of Mounts Creek.[264]

Stewart's Crossings of the Youghiogheny, at Connellsville, Pennsylvania. Braddock's army crossed from the right foreground to the end of the present railroad bridge, right center, near the mouth of a south verge of Mounts Creek. *Author photo.*

The Stewart's Crossings ford is precisely located in surveys for land grants in the area on both sides of the river. The survey for the 1769 land grant to William Crawford's son, John, on the south side of the river, at "Stewards Crossings," locates the crossings immediately below, on the west side of the mouth of Opossum Run (Harper's Run).[265] A survey for a land grant to William Crawford, also by order of a 1769 survey, on the north side of the river (not the south side, where his cabin has been reconstructed), locates the crossings at the mouth of Opossum Run and east of what was then the mouth of a south verge of Mounts Creek.[266] The resurvey of this grant in 1793 indicates that the crossings site was still between the mouth of Opossum Run and the mouth of the south verge of Mounts Creek. The original outflow of Opossum Run was north of the intersection of present North Seventh Street with Torrance Avenue in the Connellsville City Park. The run, from present Vanderbilt Road to the river, is now buried beneath a shopping mall and diverted from its original location. The crossings forded the river to the north bank between the present abandoned railroad bridge on the west and

Narrows Road: The Miner Drive section of Braddock's Road on the Narrows Ridge, looking south to its junction with present Narrows Road, curving to the right toward the area of the site of the army's thirteenth ("Over the River") encampment. The army halted in the camp for a day while this steep section of the road was opened for the army's passage. *Author photo.*

Opposite, bottom: The present site of the Davidson farm and the thirteenth encampment. The military road extended from the mid-foreground, on the north side of present River Avenue, past the vicinity of the shed, at right center, turning left at the houses in the tree line and moving over the elevation of the Narrows in center background. *Author photo.*

Connellsville's sewage disposal facility on the east. Gordon reported the road "uneven to the ford, the ford rough, the rest good."[267]

On the north side of the river, the quest would be the immediate gradual spur leading to the higher lands above the river. The road crossed Mounts Creek immediately east of its south verge mouth, at a horseshoe bend of the creek on the west side of Connellsville's sewage disposal complex. Crossing the area of the now abandoned railroad bridge and continuing up the spur and across the west end of River Avenue, the road followed the ridge contours, crossing the Narrows Road as it began to ascend the steep spur on a course now identified as Miner Drive. The track of the road from River Avenue to Miner Drive is still discernible through this area.

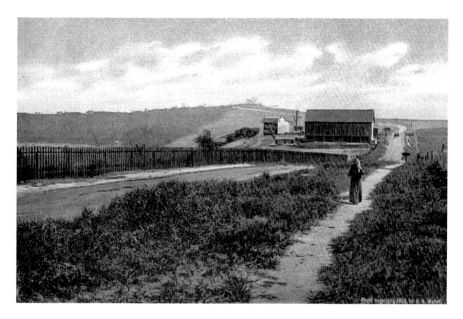

Braddock's Road north from Stewart's Crossings at present Connellsville, Pennsylvania, to the Narrows, as recorded by Lacock and Weller. The road can be seen continuing past the barn, turning left and ascending the elevation at the Narrows above the Youghiogheny River. The area at the time was known as Davidson for the farm and was the thirteenth encampment site of Braddock's army. Lacock and Weller, postcard No. 47, 1908. *Braddock's Road Preservation Association.*

Once on the north side of the river, the army went into camp, according to Orme, "about a mile on the west [east] side [of the river]."[268] The day's march, he said, "did not exceed two miles." Lacock placed the encampment at an indefinite location "a mile north of the mouth of Mounts Creek; but most probably it was on Davidson's land, southeast of the Narrows." Gist, who never used fractional miles on his map, placed the camp one mile "Over the River."[269] Engineer Gordon recorded a distance between his encampment at "Stewarts" to the "Main Crossing" camp at two miles.[270]

There is one location compatible with those distances from Stewart's Crossings encampment to Camp 13 that provides an acceptable area for the size of Braddock's army. It agrees with the position Gist marked on his map, between the Narrows and the prominent bend of Mounts Creek. This location apparently confused the unidentified British officer into believing that the Youghiogheny was on both sides of the army.[271]

The only level area suitable for an encampment site is about 0.74 mile north from the crossings' north bank in the vicinity and immediately north of present River Avenue, or about 1.48 miles from the twelfth encampment site south of the river.[272] The terrain for 0.6 of a mile north of this location, until the Narrows Road/Broad Ford Road fork is reached, is unsuitable for an encampment. This site is in agreement with Gist's listing a distance of 1 mile "Over the River," Gordon's listing of 2 miles between encampments and Orme's statement that the camp was about 1 mile on the east side of the river and that the day's march "did not exceed two miles." Gordon recorded "a steep Bank in the front of the Camp."[273] A steep ascending spur begins on the army's road on Miner Drive north of River Avenue, with the narrows of the Youghiogheny on the west side and the drop-off to Mounts Creek on the east.[274] The army, less its advance party, remained in Camp 13 through June 30.

Terrapin Creek

Camp 13 to Camp 14

After a halt in the "Over the River" (or "Main Crossing") camp, the army departed on July 1, continuing to follow the branch of the Catawba Path,[275] on what is now Miner Drive, for about 0.6 mile to the present Narrows Road (1033) junction with the Broad Ford Road. The Narrows Road follows the army road for about 1.59 miles northerly before the road turned to the north-northeast on what is now the Upper Tyrone/ Bullskin Township line. Leaving the Narrows Road, the path is clearly discernible, but abandoned, for about 0.22 mile where it was severed by a railroad. Continuing on the northeast side of the railroad, the path is now a restricted farm road for about 0.4 mile. On the north end of this farm road, Braddock's Road joins the maintained township road T762. It continued this course to the junction with the present Mount East Road at the northwest corner of a cemetery.[276] Mount East Road follows the army's route about 0.37 mile before the route left the maintained road and moved to the right, down into the Everson Valley.

Although the Catawba Path maintained for the most part the practice of following the heights, there was no way to avoid the crossing of the Everson Valley. However, the road crossed the present Everson Valley Road at the divide between a head branch moving north through Everson to Jacobs' Creek and the head branch of Irishman's Run flowing south to Mounts Creek.[277] Exiting the valley, the nearest spur of the elevated land was followed by the path/road, again to the heights for the remainder of the day's march. The road weaved along the present township line, south of the community

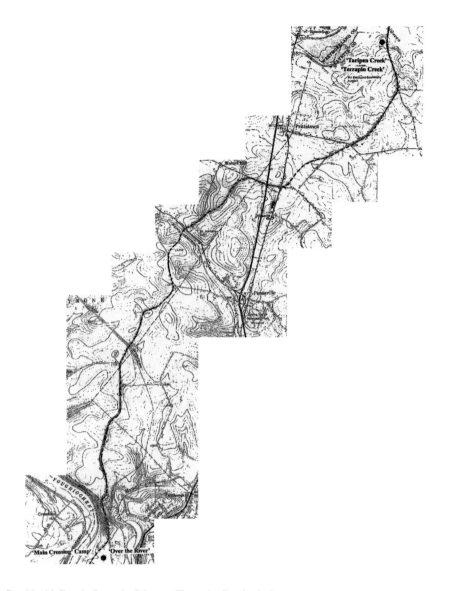

Braddock's Road: Over the River to Terrapin Creek. *Author map.*

of Walnut Hill, crossing to the east present Highway 119, until it reached the area south and southeast of the present community of Prittstown. Here, staying near the crest of the elevated land above the head branches, it turned more to the northeast and finally to the north a short distance south of "Taripen Creek" ("Terrapin Creek"), now known as Green Lick Run, and the next encampment on the south side of the creek.[278] Orme wrote that the

army "could advance no further by reason of a great swamp which required much work to make it passable."[279] The early abandoning in this region of sections of the army's Catawba Path road for more accessible routes and the intensive cultivation and development in the centuries past has all but eradicated most visible traces of the road, except where it is still in use.

Captain Cholmley's batman wrote that this day's march was through a "pleasant Cuntry";[280] the British officer, as aptly, described it as "a very long & high ridge."[281] There was a wide variance in the recorded estimates of the distance traveled between Camp 13 and Camp 14. Captain Orme put the distance at "about five miles,"[282] the batman recorded 9 miles[283] and the British officer wrote "8 or 9 mile."[284] Gist, intimately familiar with the area and the well-used path, recorded the distance at 7 miles.[285] The actual distance from Camp 13 to Terrapin Creek, by the plotted road, was about 7.63 miles. Again, some of the discrepancy in the officers' figures could probably, in the main, be attributed to a lack of familiarity with the country. Also, Braddock's army, as noted earlier, from the advance party to the rear guard, required a long column when marching and an extended area for encampment.[286]

Camp 14, in confusion, has over the years acquired several names. Halkett's Orderly Book incorrectly called it "Camp Near Jacobs Cabbin."[287] Lacock also incorrectly located the camp near Jacobs' Cabins.[288] Orme refers to the "great swamp."[289] This led to a historical marker at the site of the "Great Swamp Camp."[290] Gist on his map identifies the camp as "Taripen Creek," and engineer Gordon recorded it as such.

A corduroy road had to be built across the swamp on either side of the creek to enable the loaded wagons and cannons to be moved to the next encampment. Traces of this crossing of the swamp and creek were eradicated by the building of a dam for the present Green Lick reservoir, although what is probably a short stretch of the road is located on the east side of the north end of the road and the reservoir dam.

Some of the earliest settlements from the Youghiogheny to Terrapin Creek were made along or near Braddock's Road.[291] On the north bank of the Youghiogheny at Stewart's Crossings, including the area of the "Over the River" or "Main Passage" encampment, William Crawford was surveyed and granted three hundred acres on both sides of Mounts Creek in 1769.[292] Adjoining Crawford on the west, where the road ascended the spur toward the encampment, William McCormick, Crawford's son-in-law,[293] was granted eighty-five acres.[294] Abner Mounts, for whom Mounts Creek was named, was surveyed and granted a tract of land with Braddock's Road

extending north through the western end of his grant.[295] Adjoining Mounts on the north, William McKee was granted land on both sides of the road, where he settled in 1767.[296] Ann Connell also settled in 1767 on the land adjoining McKee on the north. Braddock's Road continued through her property, from about 2.6 miles north of Stewart's Crossings to about 3.26 miles north of the crossings on her north boundary.[297] This section of the road includes the portion where it leaves the present Narrows Road and turns to the northeast in a clearly defined abandoned segment that was severed by the present railroad at the beginning of the restricted farm lane mentioned earlier.

Braddock's Road, north of Ann Connell's land grant, followed by the present township road T762, ran in the vicinity of the boundary between the tracts granted to John Vance and William Boyd.[298] The road continued north along the western portion of a land grant to Edward Doyle on both sides of the Everson Valley as it approached the divide at the head branch of Irishman's Run, flowing southeast down the valley to Mounts Creek.[299] Crossing the valley, the road ascended and followed the ridge to the northwest along a boundary between a grant to Ann Stephenson on the northwest and Isaac Meason on the east, which extended to the community of Walnut Hill.[300] Moving through the present Prittstown area, the army's road, after leaving what was later the northern section of Isaac Meason's grant, continued through the lands that were later surveyed for William McMacken, John Henderson and Ann Fitzgerald, all in 1769.[301] For the remainder of its course through present Bullskin Township, including Camp 14 at Terrapin Creek (Green Lick Run), the road cut its way through lands that would be granted to the Meason family.

Bordering the northeastern boundaries of Henderson and Fitzgerald was a tract called Greenland, granted to Catherine Meason and reaching Jacobs' Creek on the west and the branches of Mounts Creek on the east. The army's road wound along the ridge in what was the eastern portion of the Greenland grant. The Mount Pleasant/Scottsdale Airport is located in the grant's western section.[302] John Meason took up the land above Catherine's northern lines, extending past Braddock's fourteenth encampment on the south side of Terrapin Creek to present Hammondville on the north, and from Jacobs' Creek on the west, on both sides of Green Lick Run, to the land of Hannah Meason on the head branches of Green Lick Run on the east. The army's road ran through the center of John Meason's tract.[303] Land on the northeastern boundary of Meason's tract was granted to Catherine Moore, a tract described as "on both sides of braddock's road Joining an

improvement made by Isa[a]c Mason [Meason] on the Waters of Jacob's creek." The southwestern corner of Moore's grant was a short distance west of the army's road. The grant extended eastward and northward across the road, still recognized as a landmark by the surveyor seventy-four years after the road was established.[304]

The final northern trace of the army's road in Fayette County ran through another tract granted to John Meason. Adjoining on the north his Green Lick tract, it extended from present Hammondville at its southeastern corner with Moore's land, north across Jacobs' Creek, including the present communities of Bridgeport and Buckeye in Westmoreland County. Diagonally across this tract, the army's road moved through the low areas surrounding Jacobs' Creek and the site of the army's fording of the creek.[305]

Jacobs' Cabins

Camp 14 to Camp 15

Afterwards laying a corduroy road over the swampy area of Terrapin Creek (Green Lick Run) and Jacobs' Creek, the army began its march almost directly north on July 2 toward its next encampment: Jacobs' Cabins. The site is believed to have been the part-time residence and hunting village of Captain Jacobs, the Delaware chief who was responsible for much bloodshed on the Pennsylvania frontiers.[306]

Orme stated that the army marched "about 6 miles" to "Jacob's Cabin" from the camp south of the swamp on Terrapin Creek.[307] Lacock believed, despite contradictory evidence, that there were two Jacobs' campsites and reached conflicting conclusions regarding the Terrapin Creek swamp camp, the distance traveled after leaving it and the actual site of the "Jacobs Cabbins" camp.[308] Halkett stated that the July 2 camp was "at Jacobs Cabbins."[309] The batman also recorded the distance "about 6 Miles," as did the British officer.[310] Cassell located the July 2 camp on the Sand Hill Road, about 1.4 miles north of the intersection of Main Street and Braddock Road Avenue in Mount Pleasant, or about 1.5 miles by Braddock's Road south of the actual Jacobs' Cabins site on the ridge north of Simpson Hollow.[311] Wallace located the site "five and a half miles, by the Braddock Road, from the crossing of Green Lick Run." He placed the site "on a gentle ridge just east of what was once Jacobs Swamp."[312] Steeley placed the Jacobs' Cabins site about half a mile southwest. Gist recorded 5 miles between the camps.[313] The distance, following the army's road, is 5.6 miles, or 5 direct-line miles.

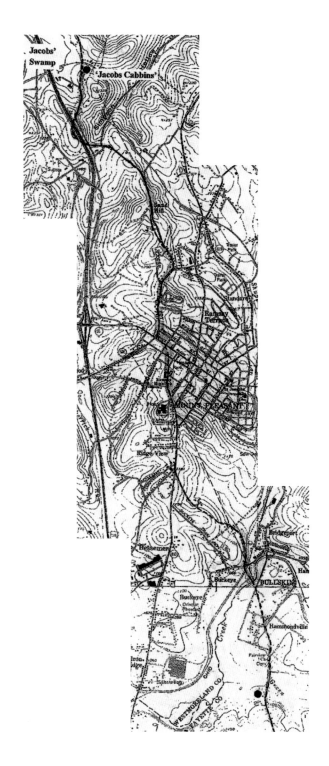

Braddock's Road:
Terrapin Creek
to Jacobs' Cabins.
Author map.

Leaving the Green Lick Run camp and keeping Jacobs' Creek and its swamps to the west, the road continued on the Catawba Path through present Hammondville until it reached a fording of Jacobs' Creek in the Bullskin community at the corner of the Huntingdon South township line at the "Braddock's Fording; thence along Braddock's Road to Mount Pleasant township line."[314] In this vicinity, the road left the Catawba Path and joined a branch of the Glades Path northward.[315]

On a north course, after fording Jacobs' Creek at the township corner, the road reached for the nearest elevation spur, roughly paralleling the Mount Pleasant township line, and at the crest of the elevation, it followed what is now Route 819 into Mount Pleasant on Eagle Street. Passing to the east of the present city hospital and Ramsey High School, the road would have held to a north course, keeping to the crest of the elevation of the ridge, leaving Eagle Street in the vicinity of Spring Street and joining Braddock Road Avenue at its intersection with West Main Street. It has been suggested that the road continued northeast on Eagle Street, to the end of that street, before turning northwest and joining Braddock Road Avenue, after passing through what is now a housing development and a cemetery.[316] Those developments have eradicated any possible evidence that this was the route. However, such a course would have required the unlikely and unnecessary brief loss and subsequent laborious reclaiming of elevation.

Following the course of the Braddock Road Avenue (Route 981), the army continued its north course to the present Sand Hill Road, which stayed with the crest of the ridge. About four hundred yards north on the Sand Hill Road, the course of the road is to the west of the present road for about five hundred yards. Reaching the head of Simpson Hollow, the road swung to the west briefly, staying with the elevation now crossed by Highway 119 before swinging back to the north and northeast, along the base of a small ridge on what is now West Technology Drive. The army had reached "Jacobs Cabbins" on the eastern edge of Jacobs' Swamp. On this ridge was the site of Jacobs' hunting camp, which locally is known as a former Indian occupation site where artifacts have been found.

There were nine land grants along Braddock's Road between Camp 14 on Green Lick Run and the site of Jacobs' Cabins at Camp 15, all on both sides of the military road.[317] They began with John Meason's grant, which included the site of Camp 14, and continued north through Catherine Moore's grant and the other John Meason grant at Braddock's Fording of Jacobs' Creek, from Fayette to Westmoreland County.[318] The first ridge followed by the army's road north of Jacobs' Creek was granted to Hugh

Bay.[319] The land encompassing the crest of the ridge and the course of the road along present Highway 819 past the hospital and Ramsey High School was granted to James Taylor.[320] After passing the present site of Ramsey High School, the road, continuing along the ridge, entered the land that was granted to John Niel/Adam Bratton on the west side of present Mount Pleasant. The road followed through this tract a course now recognized as Braddock Road Avenue, exiting the tract after reaching the present Sand Hill Road, which was the army's road through the grants of James Hamilton and John Nichols.[321] On the north boundary of the Nichols tract, George Swan applied for a grant of a tract of land in 1769. Swan's tract was at the head of Simpson Hollow, where the army's road swung to the west to stay with the high land and then back to the southeast of Jacobs' Swamp, cornering on the northeast with the ridge site of Jacobs' Cabins.[322]

Chapter 19

Lick Camp

Camp 15 to Camp 16

D eparting the Jacobs' Cabins hunting complex (Camp 15) on July 3, the army marched north, turning gradually to the northwest and west, keeping to the east and north and skirting the extended swampy area known as Jacobs' Swamp. The route followed the edge of this swamp about 0.96 mile before turning abruptly southwest for 330 yards (0.188 mile) and then back to the west into a valley at the head of Belson Run. The former swamp is now a heavy industrial area that begins at the western base of the small ridge at "Jacobs Cabbins" and extends to the west, beyond Highway 119.

The road continued west of Highway 119 and is buried under the industrial complex and the highway going through the area. Jacobs' Swamp is still remembered by the local residents and pointed out as the area that was drained and filled in for the construction of the Sony plant, south across the industrial highway and the path of Braddock's Road, from the American Video Glass company plant.

Braddock's Road from Jacobs' Cabins, north and west around Jacobs' Swamp to the head of Belson Run, is one of the best-documented sections of the road, as recorded by the early surveyors of the land grants in the area.[323] In pursuance of an order in 1769, a survey was made of Braddock's Road for one and a half miles, from "Jacobs Hunting Cabbin" to a spring at the head of Belson Run Valley. It depicts the road from Jacobs' Cabins circling around Jacobs' Swamp and into the valley of the run, citing courses and distances.[324] Separate land grant surveys confirm and refine the courses of the surveyed army road. After leaving the Jacobs' Cabins site, the road

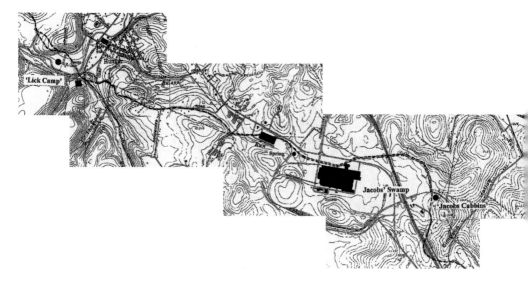

Braddock's Road: Jacobs' Cabins to Salt Lick. *Author map.*

was also surveyed as a boundary for individual land grants. One survey shows the army's road on the northeast side of Jacobs' Swamp, immediately north of Jacobs' Cabins.[325] In another survey, almost three hundred acres of the Jacobs' Swamp area was granted to Thomas Bradford, with the survey depicting "Braddocks road" on the tract's northern boundary, on the north side of the swamp.[326]

The survey for a tract of land on the west side of Jacobs' Swamp, at the head of the Belson Run Valley, illustrates the army's road extending from Thomas Bradford's northwest corner, north of the swamp and down (west) into the valley through a land survey for James McKee/David Sample.[327] One survey referred to a tract of land immediately north of Braddock's Road and Jacobs' Cabins as "North from Jacobs fort."[328] Scars of two small stretches of a road, often cited as parts of Braddock's Road west of the American Video Glass Company, on each side of the present Central Road[329] are not confirmed as part of the army's road by the land grant surveys. The scars of this road form a radical jog northwestward from the depicted western course of Braddock's Road and represent part of the northeast boundary of the large grant surveyed in 1769 for McKee/Sample.[330] Indicated is a decades-later fork of a road along the tract boundary, leading to a north-bearing route now followed by Central Road.

Reaching the head of the Belson Run Valley, Braddock's Road followed close to the path of the present State Route 3093 (Old 119) west by northwest,

Braddock's Lane: Once known as "Braddock's Lane," this section of the road is now called Sand Works Road—here looking west toward Preacher Street, toward Sewickley Creek and Lick Camp. *Author photo.*

before crossing the run, about 2.2 miles from Jacobs' Cabins and ascending a small ridge to Sand Works Road (earlier known as Braddock's Lane). The army's road, along the present Sand Works Road, would be followed closely by the north boundary of a land grant to John Wyand.[331] Crossing Belson Run to the top of the ridge, the road, after about 1,500 yards (0.85 mile), becomes Preacher Street. Eventually relegated to a farm lane, the road continues as Preacher Street for about 900 yards (0.51 mile), where it crosses Walnut Street as it goes through the Watkiss-Truzzie-Strosko farm south of Hunker, Pennsylvania. Preacher Street became the boundary between the land grants of Jacob Leightly on the north side and Robert McCandlesh on the south side.[332] Impressive scars of the road remain on the farm. Beneath the farm at Walnut Street is an abandoned coal mine that was extended under Braddock's Road.

Weaving down off the ridge, the military road crossed and continued to the mouth of Lick Run, now known as Buffalo Run, near its mouth on Sewickley Creek, after about another 650 yards (0.37 mile). The route is now

crossed by a railroad and State Road 3039 at a liquefied gas trucking facility. This section of the road became the boundary between the north end of Robert McCandlesh's grant and the grant to John Goudy (Gaudy) on the banks of Sewickley Creek, including the mouths of Lick Run (Buffalo Run) and Belson Run.[333] The road forded the creek near the mouth of Lick Run. The crossing later became known as "Goudy's Fording."[334] On the north bank of Sewickley Creek, Braddock's army made Camp 16, called "Lick Camp" by Gist,[335] "Salt Lick" by Gordon,[336] "Lick Creek" by the British officer[337] and "Camp at the Deers lick" in Halkett's Orderly Book.[338] Orme identified the campsite as "Salt Lick Creek" and "Salt Lick Camp."[339] The British officer noted that "Lick Creek" took its name from "a lick being there, where Deer, Buffaloes & Bears come to lick ye Salt out of ye Swamp." A large, swampy salt lick area of Sewickley Creek extends for a distance immediately to the west of the mouth of Buffalo/Lick Run.

Camp 16 was four miles from Jacobs' Cabins by Braddock's Road. The British officer and Cholmley's batman estimated five miles,[340] while Orme

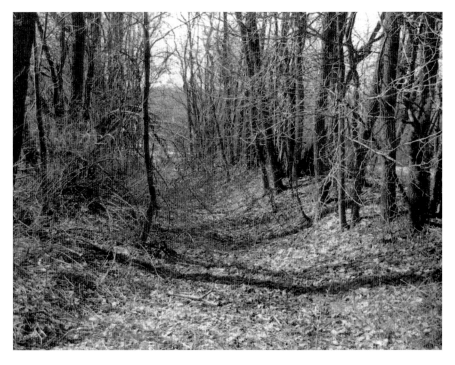

Jacobs' Cabins to Lick Camp: Above the east bank of Lick Run, south of Hunker, Pennsylvania, the army road approaches Lick Camp on Sewickley Creek. *Author photo.*

recorded a confusing estimate of six miles.[341] Gist, familiar with the path, placed the distance more precisely at four miles. Gist's map depicts the route of the road approaching Sewickley Creek between two runs, those now known as Belson Run on the east and Buffalo Run (Lick Run) on the west, swinging abruptly to the left and crossing Buffalo Run shortly before it flows into Sewickley Creek and then crossing the creek immediately below the mouth of Buffalo Run.[342] The fording site was selected as a major point of reference for the later establishment of township lines. The site of Camp 16 became a part of a land grant to Theophilus Drinker, with "Braddocks road" depicted extending from the fording across his tract to the northwest.[343] The encampment area is now occupied by the water treatment plant and a storage facility for the Hunker community.

Lacock, citing "local tradition," supported the location of the Lick Camp on Belson Run, about 1.78 miles east of the "Lick Creek" campsite at the mouth of present Buffalo Run.[344] This undoubtedly led to the incorrect

Ford at Sewickley Creek. Later known as "Goudy's Fording," the army crossed here below the mouth of Lick Run (now Buffalo Run), in the foreground. Lick Camp (the sixteenth) was immediately across the ford, right center, and a salt marsh was a short distance beyond the ford. *Author photo.*

location of the camp historical marker on Route 3093, southeast of Hunker.[345] Wallace concluded that the Lick Camp site was on the edge of the "salt swamp" on Sewickley Creek.[346] Steeley, although using Orme's inflated distance of 6 miles between the camp at "Jacobs Cabbins" and the "Lick Camp," has agreed that the Lick Camp site should be on Sewickley Creek near the salt marsh.[347]

At the encampment, a council of war rejected Sir John St. Clair's proposal to bring forward Colonel Dunbar's detachment, mainly because it would force too great a delay in the expedition, allowing the French to better prepare for Braddock's army.

Hillside Camp

Camp 16 to Camp 17

Leaving Lick Camp on the north side of Sewickley Creek the morning of July 4, Braddock's army marched north by northwest above and along what is now the Penn-Valley Road. This road ends and is severed at Interstate 70, but its original course can be traced to the north side of Interstate 70, where it is becomes Fox School Road (SR 3076). Continuing north on this road, past the intersection with the Hunker-Waltz Mill Road (SR 3014), at a car auction complex, where it is identified as Wagner Road (SR 3075), Braddock's Road reached a major branch or run of Sewickley Creek, known as Thickett or Thicketty Run, two miles from the Lick Camp on Sewickley Creek.

About 160 yards before reaching the run, the present road separates—with Wagner Road continuing to the right and across the run, while Braddock's Road continued straight ahead to cross the run—but it is now abandoned and the course blocked by a residential garage. The abandoned section can be traced to the west side of the run, where it connects with the Moore's Grove Road. About 470 yards from the run and about 2.5 miles from Camp 16, on the left side of the road, was located until the winter of 2009–10 a historical marker incorrectly designating the site as the location of Camp 17. Halkett's Orderly Book on July 4 identified the camp "at The Thickett Run." However, the next day, while still encamped, it was referred to as the camp "Near the Thicket Run."[348]

Braddock's Road continued about seven hundred yards along present Moore's Grove Road beyond the run before turning off to the right and,

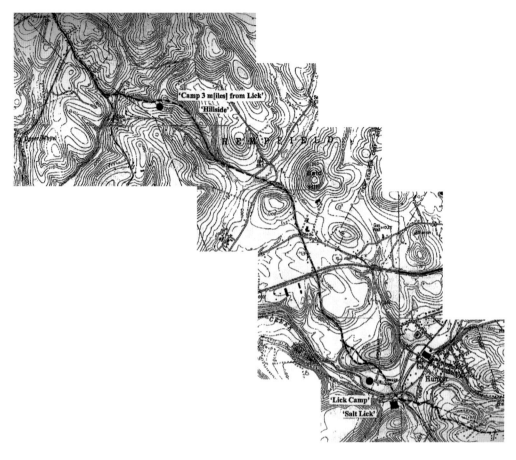

Braddock's Road: Lick Camp to Hillside Camp. *Author map.*

in a familiar practice, beginning the ascent of a finger, or spur of a ridge. To have continued along the course of Moore's Grove Road would have subjected the army to a steep, difficult defile passage along a stream branch over the ridge and down into another branch in a small walled-in valley. The abandoned but prominent scar of the army's road reached the top of the level, well-drained ridge at almost exactly three miles from Lick Camp (Camp 16), the distance recorded by Gist.[349] Orme, Cholmley's batman and the British officer, unlike Gist and again unfamiliar with the region and the Indian path they were following, greatly overestimated the distance at six miles from Lick Camp.[350] Gist, however, referred to the site as number 17, the "Camp 3 m[iles] from Lick." Gordon applied a more descriptive and appropriate title: "Hillside."[351] Gist's distance of three miles, assuming a

Thicketty Run to Hillside Camp: After crossing the run, the army ascended a spur of this ridge to its crest and the Hillside Camp (the seventeeth). *Author photo.*

minor margin of error, places the camp one mile northwest of the crossing of Thickett or Thicketty Run.[352] Gist's map places the camp between two head branches of Sewickley Creek, near the northernmost branch.[353] Such a branch is located near the northwest side of the campsite, where a land grant was later issued to Nehemiah Stokely.[354] Lacock was not precise about where he thought the camp was located, except to say that it was about a mile southeast of "old Madison," the approximate distance from present-day Madison.[355] Wallace and Steeley also made no attempt to locate the site of the camp or trace the route.[356]

Lands surveyed and granted along Braddock's Road from Lick Camp to the ridge or "Hillside" camp began with Theophilus Drinker's grant on the north side of Sewickley Creek at the salt lick, where the road crossed the creek.[357] It continued north by northwest along the west boundary of a grant to Daniel Mathias that extended north of present Interstate 70[358] before swinging northwest at Bald Hill and crossing the first of the two northeast branches of Sewickley Creek, where later a land grant would be surveyed for George Armstrong and Jacob Painter.[359] At the south corner of a grant

to George Mathias,[360] the army's road left the present Moore's Grove Road and ascended the ridge along the southwest boundary of Mathias's grant to the crest of the ridge and the "Hillside" Camp 17.

Gist and two of the Indian guides left this camp on July 4 on separate missions for a reconnaissance of Fort Duquesne, which was about 26.87 miles by the road from the camp. The troops enjoyed a welcome change in their diet when provisions, including one hundred oxen and a large quantity of flour from Colonel Dunbar's command, arrived on the second day. The army remained in camp through July 5, resuming its march the following day.

Monacatootha Camp

Camp 17 to Camp 18

O n Sunday morning, July 6, Braddock's army resumed its march northward, departing the two-day halting camp on the wide, pleasant ridge above a northeast branch of Sewickley Creek and a spring, about one mile north of the branch known as Thickett or Thicketty Run. The route swung west, off the ridge, leaving its scar and crossing to the northwest the narrow valley and branch flowing southwest to the present community of Lower Whyel. The road joined the present Waltz Mill Road, which becomes the Main Street road northwest through the present town of Madison. Main Street follows the route through the town to the Hill Top Church about 1.63 miles from the site of Camp 17. Fourteen years after the passage of the army, Gustavus Gregory applied for a grant in 1769 encompassing the area "on both sides of Braddock road."[361]

During the morning, the two Indian guides rejoined the army, followed a short time later by Christopher Gist. The Indians returned with a French scalp taken near Fort Duquesne. Gist had traveled to within half a mile of the fort and had to make a hurried escape from pursuing French Indians. Both parties reported no unusual activities at the fort nor perceived any preparations for defense against Braddock's approaching expedition.

At about eleven o'clock in the morning, French Indians attacked the baggage train at the rear of the march, scalping a soldier and a woman tending the general's cows. Another soldier was wounded, and the Indians attacked and began to scalp another soldier before the rear guard came to his relief. At about one o'clock in the afternoon, the marching column

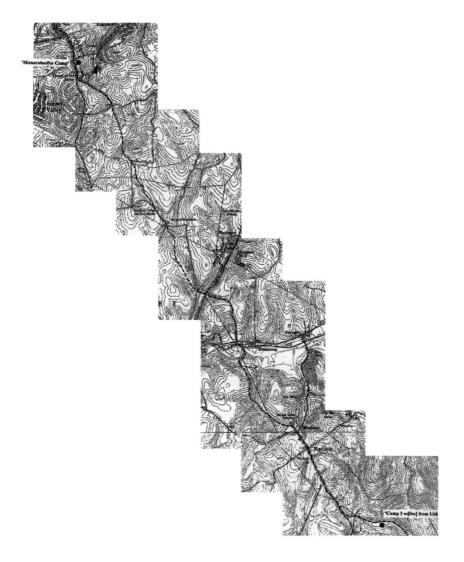

Braddock's Road: Hillside Camp to Monacatootha Camp. *Author map.*

encountered another party of Indians and fired on them. The British Indian guides, coming to the assistance of the soldiers, were fired on by the British soldiers, the soldiers thinking that they were French Indians. Even though they grounded their arms and held aloft a bough, according to prearranged rules of engagement, one of the Indians was killed and two wounded.[362] The slain Indian was the son of the chief Monacatootha.[363] His body was placed in a wagon and was buried at the next campsite with military honors.

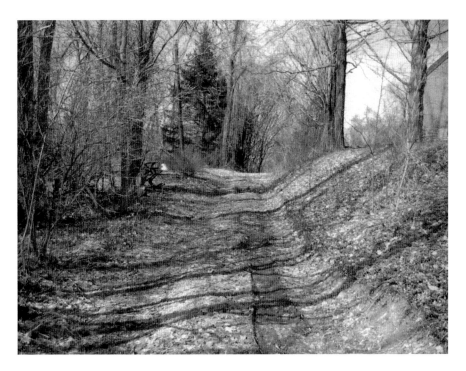

Thicketty Run to Monacatootha Camp: At the north side of present Madison, Pennsylvania, the army road ascended the nearest ridge spur alongside the Hill Top Church (right) on the way to present Evanstown and beyond to Monacatootha Camp. *Author photo.*

At the north end of the town of Madison's Main Street, the army climbed the gentle grade of a ridge spur and turned, first west, at the present Hill Top Church, then northwest and north over an abandoned but discernible section of the army's route. Continuing north about 1.66 miles from the church, the road connected with the present Evanstown Road in the community of Evanstown, crossing Little Sewickley Creek to present Buffalo Hill Road. Based on the distance traveled on this day's march and the times of the Indian attacks, the first attack probably occurred on the now abandoned section of the road on the ridge between the Hill Top Church and its connection with the present Evanstown Road and the second about two to three miles from the next encampment.

The army's road stayed with the course of the Buffalo Hill Road over a ridge and down a hollow until it reached Andrews Run branch of Little Sewickley, at a corner of the present township line between Sewickley and Hempfield. The killing of Monacatootha's son probably took place along this stretch of road.

After fording the run, the trail left the present Wallace Run Road ("General Braddock Road") and moved to the left and north by northwest, up a spur of a broad level ridge to its crest. On the north end of the ridge, the road descended into a small valley of a run before it ascended a spur of the next ridge and connected briefly with the present Reservoir Road ("General Braddock Road"). Near the trail's junction with the present road is a historical marker designating it as the site of Camp 18, Monacatootha's Camp. Leaving the present road a short distance northwest of the marker and continuing northwest, Braddock's trace intersected the present Ipnar Road north of the township line between Sewickley and North Huntingdon, where the Ipnar Road makes a ninety-degree swing to the east. Braddock's route swung at this point to the northwest down the side of a steep wooded hill, crossed a small run and began the ascent north up the following ridge. A decade ago, the trace of the road was discernible through the farmland that occupied this area. The area is now a large housing development, but traces of the road can still be found in the trees on the side of the steep wooded hill prior to reaching the housing development. Through the development, the military road ascended the next ridge in front of the present old barn and farmhouse.

At the crest of the ridge on the north edge of the development, the road is now preserved by present Fairview Drive, which continued the course of the army's road to Clay Pike Road, following it a short distance north to Camp 18, Monacatootha's Camp. The encampment site is on the crest of the ridge near the intersection of Clay Pike Road with the Guffey Road/Main Street in the community of Cereal. Orme agreed with Gist on the name for the camp, calling it "Monakatuca Camp," while Gordon preferred to identify it as the "Ridge Camp."

The encampment site is 6.97 army road miles (6.4 direct-line miles) from Camp 17. Gist, Orme and the British officer estimated the distance at 6 miles. Gist's and Gordon's maps agree on the location of this encampment.[364] It is about 2 direct-line miles north of the incorrectly located historical marker for the camp on Reservoir Road. At the encampment on the ridge, in present Cereal, surrounded by three springs, Monacatootha's son was buried with honor.[365]

Chapter 22

Blunder Camp

Camp 18 to Camp 19

The advance elements of Braddock's army began the march from the Monacatootha Camp, or Ridge Camp, on the morning of July 7. Captain Orme recorded that a decision was made to leave the Indian path they had been following in order to cross Turtle Creek in an attempt to avoid a dangerous passage through the narrows of the Monongahela. It was quickly learned that this was a tactical mistake. Orme wrote, "We were led to a precipice which was impossible to descend."[366]

In the advance party, Cholmley's batman wrote that, after a march of two miles from Monacatootha Camp, his captain's detachment encamped near Turtle Creek.[367] Gist confirmed the two miles between the two camps, as well as confirming and illuminating the locations of the two camps. He placed the site of Camp 19 on the south bank of Brush Creek, a major east branch of Turtle Creek that apparently at the time may have been considered the main bed of Turtle Creek. A north branch of the creek is now identified as the primary waterway. Gist located the camp between two branches flowing into Brush Creek from the south.

Exactly two miles north from the Monacatootha Camp is a sharply elevated spur between Tinker Run on the east and another run on the west, forming a precipice too steep for wagons and cannons. The site is now in the community of Browntown, with the community of Larimer to the north, across the latter run, and Jacktown to the south.[368] Gist called the encampment the "Blunder Camp." Gordon simply identified it as "Turtle Creek." Halkett's Orderly Book identified the encampment as the "Camp on the East side of Turtle

Blunder Camp (the nineteenth) was located in the vicinity of this Browntown, Pennsylvania neighborhood on Northeast Drive, above the Brush Creek branch of Turtle Creek in the center background. *Author photo.*

Creek."[369] Lacock, not specific, wrote only that the camp was somewhere in the neighborhood of the present communities of Circleville and Stewartsville.[370] The camp was reached by staying with the ridge and marching through the area of Circleville, midway between the two camps. Stewartsville is about a mile northwest of Circleville, both on Highway 30. Gordon, on his map, agreed with Gist on the camp's location on a ridge on the south side of Turtle (Brush) Creek. In the abstract of his journal accompanying his map, he wrote that the army "turned off the Indian path to avoid Long Run" (i.e., the Indian path by way of the Monongahela).[371]

Circleville is the site of the incorrectly identified and located "Three Springs Camp" historical marker.[372] The three springs surrounding Monacatootha Camp to the south of Circleville are probably responsible for this identification, as well as the incorrect location site of the Blunder Camp: one, the headspring of the north branch of Little Sewickley Creek, on the southwest of Monacatootha Camp; another, east-northeast of the camp, a headspring of Tinker Run; and the third, north of the Monacatootha

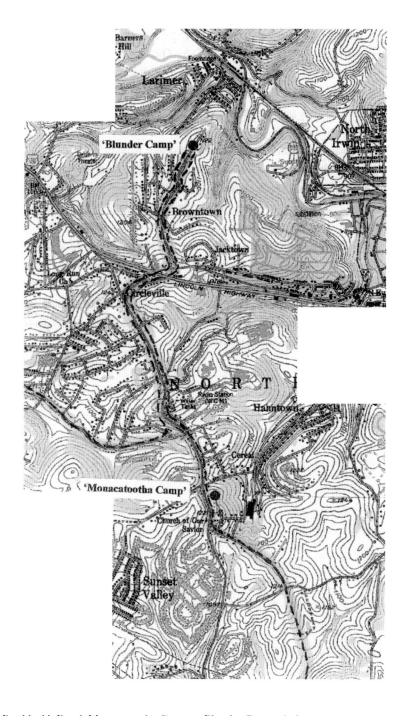

Braddock's Road: Monacatootha Camp to Blunder Camp. *Author map.*

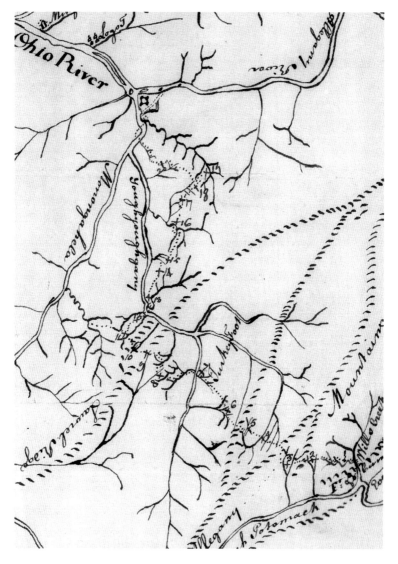

Detail of Gist's map depicting Braddock's Road (dotted line) between Camps 18 (Monacatootha), 19 (Blunder) and 20 (Head of Sugar Creek). Fort Duquesne is visible at top left. Note the route's similarity with the "Indian Map." *John Carter Brown Library.*

Camp, a headspring of the head branch of Long Run. The latter Long Run headspring is near the intersection of McKee Road, Clay Pike Road and what remains of the "3 Springs Road," on the north side of Monacatootha Camp and three-fourths of a mile south of the center of Circleville.

Gist, as the only journalist to identify the Brush Creek halt as the "Blunder Camp," without placing blame, nevertheless thought it was a mistake that should not have been made. The unidentified British officer, on the other hand, blamed the guides (such as Gist, Monacatootha and members of the guide party): "the Guides having lost their Way; we kept to ye right of ye Old Indian path to avoid some bad Swamps which put the Guides entirely out."[373] A map, based on information supplied by "an Indian,"[374] also asserts that Gist and the guides lost their way. Identified as *Copy of a Sketch of the Monongahela with the field of Battle Done by an Indian*, the map shows the "Rout[e] of the Army" to a point "Where the Guides lost their road." From that point, the map shows a path to and across Turtle (Brush) Creek, along a ridge that continued to the west of "4 Mile Run" on a route to "Fort Du Quesne," a route described as the "Ridge proposed by C. Guest and Indians for the army to march on but not followed." The map illustrates the path finally followed by the army, retracing its route to the original Indian path and down Long Run, to and over the crossings of the Monongahela to the battle site. The document includes the notation on an elevation above the battle site: "Hill the enemy took possession soon after the beginning of the Engagement." Finally, in an illustration that only an engineer or skilled draftsman could have completed, Fort Duquesne is depicted at the Forks of the Ohio, accurately drawn and properly shadowed, showing the inner four-bastioned fort with outer breastworks on the land side.

Gist was familiar with both the more northern ridge route and the Monongahela narrows path. On the last day of October 1750, he began his first mission to explore the Ohio country, leaving Colonel Thomas Cresap's settlement at the Shawnee Old Town.[375] Reaching the Juniata, he turned westward, following the Indian and traders' path over the mountains to the Forks of the Ohio, a path that would be closely followed eight years later by General Forbes in his expedition against Fort Duquesne. This path followed the ridge in the vicinity of Turtle Creek to the Forks of the Ohio that Braddock's army was seeking beyond Blunder Camp. At the time of Braddock's expedition, the major path that followed from Virginia and western Maryland to the Forks of the Ohio was the route that passed the narrows of the Monongahela. It was beside this path that John Frazier established his new trading post after being ousted by the French from the Allegheny River at present Franklin, Pennsylvania. It was this path that Washington and Gist followed on their mission to Fort LeBoeuf in 1753. Just a few days earlier, Gist and the British Indians followed this path to the vicinity of Fort Duquesne on their reconnaissance missions.[376]

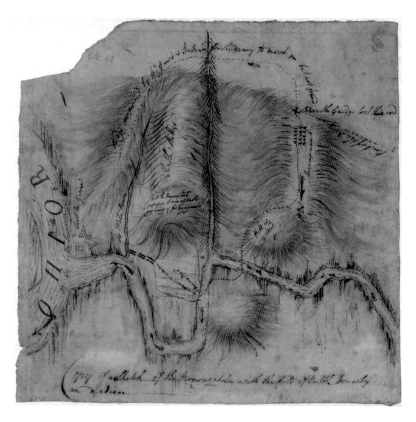

Copy of a Sketch of the Monongahela with the Field of Battle Done by (Direction of) an Indian, circa 1750s. *Library of Congress.*

It is difficult to believe that Gist and Monacatootha, both of whom had a working familiarity with the Monongahela narrows trail, lost their way. The Indian path followed the most direct route to the Forks of the Ohio, passing Frazier's abandoned trading post settlement alongside the trail. Rather, the bungled attempt apparently resulted from the army's decision to forego the well-established Indian path to avoid the passage of the Monongahela narrows, as acknowledged by Orme and Gordon.[377] Rather than losing their way, the guides, at the direction of the army, abandoned the Indian trail and attempted to take the expedition to the Turtle Creek ridge path over an unfamiliar, or nonexistent, route found not feasible for transport of the army. It was on the advice of the guides that the army retraced its course and returned to the Indian path on the next day's march.

Sugar Creek Camp

Camp 19 to Camp 20

Returning to the Indian path, the Glades Path, which led to the Forks of the Ohio,[378] Braddock's army left the Blunder Camp on the south bank of Brush Creek on July 8 and marched toward the Monongahela. The troops retraced their path south along the ridge through present Circleville until they reached the Indian path about six hundred yards north of the site of Monacatootha Camp, where they turned westward.[379]

Among the more notable features of the map prepared by Gist was his depiction of the sites and route between Monacatootha Camp and Blunder Camp. He placed the former camp between the head of the north branch of Little Sewickley Creek and the head of Tinker Run in the present community of Cereal. Blunder Camp, as previously noted, was positioned between the mouth of Tinker Run on Brush Creek and the branch at Larimer. While all previous writers have proposed that the army marched from Camp 19 (Blunder Camp) directly westward toward Stewartsville before making a full left turn and eventually reaching and following the valley of Long Run, Gist's map presents an entirely different picture. Sargent concluded that Braddock marched through Stewartsville before turning into the valley of Long Run.[380] Lacock said that at or near Stewartsville, the route took an almost ninety-degree turn until, about half a mile east of the line between Allegheny and Westmoreland Counties, it reached the Long Run Valley.[381] Steeley, on a map of the route and a proposed Blunder Camp site between Stewartsville and Larimer, also depicts the route going through Stewartsville and to the southwest toward Long Run.[382] Gordon continued the practice of straight-lining the route.[383]

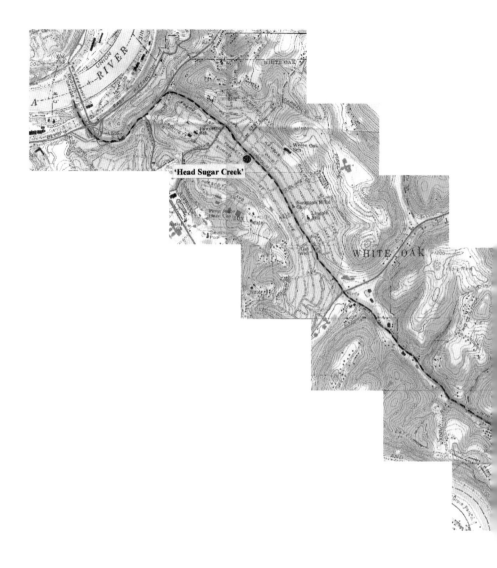

Braddock's Road: Blunder Camp to Head Sugar Creek. *Author map.*

Returning to the Indian path, Gist's "pipp'd" (dotted) route distinctly illustrates a route from Monacatootha Camp to Blunder Camp, returning back south to the vicinity of Monacatootha Camp and turning to the west, south of the head of a branch flowing north into the Brush Creek branch of Turtle Creek and the north side of a headspring of the northernmost branch of Little Sewickley Creek, toward Long Run.[384] About six hundred

148

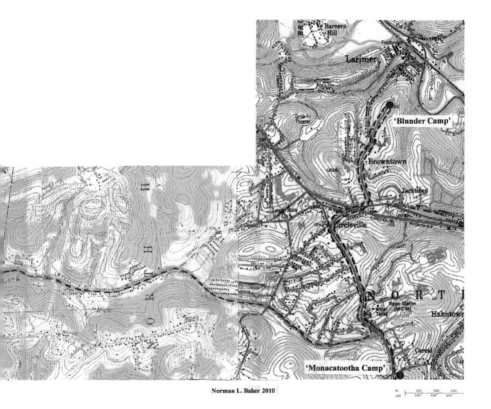

Norman L. Baker 2010

yards north of the Monacatootha Camp site is the intersection of McKee Road and the 3 Springs Road with the Clay Pike Road, on the north side of a headspring of Long Run, one of the three springs that bracketed Monacatootha Camp. The route, which is probably the Glades Path that was followed after leaving Jacobs' Creek,[385] continues westward through present housing developments in the Long Run Valley.

Orme reported that on the morning of July 8, the army marched "about eight miles to the camp near the Monongahela."[386] Cholmley's batman

stated that his captain's unit marched seven miles before moving farther with the advance party to cover the working party.[387] The British officer did not record the distance of his march but noted that his unit had to pass through "a hollow Way," which was only about fifty yards wide for about three miles, where the flanks were reinforced to prevent a

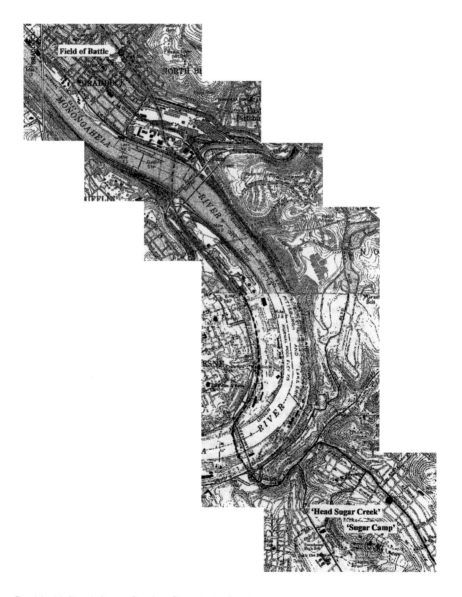

Braddock's Road: Sugar Creek to Braddock's Field. *Author map.*

possible ambush.[388] Engineer Gordon said that the army had to cross Long Run several times in the space of two miles,[389] where "we came along a Narrow Valley At the widest a Quarter of a Mile, very much Commanded on Both Sides by Steep hills."[390] This is the canyon along Long Run southeast of the crossing of the present Lincoln Way highway with Route 48 at White Oak, southeast of McKeesport.

Gist listed 8 miles between Camp 19 and Camp 20 at the head of Sugar Creek.[391] Actual computed distance is 7.78 miles—1.93 miles from Blunder Camp to McKee Road at Clay Pike Road, 600 yards north of Monacatootha Camp and 5.85 miles from the McKee Road/3 Springs Road/Clay Pike Road intersection to the camp at the "head of Sugar Creek" in White Oak. Lacock called the encampment "Monongahela Camp." A historical marker for the site was originally located at the intersection of Foster Road and Lincoln Way.[392]

The following morning, Braddock's army marched 4.3 miles (Gist put it at 5 miles) to the mouth of Turtle Creek on the Monongahela. The army forded the Monongahela at the mouth of Crooked Run and marched on the river's west bank downstream to a second fording at the west side of the mouth of Turtle Creek. About a mile from the creek's mouth, the advance of Braddock's army met the enemy. Chaotic confusion, staggering death and massive destruction of the army followed, just a few miles short of the expedition's goal.[393]

Notes

CHAPTER 1

1. Donehoo, *History of the Indian Villages*, 248.
2. The traders' path left Winchester northwest through the present community of Albin and the Indian Hollow Road to Route 522, through present Gainesboro and Cross Junction, continuing northwest through present Whitacre and over the gap of Bear Garden Mountain in present West Virginia. Following Bloomery Run to the Forks of Cacapon, over Sidling Hill and Spring Gap Mountain, it followed the Little Cacapon River to a crossing of the Potomac, finally turning west to Oldtown near the forks of the North Branch and South Branch of the Potomac.
3. Johnson, *James Patton*, 128.
4. Darlington, *Christopher Gist's Journals*, 67.
5. Johnson, *James Patton*, 128.
6. Gist, citing the gap the "Traders commonly pass thro," was probably referring to the south branch of the traders' path from Oldtown and Virginia that bypassed the mouth of Will's Creek and reached Braddock Run west of Will's Mountain, the route traveled by Colonel Patton.
7. Darlington, *Christopher Gist's Journals*, 68, 137.
8. Ibid.
9. At the crossing of the present Green Lantern Road of the route of Braddock's Road, the National Road and Interstate 68.
10. Darlington, *Christopher Gist's Journals*, 138.
11. Ibid., 69, 138–39.
12. Ibid., 70. Veech, in *Monongahela of Old*, stated that "in early times" it was known as Nemacolin's Creek, 26–27.

13. Although Veech noted that Nemacolin's camp was at the mouth of Redstone Creek, Gist's journal located Nemacolin's camp about eight miles south by southeast of the mouth of Redstone Creek.

14. "The Cavity in a Rock," six miles south of Brownsville. Darlington, *Christopher Gist's Journals*, 71, 141.

15. South of McKeesport, Allegheny County.

16. Darlington, *Christopher Gist's Journals*, 79.

17. Mulkearn, *George Mercer Papers*, 147; Darlington, *Christopher Gist's Journals*, 236; Powell, *Forgotten Heroes*, 25. See also note 36.

18. Jacob, *Biographical Sketch*, 29–45, 140. Darlington credited Jacob for naming Nemacolin as the principal of the Indians employed by Gist and Cresap for marking and clearing the road. Jacob married the widow of Michael Cresap, Colonel Thomas Cresap's son.

19. Powell, *Forgotten Heroes*, 25.

20. Veech was one of earliest supporters of the Nemacolin tradition. He opined that the credit for the early paths or trails were often stolen: "The white traders adopted them, and often stole their names, to be in turn surrendered to the leader of some Anglo-Saxon army, and finally obliterated by some costly highway of travel and commerce. They are now almost wholly effaced and forgotten." Veech, *Monongahela of Old*, 26–27. See also Wallace, *Indian Paths*, 435, with present Brownsville identified as site of Nemacolin's village, which is in conflict with Gist's visit with Nemacolin about six miles from the Monongahela and about eight miles from Brownsville, see note 13.

21. Dunlap's Path, extending from Winchester to Will's Creek to the Monongahela, descended the Chestnut Ridge from the vicinity of the present community of Summit on the National Road, joining the Lick Creek branch of Redstone Creek before continuing through present Uniontown. Colonel James Burd, on his expedition to the mouth of Redstone in 1759, related in his journal that he encountered "the path to Dunlap's place," a path he said was about a quarter mile from the "Big Rock" (Half King's Rocks, Great Rock, Rock Camp). Veech dichotomously acknowledged that Dunlap's Path was originally an Indian trail and Dunlap's trading path before the Ohio Company sought to use the passage, while insisting on identifying Nemacolin as the "engineer" of the path for the company. The trader Dunlap was located near the mouth of Dunlap's Creek, on the Burnt Cabin fork of the creek, Veech, *Monongahela of Old*, 26–27 and 27, note "e." Gist, in 1751, as noted, visited Nemacolin's camp on Dunlap's Creek, several miles from its mouth on the Monongahela. See note 13.

22. Darlington, *Christopher Gist's Journals*, 80.

23. Also called the Catawba War Path and Catawba Trail. Donehoo, *History of the Indian Villages*, 20–21; Wallace, *Indian Paths*, 436. John McGrain, in "Wagon Roads of Western Maryland," related that Mason and Dixon stopped surveying the line on October 9, 1767, at the war path when Indian leaders threatened them not to go beyond the path. At the time, they were about two miles west of the Monongahela River and immediately east of Dunkard Creek. This is in the vicinity of Crooked Run, which flows east into the Monongahela, and the

community of Rosedale, Greene County, Pennsylvania, about five miles west of the mouth of Grassy Run on the Cheat River.

24. Wallace, *Indian Paths*, 436.

25. On November 19, 1753. Darlington, *Christopher Gist's Journals*, 80.

26. A favorite path of the Pennsylvania traders.

27. Washington and Gist camped at the site on November 20, 1753, during their trip to the French.

28. Fitzpatrick, *Diaries of George Washington*, 1:44.

29. Ibid., 67; Darlington, *Christopher Gist's Journals*, 86–87.

30. Ensign Ward's deposition, in Darlington, *Christopher Gist's Journals*, 275–78.

31. Fitzpatrick, *Diaries*, 1:73–75; Baker, *French & Indian War*, 6. Ward stated that he "had the last Gate of the Stockade Fort erected before the French appeared to him." Darlington, *Christopher Gist's Journals*, 276–78.

32. Fitzpatrick, *Diaries*, 1:76–77; Baker, *French & Indian War*, 6.

33. Fitzpatrick, *Diaries*, 1:82–85; Baker, *French & Indian War*, 7

34. Baker, *French & Indian War*, 7; Fitzpatrick, *Diaries*, 1:102.

35. Confronting the soldiers was a very steep ascent on the western slope of Chestnut Ridge to its crest, then a steep descent down the eastern slope to Fort Necessity.

36. Fitzpatrick, *Diaries*, 1:102; Baker, *French & Indian War*, 8.

37. On August 2, 1758, Washington, in defense of his proposal that the Braddock's Road would be the better road for General Forbes's army, wrote that several years earlier "several of the most intelligent Indians" declared that the path leading from Will's Creek "was infinitely preferable" as a traders' path. "Therefore, the Ohio Company, in 1753, at considerable expense, opened the road. In 1754 the troops, whom I had the honor to command, greatly repaired it, as far as Gist's plantation; and, in 1755, it was widened and completed by General Braddock." Craig, *Olden Time*, 1:266; Abbot, *Papers of George Washington*, 5:353–60.

38. Jacob, *Biographical Sketch*, 29–45.

39. Wikipedia, "Nemacolin's Trail," http://en.wikipedia.org/wiki/Nemacolin's_Path.

CHAPTER 2

40. Hamilton, *Braddock's Defeat*, 76.

41. Ibid., 76–77, 81.

42. The batman of Captain Robert Cholmley, of Dunbar's 48th Regiment, placed the distance at eighteen miles. Hamilton, *Braddock's Defeat*, 10. The actual distance is about 13.7 miles. Owen's Ordinary was located on the early wagon road from Georgetown to Frederick, Highway 355, near the center of present Rockville and the Courthouse Square.

43. Cholmley's batman lists 16 miles from Owen's to Dowden's. Hamilton, *Braddock's Defeat*, 10. The actual distance is also about 13.7 miles. General Braddock's Orderly Book lists 15 miles between Rock Creek and Owen's, between Owen's and Dowden's and between Dowden's and Frederick. Lowdermilk, *Along the Braddock Road*, xxix.

44. Michael Dowden's Ordinary was located on the west side of present Highway 355 ("Old Sinnaca [Seneca] Indian Trail") in Clarksburg, near Wafford's Branch

of Little Senaca. See Ralph Fraley Martz, "Dowden's Ordinary." Interstate 270 (earlier identified as Highway 240) generally parallels to the west Highway 355 from Owen's at Rockville and Dowden's at Clarksburg. Dowden's Ordinary survived until the 1920s.

45. The batman entered a distance of sixteen miles in his journal. Hamilton, *Braddock's Defeat*, 10–11.

46. Lowdermilk, *Along the Braddock Road*, xxvi.

47. Ibid.

48. The batman wrote, "Nigh 18 miles." Hamilton, *Braddock's Defeat*, 12. About 12 miles from Frederick, Dunbar's troops passed through Fox's Gap at South Mountain. See Older, *Braddock Expedition and Fox's Gap*. However, the Seaman's Journal records an encampment at "Walkers," also 18 miles from Frederick and 16 miles from Conococheague, for a total distance from Frederick to Conococheague of 34 miles. Sargent, *History of an Expedition*, 370. The actual distance is about 28.5 miles. Factoring in this variation between actual and estimated, the encampment site was about 14 to 14.8 miles from Frederick, at Chapline's, on the west side of South Mountain and on the banks of a draft of Little Antietam Creek.

49. Lowdermilk, *Along the Braddock Road*, xxix.

50. Braddock's Road on Marker Road becomes Bolivar Road and, finally, Reno Monument Road, passing over South Mountain at Fox's Gap, to and with Dogstreet Road to a fork, with Geeting Road to the left to Sharpsburg and Swearingen's Ferry on the Potomac and Dogstreet to the right through Keedysville to Conococheague.

51. Hamilton, *Braddock's Defeat*, 12; Lowdermilk, *Along the Braddock Road*, xxvii, xxix.

52. Powell, *Maryland and the French and Indian War*, 58–60; Older, *Braddock Expedition and Fox's Gap*.

53. The route taken by Braddock and Washington from Shepherdstown to Winchester was not recorded, but it would have been one of two principal roads, present Highway 45 or 480 (earlier identified as Highway 48, CR-1). The latter provided the most direct route, joining with Halkett's road at present Middleway, West Virginia.

54. Evan Watkins, located on the south bank of the river at the crossing of the former Indian War Path or Great Road in the 1740s, was granted license to operate a ferry across the river to the land of Edmund Wade on the north bank. In 1756, Washington ordered the erection of Fort Maidstone on Watkins's land. See Baker, *French & Indian War*, 167.

55. The batman estimated 18 miles. Braddock's Orderly Book listed 16 miles, according to Lowdermilk, *Along the Braddock Road*, xxvii. The actual distance is about 15.6 miles.

56. Originally settled by Joseph Evans, John Evans's father, the "Big Spring" tract in the community of Pikeside, Berkeley County, West Virginia, was at the time of the Braddock expedition located in Frederick County, Virginia. Although the batman identified the encampment as "Widow Evens," John Evans, after the

expedition, converted his home into a fort, Hamilton, *Braddock's Defeat*, 13. See also Baker, *French & Indian War*, 155.

57. General Braddock's Orderly Book, in Lowdermilk, *Along the Braddock Road*, xxvii, lists 14 miles from Evans to the road to the right (Route 672), the point of rendezvous with the Halkett road. The actual distance is about 13.3 miles.

58. Ibid., xxiii. The Bear Garden Mountain is several miles northwest of Winchester and crossed by the packhorse trail in present Hampshire County, West Virginia.

59. Hamilton, *Braddock's Defeat*, 76, 78, 81–82, 84; Lowdermilk, *Along the Braddock Road*, xvii, xix, xxiv.

60. Farther to the west of this intersection, the Braddock's Road designation is again applied to a road formerly known as the "Mountain Road," running from Alexandria to the Blue Ridge Mountains, another example of the Braddock's Road misnomer that has so often been applied to routes believed to be the military road. George Washington often traveled this road on his trips beyond the Blue Ridge.

61. A multiple intersection of King Street, North Quaker Lane and West Braddock Road.

62. Lowdermilk, *Along the Braddock Road*, xxiii.

63. Hamilton, *Braddock's Defeat*, 85. See also Lowdermilk, *Along the Braddock Road*, xxiii ("Mr Miners").

64. Scheel, "General Braddock's March."

65. Some writers have located the encampment site at Hillsboro.

66. Harrison, "With Braddock's Army," 313–16; Hough, *Braddock's Road*, 7–9.

67. The numbers listed (17 and 12), from General Braddock's Orderly Book, in Lowdermilk, *Along the Braddock Road*, xxiii, are very confusing, especially the 17 miles listed from the encampment at Thompson's, when the actual distance is only about 9.5 miles.

68. Keyes purchased his land in 1745. Vestal purchased his in 1747. See the 1750 Frederick County Deed Book (hereafter FCDB), 1, 218, 298; FCDB, 2, 129, 159. See also Hough, *Braddock's Road*, 10, note 7.

69. It was a common, confusing practice of the period to interchange the names of the gap and ferry owners along the Blue Ridge. For example, Ashby's Gap was named for Thomas Ashby, who settled on land on the east side of the Shenandoah River, while the ferry across the river was also at times identified as Ashby's Ferry. The ferry actually was Kersey's Ferry, owned and operated by John Kersey, who owned the land on the west bank of the river at the ferry.

70. Vestal's house, built in 1748, has fallen victim to the elements and business development. See photo in Hough, *Braddock's Road*, 16. It survived as a residence as late as 1936, but by 1970, the roof was gone and only the stone walls had survived. See Wayland, *Historic Homes of Northern Virginia*, 40; Hough, *Braddock's Road*, 16.

71. About 0.93 mile from the east bank of the river.

72. Hamilton, *Braddock's Defeat*, 86.

73. Wayland, *Historic Homes of Northern Virginia*, 162.

74. Formerly known as Quarry Banks, the home of Robert Worthington, who settled here about 1730 and died in 1734. Wayland, *Historic Homes of Northern Virginia*, 20–21.

75. Ibid., 20. The chapel was built in 1765–69 and known also as Berkeley Church, Norborne Chapel and Trinity Chapel.
76. Earlier known as "Worthington's Marsh."
77. FCDB, 3, 22–23, 25–27, 317–21. See Hough, *Braddock's Road*, 14, 56–57.
78. Wayland, *Historic Homes of Northern Virginia*, 135.
79. Lowdermilk, *Along the Braddock Road*, xxiii.
80. In Frederick County, Virginia, the ford now marks the line between Virginia and West Virginia, where four counties meet: West Virginia's Jefferson and Berkeley Counties and Virginia's Frederick and Clarke Counties.
81. Hamilton, *Braddock's Defeat*, 86. Widow Littler was Mary Littler, the former wife of John Littler, who died about seven years earlier, in 1748.
82. Ibid., 13. The actual distance is seventeen miles.
83. Upon the return from the battle on the Monongahela, the former captain Cholmley's batman (Captain Cholmley was killed early in the battle) again stopped at "Billinger's," and he wrote, "The people of the House is two old Maids Quakors." He went foraging in the area, "being thin of Plantations," became lost in the night and had to hire a guide to get back to the camp. See Hamilton, *Braddock's Defeat*, 36.
84. General Braddock's Orderly Book locates the encampment site at George Polls (Pott's), Lowdermilk, *Along the Braddock Road*, xxvii, xxix. See also Hough, *Braddock's Road*, 26, 30.
85. The actual calculated distance is 7.5 miles. Most of the batman's estimates significantly exceeded the actual mileage.
86. Hamilton, *Braddock's Defeat*, 13.
87. Sargent, *History of an Expedition*, 371.
88. Ibid. Henry Enoch was granted 388 acres at the site in 1753, which had been surveyed by George Washington in 1750. A stockade fort was erected at his mill, and troops from the Virginia Regiment were quartered there, beginning in late 1755, following the defeat of Braddock. Baker, *French &Indian War*, 154.
89. Captain Cholmley's batman recorded an 18-mile march, in stark contrast to the actual, measured distance of about 13.6 miles.
90. In the vicinity of Back Creek and beyond to the Pott's site on the crest of the ridge, there was no desirable ground for camping, and the area was dominated by the steepness of the ridges, which taxed the stamina of the men and the horses.
91. Hamilton, *Braddock's Defeat*, 87.
92. Hough, stating he was unable to locate the site accurately, proposed a site near Whitacre, which is about four miles from Back Creek, or Pott's encampment, or about one-third of the distance to Enoch's. Hough, *Braddock's Road*, 5, 11.
93. Hamilton, *Braddock's Defeat*, 87.
94. Ibid., 88.
95. Hough incorrectly concluded that the military road continued west along Crooked Run and began ascending Spring Gap Mountain about 0.35 mile west of its actual trace.

96. The scar of the road across this field leaves a distinct trace in space satellite views.

97. A distance of about 5.6 miles from Enoch's to Spring Gap.

98. The military road moves to the right about midway between CR 2 and the Little Cacapon for about four hundred yards before it rejoins the present road.

99. The many bends in the river extended the total distance as much as 1.75 times. The distance by Braddock's Road from Enoch's along the Little Cacapon to the Potomac is about 14.5 miles. Using a direct-line distance from the mouth of Dug Hill Run to the Potomac, the distance from Enoch's is about 12 miles, the distance cited in General Braddock's Orderly Book, according to Lowdermilk, *Along the Braddock Road*, xxvii, xxix.

100. The author has been able to identify seventeen fords from the mouth of Dug Run to the mouth of the river on the Potomac.

101. The river road, with its many fordings, along the Little Cacapon, continued to be the most desirable route to the Potomac into the twentieth century, remaining a public road until 1914, when it was abandoned as a maintained passage.

102. Cox's land was surveyed by Washington in 1750. See Hough, *Braddock's Road*, 47.

103. Hamilton, *Braddock's Defeat*, 88.

104. A distance of about 5.6 miles from Enoch's.

105. See Hough, *Braddock's Road*, 8–9.

106. Hamilton, *Braddock's Defeat*, 88.

107. Cresap's settlement was between the present village of Oldtown on Route 51 and the Potomac River. The foundation of Cresap's dwelling and later fort remain. Cresap is buried nearby.

108. Along the route later followed by the Chesapeake and Ohio Canal.

109. Hamilton, *Braddock's Defeat*, 14. The actual distance is about 6.7 miles.

110. Ibid., 14. The actual distance is about 14.5 miles.

111. Months before Braddock and his army arrived, the fort at Will's Creek was known as Fort Cumberland. *A Plan of Fort Cumberland on Will's Creek & Potomack River, with a View of the Store Houses, belonging to the Ohio Company on the other Side of the River*, a map in the British Museum dated February 1755, also notes, in part, "The Virginia Troops are here Encamped, about 120, officers included, 12 Febry 1755."

112. Lowdermilk, *Along the Braddock Road*, xxx.

113. Hamilton, *Braddock's Defeat*, 15.

114. Ibid., 88.

Chapter 3

115. Address by author at the Braddock Road Preservation Association's Twenty-third Annual Jumonville French and Indian War Seminar, November 4, 2011.

116. Atkinson, "Braddock's Route," 12.

117. These various authors and cartographers are listed in the bibliography. Alexander McClean was a Pennsylvania deputy surveyor who faithfully recorded Braddock's Road on his many eighteenth-century surveys.

118. All three of these documents—"The Journal of Captain Robert Cholmley's Batman," "The Journal of a British Officer" and "Halkett's Orderly Book"— were published for the first time in Charles Hamilton's *Braddock's Defeat* in 1959.

119. The surveys of the land grants along the Braddock's Road used in this study were obtained from the Land Records of the Pennsylvania Historical and Museum Commission/Pennsylvania State Archives (all surveys and land records hereinafter cited as PHMC). Most of the surveys depicting Braddock's Road in Fayette County, from the Great Crossings to the Stewart's Crossings of the Youghiogheny, were conducted by Deputy Surveyor Alexander McClean during the last quarter of the eighteenth century. Late in the first quarter of the twentieth century, John H. Campbell, chief draftsman of the Pennsylvania Department of Internal Affairs, constructed a map of all the remaining original survey drafts on file for Fayette County in the Pennsylvania State Archives. Campbell diligently depicted Braddock's Road on the surveys previously recorded by McClean. In 1932, the Department of Internal Affairs expanded the work of McClean and Campbell, compiling a map connecting all the land grant surveys along the general course of Braddock's Road, from the Pennsylvania line with Maryland to the Forks of the Ohio—*Map of Braddock's Military Road through Pennsylvania (1755)*. Recently, and subsequent to the completion of this study, this map was made available for viewing. The surveys by McClean depicting Braddock's Road are reproduced, along with other surveys completed mainly in the early nineteenth century, the latter introducing a prevailing confusion over the route of Braddock's Road. The compilers of the map relied on the findings of Lacock in locating the army's encampments along the route, furthering road route and encampment inaccuracies that were developed in Lacock's research. Also, a considerable amount of the military road on the map is not shown on the surveys and is depicted by dotted lines, reflecting conjectural interpretation. A copy of this map was discovered in the 1970s by Lawren Dunn and Carney Rigg in the basement of Mount Washington Tavern, and in March 2013, the Fort Necessity National Battlefield made it available for viewing by the author.

120. Orme's Journal, July 4, 1755, in Sargent, *History of an Expedition*, 349.

121. Gist's mapping of his explorations was credited by Fry and Jefferson with the basic data they used for the preparation of their map of the frontier regions of Virginia, Pennsylvania, Maryland and Ohio. See *Fry and Jefferson Map 1755* in Darlington, *Christopher Gist's Journals*.

122. The copy of the second map accompanying this study is from the John Carter Brown Library Archive of Early American Images (01541, Cabinet Cj755/IMS). For a view of the copy of the first map, see Steeley, "Road Not Lost," 24. Copies of these maps are also at the Pennsylvania Historical and Museum Commission.

123. Patrick Mackellar, engineer en second on the Braddock expedition, prepared detailed maps of the battle site and the deployment of the battle forces. See Pargellis, *Military Affairs in North America*, 114.

124. Gordon authored a brief journal from Will's Creek on July 23, 1755, after the battle, noting that because of a wound to his drafting arm, he was unable to

provide a sketch of the march or the field of action. Pargellis, *Military Affairs in North America*, 104–9. Sometime later, after Christopher Gist had submitted a map of the march, a map that has been attributed to Gordon noted his reliance on Gist's earlier map of the march and cited work on the road, quality of the road and the camps.

125. Pargellis, *Military Affairs in North America*, 108–9.

126. Ibid., Gordon's map. Orme, at some unspecified date, also prepared a map of Braddock's route, with identification of waterways along the route, but also, to a great extent, with different encampment identifications than those used by Gist and Gordon. Orme's map identifies two third encampments, two fourteenth encampments, no encampment on Brush Creek (i.e., "Blunder Camp ") and a total of nineteen encampments instead of twenty. His map depicts the army marching directly from Monacatootha Camp to the camp on Sugar Creek in the White Oak community. See *Map of the Country between Wills Creek and Fort de Quesne*, "based on a drawing by Capt. Robert Orme." Also, there is a large-scale version published in Thomas Jeffrey's *General Topography of North America and the West Indies* and Jeffery's *Map of the Country between* Will's Creek *& Monongahela River, Shewing the Rout and Encampments of the English Army.* See Schwartz, *French and Indian War*, 50.

Chapter 4

127. Hamilton, *Braddock's Defeat*, 17; Sargent, *History of an Expedition*, 380–81. Orme's Journal, 323, recorded the advance party departure date as May 30, while Cholmley's batman and the Seaman's Journal placed the date as May 29.

128. Hamilton, *Braddock's Defeat*, 17; Seaman's Journal, 380–81.

129. Sargent, *History of an Expedition*, 324.

130. Lacock, "Braddock Road," 7–8.

131. Currently, the traces of four major roads pass through Sandy Gap. The first is the trail used by Gist in his early explorations west that was converted into Braddock's military road. This was followed by an eighteenth-century colonial road, apparently seeking to ease the difficulties of Braddock's Road, a trace located and explored by Robert Bantz, with several hundred feet separating the two roads. Bantz, with years of study and field work on Braddock's Road, found cannonballs, musket balls, parts and military utensils along the northern military route, while the southern colonial road yielded only domestic goods and no military hardware. Lacock apparently mistook the trace of the colonial road for Braddock's Road, missing the military road trace several hundred feet to the north. See Lacock, "Braddock Road," 7–8; Lacock and Weller, "Mount Nebo" postcard, Braddock Road Postcard Collection; Whetzel, "National Road Bicentennial," highlighting Bantz's more recent studies on the road, 27–35; and the Cumberland Road Project website. The other roads passing through Sandy Gap are Route 49—the former Cumberland Road and, incorrectly for a long segment, designated "Braddock Road" in the twentieth century—and Interstate 68.

132. Sargent, *History of an Expedition*, 381.

133. Ibid., 326–27; Gist's map. Gist, with Braddock, took the Narrows route. The actual distance by the Narrows from Fort Cumberland is 4.96 miles. On his second exploration of the Ohio country, Gist camped in the vicinity on November 4, 1751, after riding through Sandy Gap.

CHAPTER 5

134. Hamilton, *Braddock's Defeat*, 19–22.
135. Sargent, *History of an Expedition*, 331.
136. Hamilton, *Braddock's Defeat*, 41–42.
137. Orme and Gist estimated 5 miles; the journal of the unidentified British officer in Hamilton put the distance at 6 miles. The actual distance from Camp 1 to Camp 2 is about 5.92 miles. Sargent, *History of an Expedition*, 333; Gist map; Hamilton, *Braddock's Defeat*, 42.
138. Formerly the site of Gwynn's Tavern, also identified as the Six Mile House to indicate its distance from Cumberland via the Narrows route; it is now the site of a Burger King restaurant.
139. Known as the LaVale Toll House, still standing and restored, built in 1835.
140. Lacock, "Braddock Road," 13. Locally known as Braddock Spring. See Lacock and Weller, postcard No. 9. "Braddock Spring, near Six Mile House, east of Clarysville, Md.," Braddock Road Postcard Collection.
141. Lacock, "Braddock Road," 14.
142. During the period of Lacock's research, the trace of the road passed through what was known as Layman's orchard in what is now the south section of the Maplehurst Country Club. Lacock, "Braddock Road," 15. See also Lacock and Weller, postcard No. 11, "Layman's Orchard, near Frostburg, Md.," Braddock Road Postcard Collection.
143. Sargent, *History of an Expedition*, 333; Hamilton, *Braddock's Defeat*, 42.
144. Sargent, *History of an Expedition*, 333.

CHAPTER 6

145. This positions the campsite in the vicinity of the east–west section of the Maplehurst Road, leading into the Maplehurst Country Club, south of the upper headsprings of the eastern branch of George's Creek.
146. Sargent, *History of an Expedition*, 334.
147. Braddock Park and the trace of the road through it have been developed out of existence with only a faint, difficult-to-recognize trace on the western end of Bowery Street Extended. For an earlier view of the park, see Lacock and Weller, postcard No. 12, "Braddock Park, Frostburg, Md.," Braddock Road Postcard Collection.
148. The stone has survived and is displayed at the Frostburg Museum.
149. Sargent, *History of an Expedition*, 335. Braddock's Road was depicted on U.S. Geological Survey maps in the beginning of the twentieth century (1908) as a

trail from Sand Spring Run in Frostburg to the crest of Big Savage Mountain. As late as 1949, a section of the road through the strip mine operation is shown on the survey maps. Sections of the road on Big Savage Mountain are marked with signage erected by Robert Bantz from the Braddock Road Preservation Association.

150. Sargent, *History of an Expedition*, 335. The traces of the road on Big Savage Mountain are accessible by taking Route 546, the Beall School Road, south from Interstate 68 for about one mile, continuing to the left on the Beall School Road and then to the right on St. John's Rock Road for about 0.44 mile. Take the forest road on the left to the crest of the mountain, and the Braddock's Road markers are on the left (north) side of the road.

151. Sargent, *History of an Expedition*, 335.

152. Gist estimated fifteen miles from Fort Cumberland, by way of the Narrows.

Chapter 7

153. The British officer recorded that his unit of the army reached to within four miles of Little Meadows on June 15, which, based on the accuracy of his estimate, placed his unit to the rear of the lead brigade. Hamilton, *Braddock's Defeat*, 42.

154. Lacock, "Braddock Road," 16–17.

155. The road trace across Two Mile Run is about 0.2 mile north of the National Road's crossing of the run.

156. Lacock, "Braddock Road," 18. Merrbach descendants continue to be the principal residents of the community.

157. Sargent, *History of an Expedition*, 335.

158. The fording of the Casselman (Castleman) river of the Youghiogheny, about 2.46 miles west of the Little Meadows camp. Sargent, *History of an Expedition*, 335–36. See also Hamilton, *Braddock's Defeat*, 22, 42–43.

159. February 14, 1760, patent no. 1680 to Joseph Tomlinson, Frederick County, Maryland. See also McGrain, "Wagon Roads of Western Maryland."

Chapter 8

160. Sargent, *History of an Expedition*, 336. From the Little Meadows camp to the eastern boundary of Grantsville via Braddock's Road is 3 miles; to the center of the town, the distance is 3.63 miles.

161. Sargent, *History of an Expedition*, 335–36.

162. Not to be confused with the Chestnut Ridge in Fayette County, Pennsylvania, previously known as Laurel Hill, the site of Half King's Rocks, Veech, *Monongahela of Old*, 25, 27.

163. Lacock, "Braddock Road," 18–19.

164. Sargent, *History of an Expedition*, 337.

165. Ibid., 336–37.

166. Gist, Gordon and Orme listed 4 miles from Little Meadows. The actual distance is 4.45 miles. The camp was 24.64 miles from Fort Cumberland over the road through Sandy Gap and 26.05 miles over the road through the Narrows of Will's Creek.

167. Hamilton, *Braddock's Defeat*, 43–44, 22.

168. Sargent, *History of an Expedition*, 337.

169. Hamilton, *Braddock's Defeat*, 22.

CHAPTER 9

170. A historical marker on the National Road near the crest of the mountain notes that it acquired its name from a black member of a party led by Thomas Cresap, named Nemesis, who was killed in an engagement with Indians on the mountain.

171. Sargent, *History of an Expedition*, 337.

172. Ibid., 338. The reference to "no water" conflicts with the road's crossing of Puzzley Run and the proximity of the waters of Mill Run and its branches in the valley west of Keyser's Ridge.

173. Hamilton, *Braddock's Defeat*, 44.

174. Gist's and Gordon's maps. Gist kept detailed, erudite journals during his explorations in 1750–52 and his journey with Washington in 1753. He often encountered and depended on bears for subsistence, yet he did not spell "bear" as "bare" in those published journals. Nevertheless, the Bear Camp designation has persisted to the present day and seems to be "etched in stone."

175. At the Bear Camp, the army was now about 33.04 miles from Fort Cumberland by way of Sandy Gap, or about 34.45 miles over the Narrows route.

176. The "Good Spring" land patent, surveyed on both sides of the military road on April 4, 1774, extended west from near Puzzley Run. The National Road built a stone bridge over the run in 1817, and it still stands in private use.

177. Lacock, "Braddock Road," 20. See also Lacock's map of the road, between pages 20 and 21. Robert J. Ruckert was one of the early discoverers of the trace of Braddock's Road west of Keyser's Ridge and along Mill Run to Bear Camp. Ruckert, "Braddock Military Road," 569–71.

CHAPTER 10

178. A halt of two days, "having a road to cut into the side of a mountain." Sargent, *History of an Expedition*, 338; Gordon recorded, "the Ridge ½ mile up in zigzags," journal abstract, Gordon's map.

179. It was the second of three streams along Braddock's Road to be named in honor of the general and his army.

180. Gist's map.

181. Sargent, *History of an Expedition*, 340.

182. Gordon's map.

183. Gist's map.

184. Sargent, *History of an Expedition*, 340.

185. The distance from Fort Cumberland to the Great Crossings on the Youghiogheny by way of the Narrows is 39.97 miles; through Sandy Gap, it is 38.56 miles.

186. Gordon's map.

187. A branch of Mill Run, earlier known as Froman's Mill Run.

188. Duly noted by Gordon.

189. Ibid.

190. PHMC Survey C-2-59, March 1, 1802, Peter Augustine, 312½ acre; Survey C-64-71, 1830. Later, the incorrect identification of the Cumberland and National Road through Addison as Braddock's Road would be corrected and identified as the "U.S. Turnpike." PHMC Survey C-90-185, October 21, 1825. See also the 1932 map prepared by the Pennsylvania Department of Internal Affairs of the surveys along Braddock's Road, which perpetuates the initial errors in misidentifying the early road through Addison as Braddock's Road, while at the same time recording a survey farther south depicting "Braddock's Old Road." Lacock opted for the course through Addison, apparently based on the use of the surveys with the incorrect road identifications.

191. Lacock, "Braddock Road," 21–22.

192. Ibid., 22, note 49; PHMC Survey D-11-107, 108, 109, Conrad Wable, 223¾ acres, "Wables fancy," October 8, 1788, "Situate on the head branches of Froman's Mill Run [Chub Run branch] and Braddock's Old Road in Turkeyfoot Township [now Addison Township], Bedford County [now Somerset County]." The surveyor, Alexander McClean, painstakingly depicted the twisting course of the road through the land grant. McClean was the same surveyor who studiously depicted Braddock's Road on the several surveys extending for miles north and south of Fort Necessity.

193. Martin Hileman acquired a tract of land adjoining to the west of Conrad Wable on the head branch of Braddock's Run. PHMC Survey C-108-144. A distinct trace of Braddock's Road is now known as Hileman's Lane.

194. Contrary to Lacock's assertion that Shippen's map of 1759 "would seem to confirm" Lacock's course of the road through Addison and down the north branch of Braddock's Run, Shippen's course of the road follows Braddock's Run from its head to its mouth. Gordon straight-lined the road from Bear Camp to the Youghiogheny, along the north bank of Braddock's Run, from the head branch of the run to its mouth on the Youghiogheny. The earlier cited Orme map also depicts the road following the full length of Braddock's Run to the Youghiogheny. Lacock, "Braddock Road," 22, note 49. See also Thomas Hutchins's *Map of the Country on the Ohio and Muskingum Rivers*, which distinctly depicts "Braddock's Road" following Braddock's Run, from its head to its mouth. William Scull's map of 1770 shows the road crossing the Winding Ridge and following Braddock's Run, also from its head to its mouth at the Great Crossings. Scull updated Nicholas Scull's map of 1759 using information gained during the French and Indian War. *A Map of Pennsylvania*, based chiefly on William Scull's map, was published by Robert Sayer and J. Bennett in June 1775.

195. PHMC Survey No. 3078, C-233-29, April 17, 1769; Survey No. 3590, C-108-240, May 3, 1769; Survey No. 3570, C-168-239, June 27, 1769, "on Braddock's road on the West side of the Great Crossings of Youghiogeni."

196. "Buffler river" refers to French Creek, or Riviere Au Boeuf, a small but vital water passage used by the French forces between Fort LeBoeuf, at present Waterford, Pennsylvania, and Fort Venango, or Fort Machault, at present Franklin, Pennsylvania, on the Allegheny River. Washington and Gist used this passage during their visit to Fort LeBoeuf in 1753. Sargent, *History of an Expedition*, 340.

CHAPTER 11

197. Orme called the encampment "Squaw's fort." Sargent, *History of an Expedition*, 340. Halkett's Orderly Book did not give the camp a name. The river in the vicinity of the former road crossing, flooded behind its dam, is about four hundred yards wide. Only at the times when the water is let down in this river-formed lake can the crossing area approach its 1755 appearance.

198. Hamilton, *Braddock's Defeat*, 44. This was where the women and children who accompanied Half King's contingent in the operations that led to the battle at Fort Necessity secured themselves during that campaign.

199. Sargent, *History of an Expedition*, 341.

200. Gist's map.

201. Sargent, *History of an Expedition*, 341; Hamilton, *Braddock's Defeat*, 22, 44.

202. Gist's map.

203. Lacock, "Braddock Road," 24, note 52. Veech, *Monongahela of Old*, 59, wrote that the encampment was "near the Twelve Springs," a community identification dating back almost one hundred years earlier. Joseph Shippen Jr. depicted the first known identification of the "12 Springs" on his map of November 1759. William Scull followed, with his identification of the "12 Springs" on his map of 1770. None of narratives of the participants of Braddock's expedition refer to the camp by that name. Veech added that the camp was "between Mt. Augusta and Marlow's," no longer commonly identified locations.

204. Sargent, *History of an Expedition*, 341; Lacock, "Braddock Road," 24, note 52. Lacock also refers to "a hotel at Twelve Springs on Braddock Road, one mile south of the National Turnpike." However, Braddock's Road at the encampment was only half a mile south of the National Road (Highway 40).

205. Hamilton, *Braddock's Defeat*, 112.

206. Gordon's map.

207. The batman related that two wagoners were wounded and a servant scalped. The British officer listed five deaths, while Orme said that three men were shot and scalped. Hamilton, *Braddock's Defeat*, 23, 44–45; Sargent, *History of an Expedition*, 341.

208. PHMC Survey C-233-29, April 17, 1769, Jacob Spears, 357¾ acres on east bank of river, called Nobblely Nowl, including the present site of Somerfield; Survey C-108-240, June 23, 1770, Benjamin Loxley, 362¼ acres, on west bank of river,

called Wakefield; Survey C-168-239, December 6, 1769, John Rice, 102 acres on both sides of Hall Run from its mouth on the river, "on Braddocks road."

209. Lacock, "Braddock Road," 23.

210. See Lacock and Weller, postcard No. 29, "River Hill, near Somerfield, Pa.," Braddock Road Postcard Collection.

CHAPTER 12

211. Sargent, *History of an Expedition*, 341–42.

212. Hamilton, *Braddock's Defeat*, 23.

213. Ibid., 45.

214. PHMC Survey No. 3383, C-7-222, June 13, 1769, William Brooks, 234½ acres, "where Braddocks Road Crosses the Great Meadows," called "Mont Washington."

215. Gist's map. This is the third stream along the route designated to recognize the Braddock expedition.

216. Braddock's army was now 54.12 miles over Sandy Gap from Fort Cumberland, or 55.53 miles through the Narrows.

217. Gordon's map.

218. Sargent, *History of an Expedition*, 343; Hamilton, *Braddock's Defeat*, 112.

219. Lacock, "Braddock Road," 25. Veech probably can be credited as the author of the designation of this camp as the "Orchard Camp," when he wrote (in 1858) that the camp was "now the Old Orchard, near and northwest of Braddock's Grave." Veech, *Monongahela of Old*, 59.

220. Gordon's map.

CHAPTER 13

221. The third waterway with the Braddock designation along the army's road.

222. Sargent, *History of an Expedition*, 343.

223. Gist's map; Gordon's map.

224. Lacock, "Braddock Road," 25–26. At the site of "Washington Springs" was later located a tavern operated by Thomas Fossit (sometimes Fausett or Fawcett), who claimed that he shot Braddock after the general had killed Fossit's brother, Joseph, with his sword because he was firing at the French and Indians from the shelter of trees. See Veech, *Monongahela of Old*, 68–72. Joseph survived the attack. For a detailed review of this incident, see Hadden, *Washington's Expeditions*, 88–90, 114–39.

225. This is the fork in the roads to the Ohio, with the road to the left Dunlap's Path, the traders' path to Redstone Creek and the Monongahela, while the road to the right led to the Forks of the Ohio.

226. Sargent, *History of an Expedition*, 343. Orme was describing "Half King's Rocks," which is within about three hundred yards of "Washington Springs." See Veech, *Monongahela of Old*, 47. See also Lacock and Weller, postcard No. 38, "Half King's Rocks, near Jumonville, Pa.," Braddock Road Postcard Collection.

227. Shippen's map of 1759 and Scull's map of 1770 identify the "Rock Fort," or "Half King's Rocks," as the "Big Rock."

228. Hamilton, *Braddock's Defeat*, 45–46.

229. Sargent, *History of an Expedition*, 344.

CHAPTER 14

230. The northern land branch of the traders' and Ohio Company path to the Forks of the Ohio, joining the Catawba Path at Gist's settlement. Wallace, *Indian Paths*, 435–36. See also Donehoo, *History of the Indian Villages*, 20.

231. Baker, *French & Indian War*, 8.

232. Several years ago, a short distance east of the cross monument above the Jumonville community along the trace of the army's road, one-pound cannonballs and swivel gun balls from Washington's 1754 campaign were unearthed. See Hinks, *Dunbar's Camp & the Braddock Road*, and Abbott, "Braddock's War Supplies and Dunbar's Camp."

233. Gist's map.

234. Sargent, *History of an Expedition*, 344.

235. Computed distance from Fort Cumberland to Gist's plantation by the Narrows is 66.74 miles; by way of Sandy Gap, it is 65.33 miles.

236. Hamilton, *Braddock's Defeat*, 24, 46.

237. See Veech, *Monongahela of Old*, 115.

238. Christopher Gist died of smallpox on July 25, 1759, four years after Braddock's expedition, while on the road from Williamsburg to Winchester, leading a group of Catawbas toward the frontier. See Dorsey and Dorsey, *Christopher Gist of Maryland*, 28; Bailey, *Christopher Gist*, 150.

239. See PHMC Survey C-151-141, October 21, 1785. It depicts road leading from Gist's Run to the Gist House on the elevation to the west and "Christs old Field & Cabbin" on north side of Gist's Run. See also Survey B-1-103, October 26, 1785, adjoining Gist land on Gist's Run and Dunbar Creek. After Thomas's death in 1787, much of his land was sold at public auctions for minor debts. Isaac Meason purchased these lands for trivial sums and began his iron empire. A few years later, Meason was sued by the Gist heirs and was made to pay £1,200 for one thousand acres. Vogt, *Westward of Ye Laurall Hills*, 125–26; Powell, *Forgotten Heroes of the Maryland Frontier*, 27.

CHAPTER 15

240. Gordon's map.

241. A passage of the Indian trail named in recognition of the Stewart family of pioneer settlers and Indian traders. William Stewart testified in 1786 that he, his father and brothers were living near Stewart's Crossings in 1753 and "part of 1754" when driven out by the French. See Veech, *Monongahela of Old*, 60, note "d," and 113, note "a." Gist and a survey in 1769 at the crossings identified the

site as "Stewards" or "Stewards Crossings." See Gist map and PHMC Survey No. 2309, C-25-290, John Crawford, April 3, 1769, "generally called Stewards Crossings." Other contemporary surveys called it "Stewarts Crossings": PHMC Survey No. 2187, A-21-302, April 3, 1769; Survey No. 2497, A-21-207, April 3, 1769; and Survey No. 2739, M-233, November 13, 1769.

242. Gordon's Map.

243. James Harper received a land grant on the upper reaches of the run in the vicinity of present Leisenring.

244. This is a section of west Connellsville also identified as part of the community of New Haven.

245. Lacock, "Braddock Road," 27–28, note 61.

246. All of the land grant surveys along Braddock's Road, between Gist's plantation and Stewart's Crossings, were reviewed and plotted for this study.

247. "Situated on Braddock's Old Road," PHMC Survey C-172-132, James Paul(I), 159 aces, called "Rich Head," May 20, 1773. See also Veech, *Monongahela of Old*, 126.

248. "Situated on Braddock's Old Road between Laurel Hill and Stewards Crossings," PHMC Survey 493, James Boys Sr., April 20, 1785, adjoining James Paul(I) on the south and southeast; "Situated near Braddock's Road about two miles from Thomas Gist," PHMC Survey A-61-120, Samuel Works, called "Samuel's Line," March 13, 1787.

249. PHMC Survey No. 1813, C-74-267, Alexander Pollox, April 3, 1769, November 1769, adjoining Survey No. 1585, C-74-266, Robert Pollox, April 3, 1769, November 1769.

250. PHMC Survey C-195-70, Benjamin Ross, November 11, 1786, adjoining the Robert Pollox grant on the south; Survey C-168-248, Robert Ross, November 10, 1786, adjoining the Benjamin Ross grant on the southwest.

251. Lacock, "Braddock Road," 27, note 66, which noted that Stewart's encampment was "near Robinson's Falls," also said that Veech was confused by Orme's entry of June 28, when Veech said that the encampment at Stewart's was "a short half mile below New Haven" on land owned in 1858 by Daniel Rogers. The site of the Stewart's Crossings encampment (Camp 12) was in the present New Haven vicinity of the Lawrence Harrison Sr. grant, which includes Robinson's Falls. Adjoining Lawrence Harrison Sr.'s lands to the west, on the west side of Harper's Run (Opossum Run), were the lands of Battle Harrison and William Harrison. The William Harrison's tract adjoined on the south the land of John Rogers, in the vicinity of present Rogerstown. Daniel Rogers's daughter, Catherine, married Isaac Meason Sr., who purchased the Gist plantation at public auctions after Thomas Gist's death. See Veech, *Monongahela of Old*, 60, 115, 121.

252. PHMC Survey No. 3441, E-217, Lawrence Harrison Sr., September 11, 1769, called "Mount Pleasant."

253. John Crawford, the son of William Crawford, also sold his land to Isaac Meason.

254. PHMC Survey No. 2309, C-25-290, John Crawford, September 22, 1769, "includes what is generally Called Stewards Crossings," adjoining Lawrence

Harrison Sr., on the west, Robert Ross on the south and the Youghiogheny on the north and east.

255. See PHMC Survey C-25-290.

CHAPTER 16

256. The unidentified British officer recorded that the army crossed the river on June 29 and remained in camp on June 30, while the working party cleared the road for the next day's march. Hamilton, *Braddock's Defeat*, 46. Halkett's Orderly Book recorded camping "on the Yochoganney" on June 28, "at the Crossing" on June 29 and "After the Crossing" on June 30. Hamilton, *Braddock's Defeat*, 115–16.

257. A shopping development now covers this segment of the road and the run.

258. Sargent, *History of an Expedition*, 344. At Stewart's Crossings, between the mouth of the south verge of Mounts Creek and the mouth of Opossum Run, the river forms a dogleg, flowing from east to west and, west of the crossings, turns to the north as it continues downriver.

259. Lacock, "Braddock Road," 27.

260. Hamilton, *Braddock's Defeat*, 46.

261. Ibid., 115.

262. Lacock, "Braddock Road," 28. Confirmed by the land grants on both sides of the river at Stewart's Crossings.

263. William Crawford of Virginia, friend of George Washington, Indian trader, surveyor, justice of the peace, was an early settler of the area and years later a leading military leader who was brutally tortured and burned by the Indians in the Tymoochee River Valley west of Upper Sandusky in Ohio in 1782. He took up a land grant in his own name on the north side of Stewart's Crossings. A land grant was issued to his son, John Crawford, on the south side of the crossings. Veech erred when he said he believed that William Crawford did not take out a land grant at Stewart's Crossings in his own name. Veech, *Monongahela of Old*, 119. Other Crawford family members were issued grants both north and south of the crossings. William's daughter, Sarah, married William Harrison, who was also burned at the stake in a Shawnee town in the same campaign as his father-in-law. Sipe, *Indian Wars*, 662. Crawford's wife, Hannah, was the sister of John Vance, who took up a land grant along Braddock's Road north of the river and Camp 13. Crawford's son-in-law, William McCormick, was granted a tract of land on the north side of Stewart's Crossings on both sides of Braddock's Road. See Veech, *Monongahela of Old*, 118–19.

264. *Pittsburgh Tribune-Review*, "Braddock's Road to War," August 22, 2004; Connellsville Area Historical Society, "Stewart's Crossing," February 2, 2000.

265. PHMC Survey C-25-190, John Crawford, September 22, 1769.

266. PHMC Survey No. 374, W-238, William Crawford, April 3, 1769, and September 10, 1793. The mouth of the south verge of Mounts Creek, extending from the bottom (south) side of a horseshoe bend in the creek to the river, was along the west side of the railroad bridge across the river.

267. Abstract of the journal on Gordon's map.

268. The encampment was north of Stewart's Crossings on the level elevated terrace between the river and Mounts Creek, immediately south of the ascending spur of the ridge to the north above the Narrows.
269. Gist's map.
270. Gordon's map.
271. Hamilton, *Braddock's Defeat*, 46–47.
272. This area in the beginning of the twentieth century was known as Davidson, apparently in recognition of the Davidson farm referred to by Lacock and depicted but not identified as such by Lacock and Weller on postcard No. 47, "The Narrows North of Connellsville," which shows the section of Braddock's Road, now abandoned, from the vicinity of present River Avenue, north toward present Miner Drive ascending the Narrows. See also U.S. Geological Survey of Connellsville area, March 1902.
273. Gordon's map.
274. See Lacock and Weller, postcard No. 47, "'The Narrows' north of Connellsville, Pa.," Braddock Road Postcard Collection, for a view of what the thirteenth encampment site looked like in 1908 (although, as noted, it was not identified by Lacock or Weller as such), in the vicinity and to the right of the farm buildings (in the vicinity of the present River Avenue) and the now abandoned course of Braddock's Road as it continues over the crest of the Narrows in the center background (now Miner Drive).

CHAPTER 17

275. Wallace, *Indian Paths*, 436.
276. The Pennsville Mennonite Cemetery.
277. At the beginning of the twentieth century, the community in this area was known as Valley Works. See the 1902 edition of the U.S. Geological Survey topographic map.
278. Gist's map.
279. Sargent, *History of an Expedition*, 346.
280. Hamilton, *Braddock's Defeat*, 24.
281. Ibid., 46–47.
282. Sargent, *History of an Expedition*, 346.
283. Hamilton, *Braddock's Defeat*, 24.
284. Ibid., 47.
285. Gist's map.
286. Computed distance from Fort Cumberland by the Narrows is 81.04 miles; by Sandy Gap, it is 79.63 miles.
287. Hamilton, *Braddock's Defeat*, 117.
288. Lacock, "Braddock Road," 29.
289. Sargent, *History of an Expedition*, 346.
290. See the Bullskin Township Historical Society website. The marker was erected on November 30, 1932.

291. This study reviewed and plotted all the land grant surveys along the Braddock's Road, from Stewart's Crossings between Jacobs' Creek and Mounts Creek in Fayette County to the crossing of Jacobs' Creek at Bridgeport, Westmoreland County.
292. PHMC Survey No. 374, W-238, William Crawford, April 3, 1769, "on north side of Stewart's Crossing."
293. Lewis, "First White Settlers."
294. PHMC Survey, W-237, William McCormick, March 25, 1795, "on the north side of Stewart's Crossings."
295. PHMC Survey C-143-89, Abner Mounts, March 29, 1787.
296. PHMC Survey B-13-235, William McKee, 275¾ acres, November 2, 1785.
297. PHMC Survey A-14-275, Ann Connell, 307½ acres, October 31, 1785.
298. PHMC Survey R-71, William Boyd, "called Springhill," June 2, 1786.
299. PHMC Survey C-44- 225, Edward Doyle, 426¼ acres, January 23, 1786.
300. PHMC Survey C-201-80, Ann Stephenson, July 28, 1791, on Jacobs' Creek west of the Everson Valley divide with Irishman's Run; Survey A-21-290, Isaac Meason, December 22, 1785, "on the Head Branches of the Irishman's Run."
301. PHMC Survey A-21-207, William McMacken, on both sides of the old and new Highway 119, including the area around the Pennsville Church; Survey A-21-302, John Henderson, November 12, 1769, the community of Prittstown: Survey M-235, Ann Fitzgerald, November 12, 1769, "about five miles from Stewarts Crossings." The actual direct line distance is about 5.75 miles, adjoining John Henderson on the southeast.
302. PHMC Survey M-262, Catherine Meason, January 4, 1785.
303. PHMC Survey C-116-256, John Meason, December 19, 1785; Survey C-116-255, Hannah Meason, March 1, 1786.
304. PHMC Survey D-58-275, Catherine Moore, warrant January 17, 1772, survey March 7, 1829.
305. PHMC Survey C-141-30, John Meason, July 10, 1792.

CHAPTER 18

306. Captain Jacobs's principal residence was at Kittanning on the Allegheny River in Armstrong County, where he was killed in September 1756, during an attack on his village by Pennsylvania soldiers led by Colonel John Armstrong. Sipe, *Indian Wars*, 296–97, 307; Wallace, "Blunder Camp," 24, note 11; Donehoo, *History of the Indian Villages*, 73–74.
307. Sargent, *History of an Expedition*, 346. George Washington and Christopher Gist camped at Jacobs' Cabins on November 19, 1753, and January 1, 1754, on their trip to and from the French Fort LeBoeuf. See Darlington, *Christopher Gist's Journals*, 80, 86.
308. Lacock, "Braddock Road," 29–31. Lacock noted that Braddock's Road skirted to the eastward "a great swamp," known as "Jacob's Swamp," of several hundred acres. Lacock, "Braddock Road," 31, note 67. Highlighting his conflicting position regarding the encampment, Lacock located on his map

of 1912 a Jacobs' Cabin encampment on Jacobs' Creek and depicted a "Jacobs Hunting Cabin" north of Mount Pleasant.

309. Hamilton, *Braddock's Defeat*, 117.

310. Ibid., 24, 47.

311. Cassell and Cassell, "Tour of Braddock's Road," 20.

312. Wallace, "Blunder Camp," 24.

313. Gist's map.

314. For the "Braddock's Fording" designation, see Court of Common Pleas of Westmoreland County, Pennsylvania, Continuance Docket, No. 5, 443; Lacock, "Braddock Road," 32–33, note 69.

315. Wallace, *Indian Paths*, 436. The Glades Path extended from present Bedford, Pennsylvania, passed through present Somerset and Mount Pleasant and on to the Forks of the Ohio. See Donehoo, *History of the Indian Villages*, 183.

316. Cassell and Cassell, "Tour of Braddock's Road," 20.

317. All the surveys of the grants between Camp 14 at Green Lick Run and Camp 15 at Jacobs' Cabins were reviewed and plotted.

318. PHMC Survey C-116-256, John Meason; Survey D-58-275, Catherine Moore; John Meason, C141-30.

319. PHMC Survey C-6-104.

320. PHMC Survey A-82-253.

321. PHMC Survey C-164-136, John Niel/Adam Bratton and C-164-132, William Niel, adjoining tract on the east including the Mount Pleasant area; Survey C-75-157, James Hamilton; Survey C-40-211, John Nichols.

322. PHMC Survey C-220-123, George Swan, 163 acres, application August 8, 1769.

CHAPTER 19

323. All the land grants along the road from Jacobs' Cabins at Camp 15 to Camp 16 at "Lick Camp" were reviewed and plotted.

324. PHMC Survey D-46-100, William Shrater, order of survey No. 562, April 3, 1769, in the name of Andrew Forbes, "South side of Sewickly, including a Spring, and about a Mile and an half from Jacobs Cabbin on Braddocks road joining a Rich Hill and lying between sd Cabbin and said Creek," surveyor Benjamin Lodge.

325. PHMC Survey C-221-85, William Simpson.

326. PHMC Survey No. 2796, D-62-221, Thomas Bradford, April 4, 1769, 297 acres 114 poles. This tract was resurveyed for Thomas Thompson on July 11, 1769, No. 3127, P-401, 298 acres, described as "situate on General Braddocks Road about thirty miles from Fort Pitt," surveyor William Thompson.

327. PHMC Survey B-8-27, No. 1872, James McKee/David Sample, November 8, 1769, "on the lower end of Jacobs Swamps." "Braddocks Road" is shown extending from the tract's northeastern boundary with Thomas Bradford, westward down the Belson Run Valley. This tract of land included the spring cited in the 1787 survey of Braddock's Road around Jacobs' Swamp to the Belson Run Valley. See note 2.

328. PHMC Survey D-57-275, No. 172, David Barr, originally surveyed April 3, 1769, and resurveyed March 24, 1828.

329. Cassell and Cassell, "Tour of Braddock's Road," 20.

330. See note 5.

331. PHMC Survey C-221-286, John Wyland (Wyand), January 8, 1787.

332. PHMC Survey C-120-101, John Leightly, March 16, 1786; Survey M-419, Robert McCandlesh, April 28, 1787.

333. PHMC Survey C-68-42, John Goudy, March 30, 1816, and C-68-41, March 30, 1817.

334. Wallace, "Blunder Camp," 26.

335. Gist's map.

336. Gordon's map.

337. Hamilton, *Braddock's Defeat*, 47.

338. Ibid., 118.

339. Sargent, *History of an Expedition*, 346–48.

340. Hamilton, *Braddock's Defeat*, 25, 47.

341. Sargent, *History of an Expedition*, 346.

342. Gist's map.

343. PHMC Survey D-70-230, application no. 3437, June 13, 1769, Theophilus Drinker, 260 acres, 80 poles, surveyed July 23, 1828, "Situate at the crossings of Sewickly on both Sides of Braddocks road." See also A-71-165, Leonard Peck, and C-32-242, C-38-67, C-38-68, John Clark.

344. Lacock, "Braddock Road," 31–32, note 68.

345. Cassell and Cassell, "Tour of Braddock's Road," 20.

346. Wallace, "Blunder Camp," 26.

347. Steeley, "Road Not Lost," 27.

CHAPTER 20

348. Hamilton, *Braddock's Defeat*, 118–19. Orme referred to the stream as "Thicketty Run." Sargent, *History of an Expedition*, 349.

349. Gist's map.

350. Sargent, *History of an Expedition*, 349; Hamilton, *Braddock's Defeat*, 25, 47.

351. Gordon also listed three miles from Lick Camp to the "Hillside" camp, Gordon's map.

352. The actual distance is 2.96 miles.

353. Orme's map, while illustrating confusion with the names of the local waterways, also locates the encampment, as did Gist, between what is now identified as the two northeast head branches of Sewickley Creek.

354. PHMC Survey B-18-78. Nehemiah Stokely, April 29, 1785, 318 acres.

355. Lacock, "Braddock Road," 33.

356. Wallace, "Blunder Camp," 26; Steeley, "Road Not Lost," 27–28.

357. PHMC Survey D-70-230, 260 acres, eighty perches, with the road depicted extending from the crossing of the creek to the northwest side of the grant.

358. PHMC Survey C-129-213, Daniel Mathias, April 7, 1785, 338½ acres.

359. PHMC Survey C-166-158, George Armstrong and Jacob Painter, January 25, 1816, earlier (1785), the land claimed by James Brotherington.
360. PHMC Survey C-129-212, George Mathias, May 5, 1785, 258¾ acres.

CHAPTER 21

361. PHMC Survey D-70-235, Gustavus Gregory, 306 acres, 102 perches, application no. 3424, June 13, 1769.
362. Sargent, *History of an Expedition*, 350; Hamilton, *Braddock's Defeat*, 25–26, 47–48.
363. Monacatootha, Oneida chief, also known as Scarouady, successor to Tanacharison as Half King, was leader of the Indians who joined Braddock for the expedition. The Indian contingent was under the overall leadership of famed trader George Croghan, with a captain's commission, and the interpreter Andrew Henry Montour, men who were with Washington at the defeat of Fort Necessity the year before.
364. Gist's map; Sargent, *History of an Expedition*, 350; Hamilton, *Braddock's Defeat*, 26.
365. Orme in Sargent, *History of an Expedition*, 350; Cholmley's batman in Hamilton, *Braddock's Defeat*, 25–26; and the unidentified British officer in Hamilton, *Braddock's Defeat*, 47–48, all cited July 6 as the date of the death and burial of Monacatootha's son, while Halkett's Orderly Book for July 5, "Camp Near the Thickett Run," has the entry: "Monacatuthaws son will be intered this Evening." Hamilton, *Braddock's Defeat*, 119.

CHAPTER 22

366. Sargent, *History of an Expedition*, 351.
367. Hamilton, *Braddock's Defeat*, 26.
368. The encampment site was probably in the vicinity of Northeast Drive in Browntown, about 2 miles from Monacatootha Camp.
369. Hamilton, *Braddock's Defeat*, 119.
370. Lacock, "Braddock Road," 34.
371. Gordon's map journal abstract.
372. Cassell and Cassell, "Tour of Braddock's Road," 21.
373. Hamilton, *Braddock's Defeat*, 48.
374. *Copy of Sketch of the Monongahela with the Field of Battle Done by (Direction of) an Indian*, Library of Congress. The words "Direction of" were inserted by pencil between "by" and "an Indian." In the lower-right corner of the map is a faint penciled date of 1755. The name John Montresor, one of General Braddock's engineers on the expedition, appears on verso.
375. Darlington, *Christopher Gist's Journals*, 32.
376. Gist's map.
377. Sargent, *History of an Expedition*, 351; Gordon's map journal; see note 6.

CHAPTER 23

378. Wallace, *Indian Paths*, 21.

379. See Hamilton, *Braddock's Defeat*, 48. The British officer noted, "we were obliged to halt within 600 yards of ye first halting." See also Wallace, "Blunder Camp," 30, and "Indian Map."

380. Sargent, *History of an Expedition*, 352, note 1. Orme's map does not show or mention Blunder Camp but depicts the army marching directly from Monacatootha Camp down Long Run to the head of Sugar Creek in present White Oak. See the map in the January 1759 Grand Magazine and Thomas Jeffrey's A General Topography, referenced earlier.

381. Lacock, "Braddock Road," 34–35.

382. Steeley, "Road Not Lost," 28.

383. Gordon's map.

384. Gist's map. See also the Library of Congress "Indian Map," which illustrates that the army had to backtrack from Brush Creek to the point where it had earlier left the Indian path before advancing down Long Run.

385. Wallace, *Indian Paths*, 21.

386. Sargent, *History of an Expedition*, 352.

387. Hamilton, *Braddock's Defeat*, 26–27.

388. Ibid., 48.

389. This may be the "swamps" referred to by the British officer.

390. Pargellis, *Military Affairs in North America*, 105.

391. Gist's map. This stream was also known as "Sugar Run." Craig, *Braddock's Defeat*, 11.

392. Cassell and Cassell, "Tour of Braddock's Road," 21.

393. The total distance of Braddock's Road(s) through Virginia, Maryland and Pennsylvania to the field of battle is about 288.5 miles. Halkett's 44th Regiment marched about 129.5 miles from Alexandria to Fort Cumberland. Colonel Dunbar's 48th Regiment, marching through Virginia into eastern Maryland and back through Virginia, was forced to cover about an additional 43 miles, for a total of about 172.7 miles. By the time the expedition reached Fort Cumberland, it had put more than half of the march behind it. There was another 115.8 miles left to go before it encountered the French and their Indian allies on the banks of the Monongahela a short distance north of Turtle Creek. The distance by Braddock's Road from Fort Cumberland to the mouth of Turtle Creek, via the Narrows of Will's Creek and Blunder Camp (Camp 19), is about 114.8 miles; another 1 mile reaches the point position at the "Field of Battle," for a total of about 115.8 miles, and from there, by the most direct route to Fort Duquesne, is another 8.45 miles, for a total of about 124.25 miles; by way of Sandy Gap, it is 122.84 miles to Fort Duquesne. Compare these figures with Gist's map estimates, 47–48. Deducting about 3.8 miles for the side march to Blunder Camp, the road to the Forks of the Ohio is about 120.45 miles (by Narrows of Will's Creek) and about 119.04 miles through the Sandy Gap.

Bibliography

Abbott, Raymond B. "Braddock's War Supplies and Dunbar's Camp." *Western Pennsylvania Historical Magazine* 17 (March 1934): 49–53.

Abbot, W.W., ed. *The Papers of George Washington: Colonial Series*. 10 vols. Charlottesville: University Press of Virginia, 1983–95.

Atkinson, Thomas C. "Braddock's Route to the Battle of the Monongahela." In *Washington's First Campaign and Braddock's Defeat*. Pittsburgh, PA: M.P. Morse, 1848.

Bailey, Kenneth P. *Christopher Gist: Colonial Frontiersman, Explorer, and Indian Agent*. Hamden, CT: Archon Books, 1976.

———. *The Ohio Company of Virginia and the Westward Movement 1748–1792*. Glendale, CA: Arthur H. Clark Company, 1939.

Baker, Norman L. *Fort Loudoun: Washington's Fort in Virginia*. Winchester, VA: French & Indian War Foundation, 2006.

———. *French & Indian War in Frederick County, Virginia*. Winchester-Frederick County Historical Society Publications. Winchester, VA: Buckley's Printing, 2000.

Bantz, Robert L. "Braddock Road in Y2K: The Old Road in a New Millennium." *Archaeological Society of Maryland Ink* 27 (April 2001): 6–7.

———. "Rediscovering the Braddock's Trail." *Archaeological Society of Maryland Ink* 29 (February 2003): 1, 7–8.

Bomberger, Bruce D., and Louis M. Waddell. *The French and Indian War in Pennsylvania 1753–1763*. Harrisburg: Pennsylvania Historical and Museum Commission, 1996.

Brown, Lloyd. *Early Maps of the Ohio Valley*. Pittsburgh, PA: University of Pittsburgh Press, 1959.

Bullskin Township Historical Society. http://www.bullskintownshiphistoricalsociety.org/home.

Cassell, Frank A., and Elizabeth W. Cassell. "A Tour of Braddock's Road from Fort Necessity to Pittsburgh." *Westmoreland History* 7, no. 2 (September 2002): 17–22.

Court of Common Pleas of Westmoreland County, Pennsylvania. Continuance Dockets.

Craig, Neville, B. *The Olden Time*. 2 vols. Cincinnati, OH: Robert Clarke, 1876.

———. *Washington's First Campaign and Braddock's Defeat*. Pittsburgh, PA: M.P. Morse, 1848.

Crocker, Thomas E. *Braddock's March*. Yardley, PA: Westholme Publishing, 2009.

Cumberland Road Project. "The Forgotten Road." http://www.cumberlandroadproject.com/maryland/the-forgotten-road.

Darlington, William M., ed. *Christopher Gist's Journals: With Historical, Geographical and Ethnological Notes*. Pittsburgh, PA: J.R. Weldin & Company, 1893.

Donehoo, George P. *A History of the Indian Villages and Place Names in Pennsylvania*. Lewisburg, PA: Wennawoods Publishing, 1999. Originally published in 1928.

Dorsey, Jean Muir, and Maxwell Jay Dorsey. *Christopher Gist of Maryland and Some of his Descendents 1679–1957*. Chicago: J.S. Swift, 1969.

Fitzpatrick, John C., ed. *The Diaries of George Washington, 1748–1799*. Vol. 1, *1748–1770*. New York: Houghton Mifflin, 1925.

———. *The Writings of George Washington from the Original Manuscript Sources, 1745–1799*. 39 vols. Washington, D.C.: Government Printing Office, 1931.

Freeman, Douglas Southall. *George Washington, a Biography*. Vols. 1 and 2. New York: Charles Scribner's Sons, 1948–49.

Hadden, James. *Washington's Expeditions (1753–1754) and Braddock's Expedition (1755), with History of Tom Fausett, the Slayer of General Edward Braddock*. 2nd ed. Uniontown, PA, 1910.

Hamilton, Charles, ed. *Braddock's Defeat: The Journal of Captain Robert Cholmley's Batman, the Journal of a British Officer, and Halkett's Orderly Book*. Norman: University of Oklahoma Press, 1959.

Hamilton, S.M., ed. *Letters to Washington and Accompanying Papers, 1755–1775*. 5 vols. Boston, MA: Houghton Mifflin Company, 1889–1902.

Harrison, Fairfax, ed. "With Braddock's Army: Mrs. Browne's Diary in Virginia and Maryland." *Virginia Magazine of History and Biography* 32 (1924): 305–20.

Hersko, Ralph E. *Braddock's Road, Across Northern and Western Virginia*. West Conshohocken, PA: Infinity Publishing, 2004.

Hinks, D.R. *Dunbar's Camp & the Braddock Road*. Unpublished map and study in author's possession, 1988.

Hough, Walter S. *Braddock's Road Through the Virginia Colony*. Vol. 8. Winchester-Frederick County Historical Society Publications. Strasburg, VA: Shenandoah Publishing House, 1970.

Hulbert, Archer Butler. *The Crown Collection of Photographs of American Maps*. 5 vols. Cleveland, OH: Arthur H. Clark Company, 1907.

———. *Historic Highways of America*. Vol. 4, *Braddock's Road and Three Relative Papers*. Cleveland, OH: Arthur H. Clark Company, 1903.

Jackson, Donald, and Dorothy Twohig, eds. *The Diaries of George Washington, 1748–1799*. 6 vols. Charlottesville: University Press of Virginia, 1976–79.

Jacob, John J. *A Biographical Sketch of the Life of the Late Captain Michael Cresap*. Cumberland, MD: J.M. Buchanan, 1826.

Johnson, Patricia Givens. *James Patton and the Appalachian Colonists*. Verona, VA: McClure Printing Company, 1973.

Kent, Donald H., ed. "Contrecoeur's Copy of George Washington's Journal for 1754." *Pennsylvania History* 19, no. 1 (January 1952): 1–32.

Kopperman, Paul E. *Braddock at the Monongahela.* Pittsburgh, PA: University of Pittsburgh Press, 1977.

Lacock, John Kennedy. "Braddock Road." *Pennsylvania Magazine of History and Biography* 38, no. 1 (1914): 1–38.

Lacock, John Kennedy, and Ernest K. Weller. Braddock Road Postcard Collection, Braddock Road Preservation Association. http://www.braddockroadpa.org/postcard.html.

Lewis, William L. "First White Settlers." Fayette, Somerset and Westmoreland Counties of Southwestern Pennsylvania, June 1, 1956. http://www.fay-west.com/connellsville/historic/seq-2.php.

Library of Congress. American Memory Map Collections. http://memory.loc.gov/ammem/index.html.

———. George Washington's Papers, 1741–99. Manuscript Division, Washington, D.C.

Lowdermilk, Will H. *Along the Braddock Road.* Excerpted from *History of Cumberland, Maryland.* Leesburg, PA: Wennawoods Publishing, 2005. Originally published in 1878.

Martz, Ralph Fraley. "Dowden's Ordinary." *Montgomery County Story* 1, no. 2 (February 1958).

McCardell, Lee. *Ill-Starred General: Braddock of the Coldstream Guards.* Pittsburgh, PA: University of Pittsburgh Press, 1958.

McGrain, John. "The Wagon Roads of Western Maryland." Western Maryland History, 2010. http://www.wmdhistory.org/general/mcgrain-roads-of-west-maryland.pdf.

Mulkearn, Lois. *George Mercer Papers Relating to the Ohio Company of Virginia.* Pittsburgh, PA: University of Pittsburgh Press, 1954.

Older, Curtis L. *The Braddock Expedition and Fox's Gap in Maryland.* Westminster, MD: Family Line Publications, 1995.

Pargellis, Stanley M., ed. *Military Affairs in North America, 1748–1765: Selected Documents from the Cumberland Papers in Windsor Castle.* New York: D. Appleton-Century Company, 1936.

Parkman, Francis. *Braddock's Defeat, 1755: The French and English in America.* New York: Effingham Maynard & Company, Publishers, 1888.

Pennsylvania Historical and Museum Commission. Land Patent Records. Pennsylvania State Archives, Harrisburg, Pennsylvania.

Powell, Allan. *Forgotten Heroes of the Maryland Frontier.* Baltimore, MD: Gateway Press, 2001.

———. *Maryland and the French and Indian War.* Baltimore, MD: Gateway Press, 1998.

Ruckert, Robert J. "The Braddock Military Road." *Glades Star* 4 (June 1975): 569–71, 573–84.

Sargent, Winthrop. *The History of an Expedition Against Fort DuQuesne in 1755.* Philadelphia, PA: J.B. Lippincott & Company, 1856.

Scharf, J. Thomas. *History of Western Maryland, Being a History of Frederick, Montgomery, Carroll, Washington, Allegany, and Garrett.* Vol. 1. Baltimore, MD: Clearfield Company & Family Line Publications, 1995. Originally published in 1882.

Scheel, Eugene. "General Braddock's March through Loudoun in 1755." History of Loudoun County, Virginia. http://www.loudounhistory.org/history/loudoun-braddock-march-1755.htm.org.

Schwartz, Seymour I. *The French and Indian War, 1754–1763: The Imperial Struggle for North America.* New York: Simon & Schuster, 1994.

Sipe, C. Hale. *The Indian Wars of Pennsylvania.* Lewisburg, PA: Wennawoods Publishing, 1995. Originally published in 1931.

Steeley, James V. "A Road Not Lost: Rediscovering General Braddock's Road through Westmoreland County." *Westmoreland History* 7, no. 2 (September 2002): 23–29.

Stotz, Charles Morse. "A Letter from Will's Creek. Henry Gordon's Account of Braddock's Defeat." *Western Pennsylvania Historical Magazine* 44 (June 1961): 129–36.

Trudel, Marcel. "The Jumonville Affair." Translated and abridged by Donald H. Kent. *Pennsylvania History* 21, no. 4 (October 1954): 351–81.

Veech, James. *The Monongahela of Old.* Pittsburgh, PA, 1858–92.

Vogt, Helen Elizabeth. *Westward of Ye Laurall Hills, 1750–1850.* Parsons, WV: McClain Print Company, 1976.

Wahll, Andrew J., ed. *Braddock Road Chronicles, 1755.* Bowie, MD: Heritage Books, 1999.

Wallace, Paul A.W. "Blunder Camp: A Note on the Braddock Road." *Pennsylvania Magazine of History and* Biography 87 (January 1963): 21–30.

———. *Indian Paths of Pennsylvania.* Harrisburg: Pennsylvania Historical and Museum Commission, 1987.

Wayland, John W. *Historic Homes of Northern Virginia and the Eastern Panhandle of West Virginia.* Staunton, VA: McClure Press, 1937.

Whetzel, Dan. "National Road Bicentennial, 1811–2011." *Mountain Discoveries* (Spring/Summer 2011): 28–35.

Maps of Braddock's Road, Mapmakers and Resources

Atkinson, Thomas C. *Middleton's Map of Braddock's Road,* 1847. Drawn by Atkinson's assistant, featured in Atkinson's *Braddock's Route to the Battle of the Monongahela* and in Neville B. Craig's *Braddock's Defeat* (1848). It is also identified as *Braddock's Route A.D. 1755.*

Campbell, John H. The chief draftsman in Pennsylvania's Department of Internal Affairs in the first quarter of the twentieth century, Campbell connected drafts of individual township surveys in Fayette County, Pennsylvania. These drafts were constructed from original drafts remaining on file in the Pennsylvania State Archives, 1917–23. The drafts reproduce the route of Braddock's Road through several of the surveys, as mainly recorded by Alexander McClean, Pennsylvania deputy surveyor, in the late eighteenth century.

Copy of a Sketch of the Monongahela with the Field of Battle Done by (Direction of) an Indian. Library of Congress. "Indian Map" in *Historic Maps of Pennsylvania, 1755 to 1759 (1755.29).* Depicts "Rout[e] of the Army" to "Where the Guides lost their road," leaving the Glades Path in the vicinity of Camp 18, on a route to Blunder Camp (Camp 19) on the Brush Creek branch of Turtle Creek. It retraces the route to the original Indian and traders' path down Long Run, to the Monongahela and the field of battle. The words "direction of" were inserted on the map in pencil, as well as the date of 1755. The name of Lieutenant John Montresor, an engineer and mapmaker on Braddock's expedition, appears in pencil on verso.

Gist, Christopher. *The Draught of Genl. Braddocks Route Towards Fort DuQuesne as Deliver'd to Capt. McKeller Engineer. By Christ. Gist the 15th of Sept. 1755.* This map depicts encampments and distances between them. It is one of two known existing maps. The map used in this study is in the John Carter Brown Library Archive of Early American Images (01541, Cabinet Cj755/IMS) at Brown University. A second map has less detail. Copies of the maps are also at the Pennsylvania Historical and Museum Commission.

Gordon, Harry. *A Sketch of General Braddock's March from Fort-Cumberland on the 10th of June 1755 to the Field of Battle of the 9th July Near the River Monongahela.* See Stanley Pargellis's *Military Affairs in North America 1748–1765* and the Cumberland Maps in the Royal Library at Windsor Castle. Attributed to Gordon but unsigned, not dated and after Gist's map of September 15, 1755. An "Abstract of a Journal" at the base of the map locates encampments and mileage between the camps, "Work done on the Road," "Quality of the Road," "Quality of the Camp" and "Days Halted." Gordon credits Gist's map for details in preparing his own map.

Historical Maps of Pennsylvania. www.mapsofpa.com. This invaluable online resource contains hundreds of eighteenth-century maps from various libraries, collections, archives and printed books.

Hutchins, Thomas. *A Map of the Country on the Ohio and Muskingum Rivers,* 1764–65. Library of Congress; British Library. Depicts the routes of Braddock, Forbes and Bouquet. Image used in Thomas Jeffrey's *A General Topography of North America and the West Indies* (1768). See also *Historical Maps of Pennsylvania, 1765 to 1769 (1765.1).* There is a large version of this map in the Clements Library at the University of Michigan.

Jeffrey, Thomas. A version of Robert Orme's map was published in Jeffrey's *A General Topography of North America and the West Indies* in 1768 and in Jeffrey's *A Map of the Country between Will's Creek & Monongahela River, Shewing the Rout and the Encampments of the English Army* in 1775. See Orme.

Kitchin, Thomas, Jr. *A Map of the Province of Pensilvania Drawn from the Best Authorities,* December issue of *London* magazine, 1756. See *Historic Maps of Pennsylvania, 1755 to 1759 (1756.1).* Based on Evans's map of 1749. Depicts the Indian and traders' path, which became Braddock's Road. Distances on the path lists 41 miles from "F. Cumberland" to Great Crossings, 20 miles from Great Crossings to "Gist's," 5 miles from "Gist's" to "Stewart's" (Crossings), 15 miles from "Stewart's" (Crossings) to "Salt Lick [Jacobs'] Cr.," 10 miles from "Salt Lick [Jacobs'] Cr." to "Sewickly Cr.," 12 miles to "Turtle Cr." and 6 miles to "F. du Quesne," for a total of 109 miles.

Lacock, John Kennedy. *Braddock's Military Road from Cumberland, MD. to Braddock, PA., 1755,* featured in article "Braddock Road," *Pennsylvania Magazine of History and Biography* 38 (1914).

Middleton's Map. *Middleton's Map of Braddock's Road* (1847), also identified as *Braddock's Route A.D. 1755.*

Montresor, John. *Copy of a Sketch of the Monongahela with the Field of Battle Done by (Direction of) an Indian* is also identified as the "Indian Map," Library of Congress, American Memory Map Collections, http://memory.loc.gov. The penciled date of 1755 appears in the lower right corner, and the name "John Montresor" is on verso. See also *Historical Maps of Pennsylvania, 1755 to 1759 (1755.29).* Lieutenant John Montresor

was a supernumerary engineer in the 48th Regiment of Foot in General Braddock's army and was wounded in the battle on the Monongahela.

Orme, Robert. *Map of the Country between Wills Creek and Fort de Quesne,* "based on a drawing by Capt. Robert Orme," *Grand Magazine of Universal Intelligence and Monthly Chronicle of Our Times,* January 1759, London. A large-scale version was published in Thomas Jeffrey's *A General Topography of North America and the West Indies* (1768). Still later, Jeffrey published it as *A Map of the Country between Will's Creek & Monongahela River, Shewing the Rout and Encampments of the English Army* (1775).

Rhoads, William F. *Map of Braddock's Military Road Through Pennsylvania, 1755.* Compiled and traced by Rhoads from original surveys remaining on file in the Pennsylvania Department of Internal Affairs, 1932. An expansion of the earlier connected drafts by John H. Campbell, chief draftsman in the early twentieth century, which reproduced Braddock's Road through Fayette County, as recorded on surveys by Alexander McClean. Most of the road was not depicted on the original surveys and is shown on the map as a conjectural dotted line, with the expedition's encampment sites sometimes erroneously located and reflecting conclusions reached by John Kennedy Lacock.

Scull, William. April 4, 1770 map of western Pennsylvania similar in most details to the map by Joseph Shippen Jr., *A Draught of the Monongahela and Youghigheny,* November 1759. See *Historical Maps of Pennsylvania, 1770 to 1774 (1770.1). A Map of Pennsylvania,* based on William Scull's map, was published by Robert Sayer and J. Bennett in June 1775, and in *North American Atlas of 1777,* Library of Congress. Scull's map depicts, from "Fort Pitt, formerly Fort Duquesne," "Genl. Braddock's Field," "Sewickly Cr.," "Salt Lick Cr. or Jacobs Cr.," "Stewarts Crossing," "Guest's [Gist's]," "Dunbar's Camp," "Big Rock [Half King's Rocks]," "Great Meadows," "12 Springs" and "Great Crossing" along the entire length of Braddock's Run between the Great Crossings and Winding Ridge, followed by a straight line of the road to Fort Cumberland.

Shippen, Joseph, Jr. *A Draught of the Monongahela and Youghigheny,* November 1759. Depicts "Martin's" on George's Creek, Savage River and Savage Mountain, "Little Meadows," "Little Crossings [Castleman or Casselman River]," "Great Crossings," "12 Springs," "Great Meadows," "Big Rock [Half King's Rocks]," "Dunbar's Camp," "Guest's [Gist's]" and the junction with Burd's Road to "Fort Burd." The road is straight-lined north across the Youghigheny at Stewart's Crossings, ending after turning across Jacobs' Creek. Located at the Pennsylvania Historical Society. A second map—similar in detail and undated but probably also about 1759—continues "General Braddock's Road" straight-lined to the Monongahela and "Braddocks Field." At the Forks of the Ohio, Shippen depicts "Ft. Pitt" and, nearby, "Croghan's Plantation." Located at the British Museum.

United States Geological Survey. *Frostburg Map,* 1908. The route of Braddock's Road was depicted as a trail from the Sand Spring Run branch of George's Creek to the present Interstate 68 on the 1908 USGS map of the Frostburg, Maryland area. This portion of the military road has now been destroyed by a strip mining operation in the area. As late as 1949, a portion of the road through the mining operation was shown on the USGS survey maps. Northwest of Interstate 68, the scar of the military road has survived in its course over Big Savage Mountain.

Unknown mapmaker. *Fort Cumberland to Fort Erie*, circa 1754. Map of the route from Fort Cumberland to Fort Duquesne by way of the Great Crossings, Great Meadows, Stewart's Crossings, the east side of the Monongahela through the Narrows on the Indian and traders' path (rather than the double fording of the river route by Braddock's army) and across the mouth of Turtle Creek. See *Historic Maps of Pennsylvania, 1755 to 1759 (1755.30)*. See also Archer B. Hulbert's *The Crown Collection of Photographs of American Maps* (1907).

Unknown mapmaker. *Fort Cumberland to Lake Erie*, circa 1759. Map of the route from Fort Cumberland to Fort Pitt by way of the Great Crossings and Stewart's Crossings. Depicts Braddock's Road and the two fordings of the Monongahela to the field of battle. See *Historical Maps of Pennsylvania, 1755 to 1759 (1759.10)*. See also Archer B. Hulbert's *The Crown Collection of Photographs of American Maps* (1907).

Index

About the Author

Norman L. Baker has been researching the American colonial period, its explorers and its frontiersmen for several decades, devoting a major portion of that study to the French and Indian War and the Revolution. He is a veteran of World War II in the Pacific, was a member of the assault forces in the Battle of Iwo Jima and served in the Korean War, with one year of continuous combat and participation in three major battles. Currently, he is the president of the Fourth Marine Division Association, the "Fighting Fourth of World War II," and the historian of the French and Indian War Foundation.

Baker graduated from Indiana Institute of Technology with a Bachelor of Science in aerospace engineering. With the Boeing Pilotless Aircraft division in Seattle, Washington, he was a development engineer on the Bomarc missile program. Norman formally proposed the development of a space shuttle vehicle in October 1955. Later, as a result of his space shuttle

proposal, he was asked to move to Washington, D.C., as an editor of *Missiles and Rockets* magazine. Eventually establishing his own publishing corporation, with publications in space and defense, he founded *Defense Daily*, currently covering the nation's defense establishment.

As a journalist publisher, Baker was a White House correspondent for several years, covering eight presidential administrations; a Senate and House Press Gallery correspondent; and for a time dean of the Pentagon Press Corps.

Baker was a founder and a president of the National Space Club, established in 1957 to stimulate and recognize American leaders in the national space program. Norman founded the Astronautics Engineer Award in 1958, which annually recognizes the nation's outstanding space engineer. In 1965, he authored *Who's Who in Space*.

Norman has compiled what is considered to be one of the most comprehensive studies identifying and locating the forts of the French and Indian War, extending from the St. Lawrence River to Georgia. He is also author of *Frontier Forts of Berkeley County* (1999); *French & Indian War in Frederick County, Virginia* (2000); *Valley of the Crooked Run: The History of a Frontier Road* (2002); and *Fort Loudoun: Washington's Fort in Virginia* (2006).

Baker is the recipient of the Golden Owl Award of the National Press Club, the Life Membership Award of the National Space Club, the Stewart Bell Jr. Award for "Achievement in the Field of Historical Literature," the Shenandoah University's President Award for "Outstanding Service in Community History," the Fort Loudoun Award for "Outstanding Contribution to the Preservation of Our French & Indian War Heritage" and the Indiana Institute of Technology's Order of the Silver Slide Rule Award for "Outstanding Service to Industry and Commerce." In 2011, he was inducted into the Virginia Historical Series Hall of Fame.

Visit us at
www.historypress.net
..
This title is also available as an e-book